SO-BRD-529

# Baskets and Basket Makers

## in Southern Appalachia

*by John Rice Irwin*

Schiffer Publishing Ltd

Box E, Exton, Pennsylvania 19341

# Baskets and Basket Makers
## in
## Southern Appalachia

**Other books by John Rice Irwin:**
*Marcellus Moss Rice and His Big Valley Kinsmen*
*Musical Instruments of the Southern Appalachian Mountains*
*Guns and Gunmaking Tools of Southern Appalachia*
*The Arnwine Cabin*

©Copyright 1982 John Rice Irwin

All rights reserved. No part of this book may be reproduced or utilized in any form or by any means, electric or mechanical, including photocopying, recording, or by any information storage and retrieval system, without permission in writing from the Publisher.

Library of Congress Catalog Card Number: 81—86386
ISBN: 0916838609 Hard
ISBN: 0916838617 Soft

Printed in the United States of America
Schiffer Publishing Limited, Box E, Exton, Pa. 19341

Dedicated to the old-time mountain basketmakers who received scant remuneration and little recognition for their years of toil in creating one of the most useful and artistic possessions in the lives of our people in Southern Appalachia.

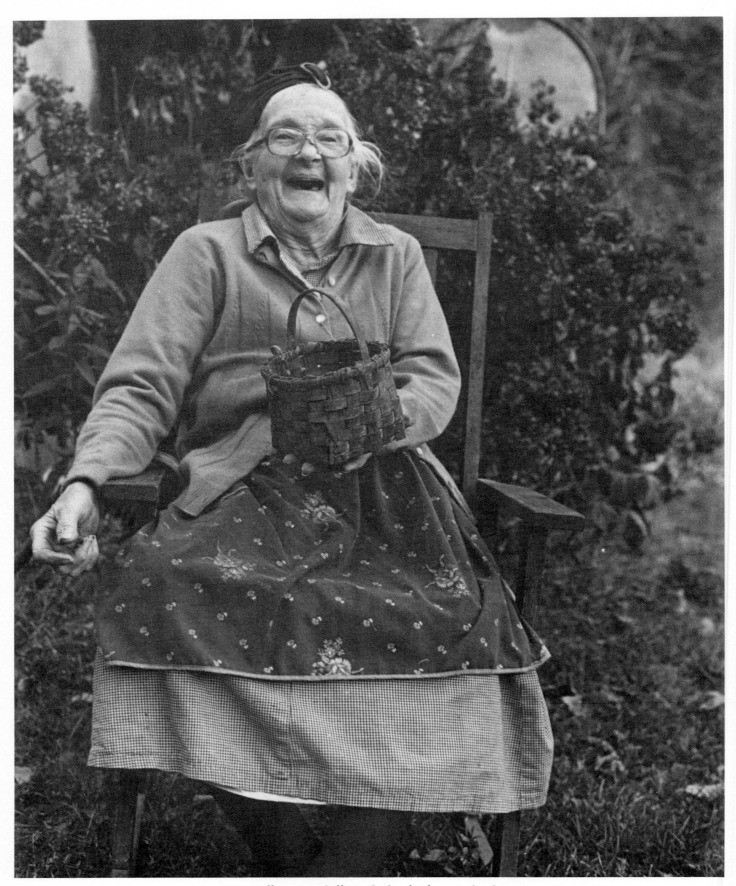

Dollie Turnbill and the little egg basket
she used for about 65 years. (Photo taken by
the author about three weeks before her death)

# Preface

John Rice Irwin's Museum of Appalachia houses one of the most impressive collections of authentic Appalachian artifacts in our mountains, and I have yet to meet a collector or scholar or enthusiast who disagrees. It is, in a word, staggering. In fact, when I and the students I work with to prepare the Foxfire books come up against a puzzle regarding some item of material culture, an example of which we either can't find or identify, it is often John Rice to whom we turn for help. He has yet to fail us.

But perhaps even more extraordinary than the fact of his collection itself is the fact that he can accurately put most of the items in context, unlike the owners of the numerous lifeless, undocumented collections that dot the region. Not only does he know who made and/or used many of the items in the collection, but he also often has photographs of those people and their surroundings, data about family backgrounds, specific construction details about the artifacts, and the specific purposes the artifacts served within the families that owned them. It's an unusual, and extremely valuable, dimension that most collections lack—especially those collections made with the help of area antique dealers who buy their artifacts from "pickers" who, if they have documentation to go along with them at all, have often simply made it up.

This book is a good illustration of the kind of work John Rice has done throughout his museum. It will be an extremely useful tool for us at Foxfire as we work to document as well as we can the variety of forms traditional handmade containers took in our part of the mountains; it will probably also be fascinating for those more casual observers or collectors who, until now, assumed that there were only a few traditional basket styles; and it should serve as an indication of the kind of information any responsible collection of artifacts should have if it is to be of any real use to future generations.

Eliot Wigginton

Eliot Wigginton is the founder and director of the Nationally acclaimed Foxfire Project in Rabun Gap, Georgia.

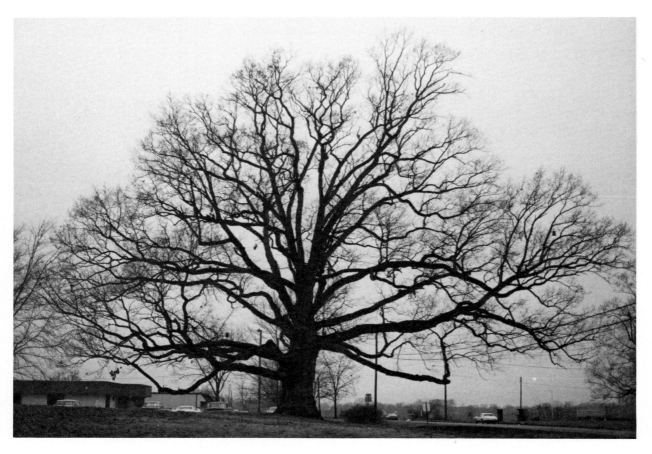

The "Baby" white oak of McMinnville, Tennessee
The white oak provided the material for perhaps ninety percent of all baskets made in Southern Appalachia. The story of this magnificent specimen is found on pages 77 and 78.

# Introduction

The basket, perhaps as much as any other singular relic, conjures up fond and nostalgic memories from the past. And it was one of the few articles from our forebears which was equally important to both men and women, the young and the old, and to the poor and the affluent. As far back in history as factual information is available we find an important dependence upon baskets. The Egyptians were using them 7,000 years ago as agriculture and grain baskets; the ancient Assyrians used them in their everyday affairs; the Greeks used them, not only for various utilitarian purposes, but as ceremonial articles as well; the Romans used them in a multitude of ways; and of course they were commonly used in other parts of Europe. In the second chapter of Exodus the account is given as to how Moses was hidden in an ark made of bullrushes daubed with slime and pitch. An ark was in fact a basket. So it comes as no surprise that frontier America came to depend so greatly on the basket. The lifestyle of the pioneer people lent itself to the need and use of baskets; there was a plentious and varied supply of basket materials; and the people possessed the know-how to make them. The basket came to be a symbol of the rural-farm-forest oriented society; and it came to occupy a respected place in the culture of the folk in Southern Appalachia.

What person of rural Appalachia does not recall seeing his venerable grandfather feeding his horses and his pigs from the old white oak basket and what pleasant memories the little berry baskets recall--that somewhat festive occasion when family members as well as the neighbors would join one another in searching the back pastures and the "grown-up" knobs and the abandoned corn fields for blackberries. And the small oak baskets spark an instant recall of the egg-gathering in the high hay lofts and under the horses' mangers, and for duck eggs down by the pond. One might also recall the well-cared for basket which grandmother used for several decades to carry her butter and eggs to the nearby country store and which she used to fetch home her groceries--coffee, baking powder, soda, salt, and maybe some sugar. The fact that these baskets often were made by a member of the family, by a relative, or at least by a neighbor added to one's affinity for them.

But several years ago the galvanized bucket, the factory-made wooden boxes, the paper bags, and especially the cheap plastic containers put an almost complete halt to these interesting and varied creations of the mountains. Who could afford to make or pay for a white oak basket requiring twenty hours labor, when, for the equivalency of fifteen minutes labor, he could buy a usable substitute?

So the old-time basketmakers went out of business in the early decades of this century; and once the existing baskets were worn out, or hung up as keepsakes, they were replaced by cheap factory-made containers. But as the old baskets began to be acquired as a remembrance of grandma and as the rather phenomenal basket collection craze progressed, the old supply was almost exhausted. But interestingly this widespread interest in baskets has had beneficial effects. It has helped to preserve the old baskets by retrieving them from the leaky smokehouses and the detritus-filled barns and woodsheds. Secondly, it has encouraged a few of the old-time basketmakers to renew, often after thirty or forty years re-

spite, their basketmaking; and finally it has encouraged a significant few younger folk to take up the craft. The latter happily promises to retrieve the art of basketmaking from a path of near certain extinction.

A quarter century ago, long before it was fashionable, I started collecting baskets from the mountains and valleys of East Tennessee, eastern Kentucky, southwestern Virginia, and western North Carolina. This is not to say that baskets were the only, or even the primary object of my pursuits; for I collected everything which might have had a bearing on the history, culture, and lifestyle of the people of this region of Appalachia. These relics I eventually used as the beginning of the Museum of Appalachia which is located on I-75, fifteen miles north of Knoxville, Tennessee. The Museum now houses over 200,000 regional relics and emphasizes the action-oriented open-air type farm and animal, folk-type museum.

The Museum, which is open the year 'round, has baskets displayed throughout the village in the various old log homes and cabins, in addition to the extensive basket exhibit in the Display Building. In an endeavor to personalize the individual baskets as much as possible, and for the purpose of recording the history, background, maker, owner, and human interest anecdotes relating to the baskets, this book is being written.

Although some recent attention has been given to basketry as a modern craft, to the various materials and techniques used in basketmaking, little has been done relative to the historic background of baskets and basketmakers. This is even more the case with regard to basketry in the Southern Appalachians where it was so important in the lives of the people. Carroll J. Hopf in his 1965 thesis on baskets for New York College in Oneonta makes the following statement in this connection:

"The experience of doing secondary research in this field indicates a lack of deliberate written information on virtually all aspects of Early American basketware. I know of no single publication, magazine, or book given over entirely to this subject."

Scholars and researchers in the future, hopefully, will take the factual and human interest information recorded here and use it to help in a more realistic portrayal of the neglected history and culture of our people. They will be able to credit the contributions made by the Indians, the Scotch-Irish, the English, the Germans, and others. And the results will be much more significant and encompassing than the mere history of the techniques, materials, and forms of the baskets themselves. Surely, items made and used so continuously and regularly in pioneer times, and well into the twentieth century for utilitarian and aestheric purposes, will give some insight into the various aspects of the lifestyles of our people.

J.R.I.
Norris, Tennessee
March, 1982

# Table of Contents

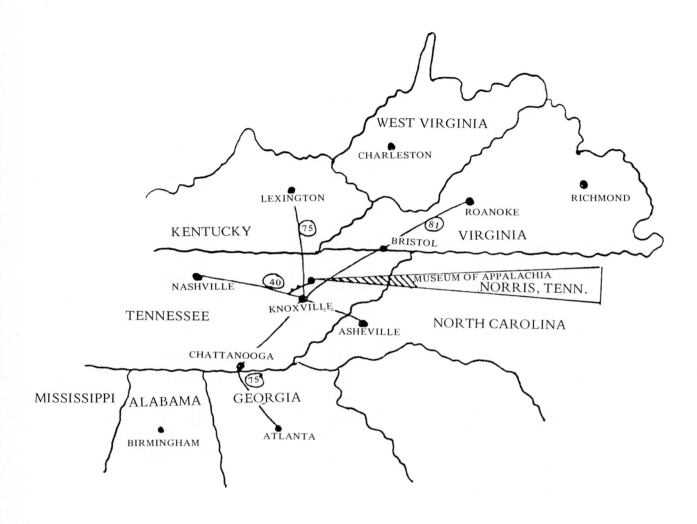

# Chapter 1

# The Importance and Use of the Basket in Southern Appalachia

If the modern household was suddenly deprived of the use of paper bags, metal pails, cardboard boxes, shopping bags, plastic buckets, tubs, and other modern containers, one would have some idea of what our ancestors' predicament would have been without the common basket. And when one considers that the need for containers in a farm setting was many times greater than that of most modern homes, he may appreciate the importance of the basket in the lives of our ancestors.

There is likely no way to statistically document the extent to which the basket was used by our Appalachian forebears. But I do recall working with my parents, grandparents, and neighbors in the 1930's in rural Appalachia, and my empirical observations indicate that its use was widespread, continuous, and almost indispensable to the performance of the daily chores.

I recall my grandfather Rice, who lived on Bull Run Creek, fifteen miles north of Knoxville, carrying into the house large white oak baskets filled with freshly shucked corn on the cob, dried and ready to be shelled as we sat around the evening fire. He had a corn sheller, but we always shelled our meal-corn by hand so we could discard any damaged or defective grains. These we placed in a smaller basket for the chickens; and the cobs were put in still another basket to be used to start the fire or sometimes to be used for their best known use in the privy.

Every morning and every evening my brother David and I would get our large baskets and go from stable to stable feeding the horses and mules the long ears of corn through the log cracks--six ears to the mule, Kate, eight ears to old Spike, the horse, and so on. We also used baskets to carry corn to the old sows and for the many fattening hogs. They had to have all they could eat twice a day.

We lived on the same farm where our Grandfather and Grandmother Irwin lived (where the city of Oak Ridge, Tennessee, is now located) and much of my childhood was spent with them. When we went with Grandpa Irwin to the foot of the mountain at the back of our farm where old pioneer homeplaces had once been and where gnarled fruit trees stood, we took our baskets. Apples may be carried in burlap bags, but not ripe peaches. One had to have baskets to carry peaches and plums. When we went to the top of the copperhead-infested Pine Mountain to pick huckleberries, wild grapes, hazelnuts, or the much sought after muscadines, we took our baskets.

During the summer months the baskets were used daily. Each morning we would "gravel" enough Irish potatoes for dinner and supper, pick the tomatoes and okra, and gather enough roasting ears for the day. Sometimes we would have to go almost a mile to a distant corn patch and each of us would carry two baskets, one under the crook of each arm. Baskets were seldom, if ever, carried in one's hands with the arms extended downward. I don't know why except that large baskets would almost drag the ground if carried in this manner; and it would certainly cause problems if one were going through weeds or high grass as was often the case.

When my brother and I went to the forest with Mrs. Ailer, the old lady who stayed with Granny Irwin, we always took a basket or two. We would gather the loose exterior bark from the scaly-bark hickory tree which made the best syrup I've ever eaten. And we gathered certain herbs she found as well.

In the fall of the year we would go with Grandpa Irwin to the top of a small mountain and there we would gather the rich heavy hearts of pine knots, lying there completely sound years after the remainder of the tree

had decayed and disappeared. This was the portion highly saturated with rosin and was used in the most primitive frontier conditions to make pine torches for lighting. The pioneers of our region also extracted, or "rendered," the rosin or tar from such rich knots to be used as a lubricant for wagon wheels and for several other purposes. We used pine knots, too, to start the morning fires. A piece of rich "fat" pine the size of one's finger would burn for minutes as if it had been soaked in gasoline.

In the late afternoon, after the mid-summer heat was somewhat less torrid, we went with the women (our mother, grandmother, and Aunt Sophia), each with his or her own basket to the bean patch to pick beans for the following day and for canning and drying. More often we would go to the cornfield where the vine-like Kentucky Wonder beans climbed to the very top of the tall Hickory King corn.

The sun in July and August was often very hot, there was little or no breeze flowing through the thick corn, and the sting of the packsaddle was always a threat. After what seemed to be hours, our baskets were all filled and the women would retire to the shady porch of Grandpa's gracious antebellum home to break the beans. One of the few chores our mother and Granny Irwin never "allowed" us to do was to break beans for fear we would miss cutting out a worm hole or that we would fail to remove all the strings.

One year our cucumber crop failed, and I recall that the Jett family brought several of the old white oak baskets filled with nice pickling-sized cucumbers. When we attended all-day church services, we, and I believe everyone else, took food in large split baskets. Of course, they were lined carefully with newspapers, which was not only beneficial from a sanitation standpoint, but which helped to keep the fried chicken, ham, cornbread, biscuits, pies, and the various other foods warm.

It seems that almost every basket one encounters in antique shops, or elsewhere, and most of those pictured in basket books or magazine articles are described as being egg baskets. The inference seems to be that carrying eggs was their only purpose. It is true that

many were used for gathering and marketing eggs; but I feel that most baskets of this southern mountain region served many purposes; for few people could afford a special basket for every use. It is true, however, that baskets for gathering and transporting eggs were perhaps most common. I do not subscribe to the often expounded theory that a basket can be characterized as an egg basket based on its size and shape. I have seen baskets which held a bushel and were used for marketing eggs; and others which were used for the same purpose held no more than a dozen. By the same token I have seen baskets of every size and form which were used to carry the eggs to the store on Saturday. Through the week the basket may have been a bean basket or a feed basket; but on Saturday it was an egg basket and may very well have been called an egg basket by members of the family, thus inadvertently giving a collector or researcher the impression that it had that special or singular use.

One of the first chores I can recall, starting before I was of school age, was that of gathering eggs. This was not so simple a task as one might first imagine, because our large flock of hens roamed in and around the great log barn, in and out a half-dozen other buildings as well as having free range around the numerous wheat and hay stacks, the fence rows, and in the nearby woods.

Sometimes the eggs were found in a small camouflaged nest in the corner of the wood shed, sometimes far back under the floor of the wheat granary and sometimes in the very top of the barn. In gathering eggs, we used small oak split baskets which on occasions we would fill two or three times in one evening, each time emptying the contents into a larger basket.

If there was one routine which we followed consistently, it was taking the eggs to the store on Saturday. All week we stored them in a cool place and on Friday night my mother would get the large white oak baskets out and neatly line them with newspaper. This, I always assumed was so that a broken egg could be easily removed and eliminate the need to clean the entire basket. The eggs were washed

and often candled. Sometimes we would have two or three heaping baskets, perhaps twenty-five or thirty dozen. But in the fall of the year during moulting time the number of eggs would be reduced to a dozen or so which could be carried in one small basket.

At Nash Copeland's store the eggs would be traded for the few groceries we needed and these would be brought home in the same baskets. All our neighbors brought their eggs to the store in similar-type baskets, as I recall. (Eventually some of those with larger flocks started using egg crates.) One of my most vivid memories is of old Uncle Billy Hightower coming down the road with a heaping basket of eggs in the crook of each arm. He had lost both his hands in his youth (in a dynamite explosion, I think.) But, as stated earlier, everyone carried the baskets on their arms anyway, and Billy was at no disadvantage in carrying his egg baskets.

Burley tobacco was the primary cash crop in Southern Appalachia and here again the basket was used throughout the growing and processing of the plant. When the small plants were pulled from the seed bed in April or May, they were neatly packed in baskets. While the local handmade baskets were sometimes used for this purpose, the factory made bushel baskets were preferred because their shape and size made packing the plants easier. But these bushel baskets were too cumbersome and heavy for the one who dropped the plants in the fields at eighteen-inch intervals where they were to be "set out". Hence the plants, after being hauled in a mule-drawn sled or wagon to the field, were transferred to the old homemade baskets. One could hold the basket in the crook of the arm, thereby freeing both hands to remove and drop the plant. Handmade split baskets were almost universally used for this purpose, and those with rectangular shapes and having low sides were preferred for the "dropping" baskets.

Sometimes the more meticulous tobacco growers would "prime" their tobacco a few days before it was to be cut. This was a practice of going through the patch, row by row, picking off the lower ground leaves from each stalk which had matured and which would

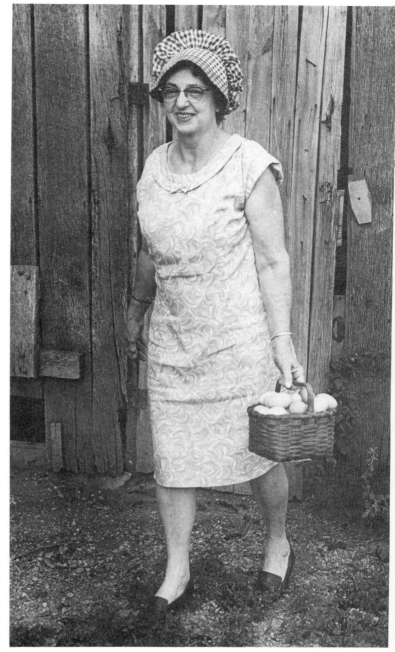

The gathering and marketing of eggs was probably the most common use of the typical white oak basket of Southern Appalachia. The young lady shown here coming from her chicken house, or hen house, is Mrs. Glenn (Ruth) Irwin, mother of the writer. I'm not allowed to tell when she first started gathering eggs in Grandpa Rice's barn loft, but it was about the time Woodrow Wilson was first elected president of the United States. (Photo by Gary Hamilton)

otherwise fall off and be wasted either before or during the cutting and hauling process. Again, split baskets were ideal for this chore. After the tobacco had been cut and hung in the barn to cure, there would be some leaves that had broken off the stalks and were left in the fields. The old men and young children would often take their handmade baskets and glean the entire field for these leaves.

After the tobacco had cured in October and November it would be stripped from the stalks, graded, tied and packed on baskets. These baskets are factory made and are the only ones I know of that served no other purpose. They are flat, contain large holes and are especially and exclusively made for handling loose tobacco; and such a basket is capable of accommodating six hundred pounds or more of burley tobacco.

The foregoing descriptions of the uses of baskets represent one young boy's observations, mainly on one farm in rural Southern Appalachia during the late 1930's and the 1940's. While this may give an indication as to the extent to which the basket was employed and the constant reliance upon it as a gathering and storage item, it certainly does not tell the whole story.

All indications are that the basket was depended upon even more in the earlier times in our region. And I am sure that other families used baskets in ways other than those employed by our family.

Horace M. Mann, who later served as the curator of the Doylestown (PA) Museum spoke of his observations of basketmakers in Appalachia. "In 1917", he said, "I made a two month's trip on horseback through the Big Smoky Mountains...about 100 miles northwest of Asheville". (This was near the Tennessee state line.) "At that time I found nearly every native making baskets for their own use..."

Women in earlier times used baskets in connection with spinning and weaving, for such purposes as picking cotton, storing wool, feathers, etc. There were lunch baskets, picnic baskets, sewing baskets of various types, and dainty little baskets used for trinkets. Very often such a basket would be "put up" as a "keepsake" in remembrance of the person who made it or in memory of one's mother or aunt who once owned it.

While the basket was of inestimable importance in the performance of everyday chores in the homes and on the farms of Southern Appalachia, it also was important as a source of income for the basketmaker himself. It is true that he got but little pay for his laborious tasks, but it was often in addition to whatever other small income he had. As will be noted throughout the book, baskets were often traded for corn, meat or other food; and in many instances that was about the only food a family had through the winter months.

Many country stores accepted baskets in exchange for items purchased. Mildred Youngblood, discussed in Chapter IV, remembers that practically everything her mother ever got from the local store she did so in exchange for her baskets. In 1980 I found a small rural store near Mildred's home in Cannon County which still carried on this practice. They had on hand a hundred or more recently made baskets hanging in back of the store building.

Most, but not all, basketmakers I have known were landless tenants who moved constantly within a community from one rented cabin to another. I knew of at least two old basketmakers who had no homes at all; and who just stayed a few nights with whomever would keep them. So, the added little income these folk made from the sale of their product was extremely important to them. It is about the only craft one could enter with little or no capital. The material cost nothing (I never heard of a single basketmaker in this area who ever bought basket material) and the only tool absolutely required was a pocket knife and an ax.

## THE WALKER SISTERS
## OF LITTLE GREENBRIER

The following photographs of the Walker sisters of the Little Greenbrier community are profoundly illustrative of the varied uses of baskets by the mountain people of this region. Little Greenbrier is located near Wears Valley in Sevier County, Tennessee, and is now a part of the Great Smoky Mountain National Park.

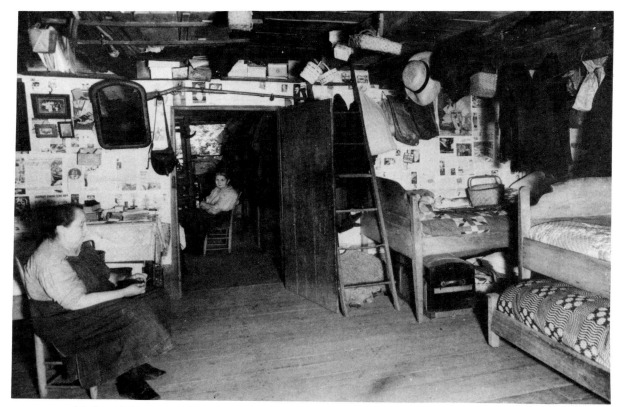

It would be difficult indeed to find another photograph which illustrates the use of baskets in Southern Appalachia as well as this one. A total of ten various shaped baskets may be seen by close observation in this interior view of the Walker home. Hettie is shown in the foreground, and Polly is sitting on the porch.

Three of the Walker sisters, Hettie, Martha, Louisa (from the left) are shown here ginning cotton. Hettie and Louisa are turning the two cranks while Martha feeds the unseeded cotton between the wooden rollers. These rollers, if the cotton is very dry, squeezes out the seeds and the ginned cotton feeds through the rollers and into the basket. (Cotton gins similar to this one were very common in the Southern Appalachian region.) The basket shown here is quite similar to the Rufus Eledge baskets illustrated and discussed later in this chapter. Both the Eledge and the Walker homesteads were in Sevier County, Tennessee, but approximately 30 miles apart.

"Hairy" John N. Walker, their father, came to Little Greenbrier, sometimes called Five Sisters Cove, from Wears Valley about 1870. This was the homeplace of his wife, the former Margaret Jane King, and he and his wife bought out the other heirs for $10.00 per share. John had served in the Civil War on the Union side and was captured and spent a hundred days in a Confederate prisoner of war camp. Tradition has it that he lost a hundred pounds during that time.

John Walker was the oldest of fifteen children; so when he and his wife started their family of eleven children, they knew how to improvise, manage, and live from the soil and the forest. John, like most of the true mountain men, was self reliant and was reported to be proficient as a carpenter, blacksmith, tanner, herder, miller, wagonmaker and so forth.

All members of the family learned to raise and preserve their food, make their own clothing, fashion their tools, and in virtually every way live in a self-sufficient manner. With the help of the family, "Hairy" John built a tar kiln (for extracting pine rosin), an ash hopper, a charcoal making pit, honey bee gums, fruit drying racks, a blacksmith shop, a grist mill, a wood turning lathe, and numerous buildings near the old log homestead.

But for some reason he never built an outside privy or toilet. The men used the woods above the house and the women used the woods below the house. In later years, it was reported that the men in the family offered to build the Walker sisters an outside toilet, but Margaret, the oldest daughter and the one who seems to have become the spokeswoman for the group, refused. She is said to have stated that everyone would see it and know what it was for, and that this would be a source of great embarrassment.

The four Walker boys married and left the old homeplace, one of the sisters (Sarah Caroline) also married, and the six sisters remained.

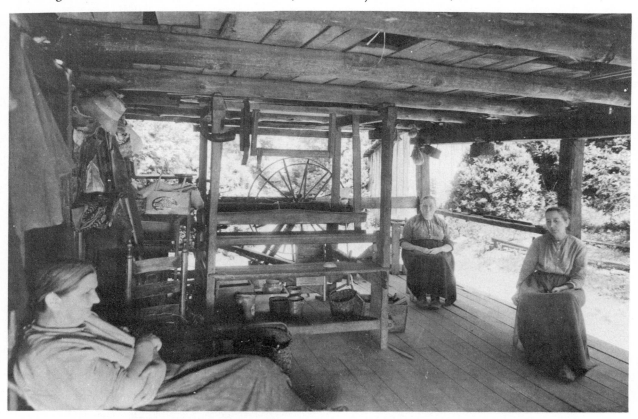

Polly, Hettie and Martha Walker, from left to right, are shown here on the porch of their Little Greenbrier home. Three small baskets may be seen hanging overhead from the rafters and two larger ones set on the floor near the weaving loom.

18

Hairy John Walker, father of the Walker sisters, is shown here with a basket (which we presume he made) filled with cherries from his orchard. This photograph was believed to have been taken in 1918 by John's son-in-law Jim Shelton, when Walker was 77 years old. The basket obviously is made of white oak splits and has the thickened handle, the type often found in the nearby Smoky Mountains.

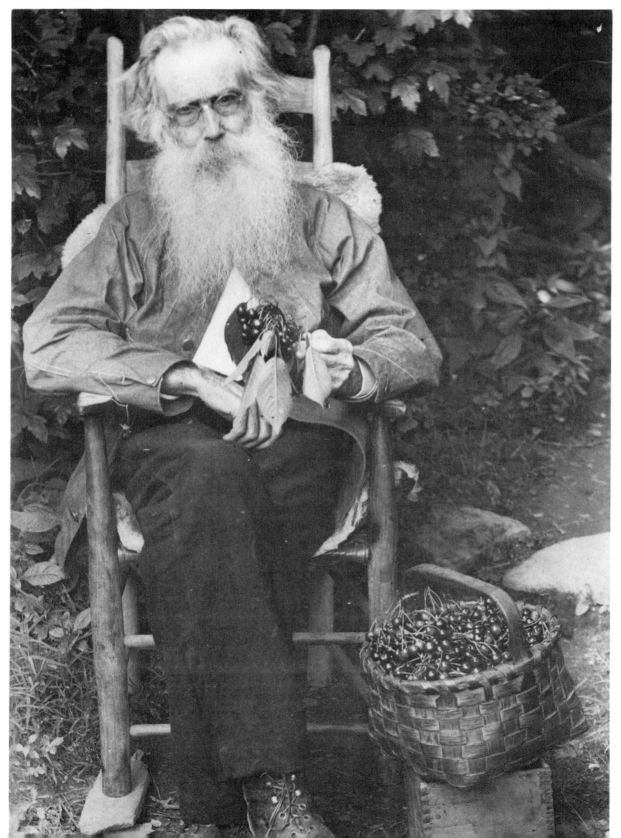

They were Margaret Jane, Polly, Martha Ann, Nancy Melinda, Louisa Susan, and Hettie Rebecca. They continued to live there in the colorful log homeplace until they died, one by one.

After the death of Louisa Susan Walker in 1964, the last sister to live in the old homeplace, most of the Walker chattels were acquired by the Great Smoky Mountains Natural History Association. A list of the inventory of the Walker family published in a booklet, entitled *Mountain Home,* by the National Park Service lists the following baskets: *split basket made by John N. Walker; split basket made by John N. Walker; basket, split double; basket, split, 9 pocket; basket, split, 2 pocket, basket reet (reed); basket split; basket split; basket willow, round, Dan's at 6 years, made by Grandmother Parry; basket; basket with spools; basket with parts of looms; basket of gourds; basket and miscellaneous; box with baskets; eight one bushel baskets; baskets; baskets; basket.*

There were specified a total of 23 baskets with many of the references in the plural, and one entry recorded as a "box of baskets". While some were described as having been made by John N. Walker and one by another member of the family, I would presume that many, perhaps most, were made by the family. No doubt, they were used to gather the bounty of the farm, the orchards, the vineyards and the forest. And they were used as carrying containers, and for various types of storage as well.

It is almost certain that baskets described as split were white oak. It is interesting to note that only one basket was described as being made from reed, or cane, and only one willow basket was mentioned. Since the willow basket was made for six year old Dan, in 1897, it is assumed it was small and toy-like and not made as a work basket. I have no idea as to the shape, configuration, or purpose of a nine-pocket basket.

These four photographs of the Walker family, taken mainly in the late 1930's and 1940's, provide rare insight into the important and varied use made of baskets in mountain homesteads of this region. The fact that they were general photographs not intended to emphasize basketry makes them even more significant. (The photographs of the Walker family were made available by Ed Trout and the Great Smoky Mountain National Park.)

FRED CARSON'S CORN BASKET
(Monroe County, Tennessee)

Close up view of the binding of the ribs, rim, and handle of the Carson corn basket. (Photo by Ed Meyer)

Mrs. Niles Stuart, who now lives in Maryville, Tennessee, remembers well seeing her father, Fred Scruggs Carson, use this large white oak basket. "Ever since I was a child," Mrs. Stuart remembers, "my Daddy used that big basket to carry corn to feed the horses. And we always called it 'the old corn basket'." It is made of white oak ribs and splits and has an opening 16" x 20". Its holding capacity is almost one bushel.

The Carsons lived in Monroe County, Tennessee, just south of the county seat of Madisonville. They were neighbors of the Kefauver family, whose best known member was United States Senator Estes Kefauver of national fame and candidate for the United States presidency. (Photo by the author)

## LITTLE CHARLIE PHILLIPS' GARDEN BASKET
### (Anderson County, Tennessee)

"I was a'cuttin' hay", Charlie Phillips remembered. "It was up here along the road, back I'd say about 1938, when an old soul came along selling baskets and I paid him fifty cents for it. He shore did give a man his money's worth."

"Yes", Mrs. Phillips agreed, "I believe it was 1939 and we've used it ever year since to gather garden stuff in and now it's plumb worn out--the bottom is almost gone."

"Lord, John Rice," Charlie continued, "if you jest had all the beans that's been picked and carried in out of the gardens and cornfields (that's where the cornfield beans grew) in that old basket, you'd have you something."

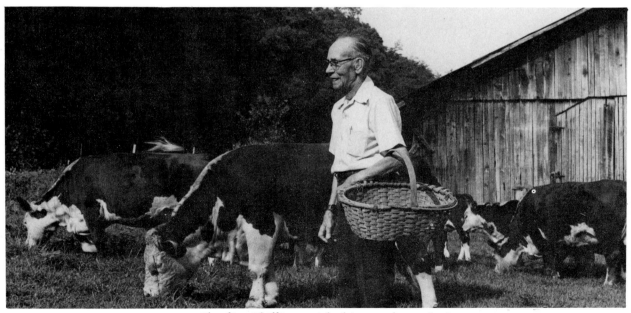

Charlie Phillips with his cattle and the garden basket he and his wife continuously used for 42 years. (Photo by the author)

Charlie is called Little Charlie so as not to be confused with Long Charlie Phillips, Windy Charlie Phillips, Sportin' Charlie and other Charlies of the same area. Charlie, who has been a dear friend for almost a quarter century, lives in the infamous area of Anderson County, Tennessee, known as "the New River section". It has been noted for its timber, its mines, and in the past for its feuding and killings. When Charlie bought the basket in the late 1930's, the coal miner was making a rela-

tively "big wage" and peddlers of all sorts came to the mining camps to sell their wares and food products.

Although this basket is made entirely of white oak splits and is plaited in the usual fashion it has two basic style differences from those more commonly found in the area. It is oblong and oval rather than rectangular; and it is larger at the top than at the bottom, somewhat reminiscent of the willow baskets.

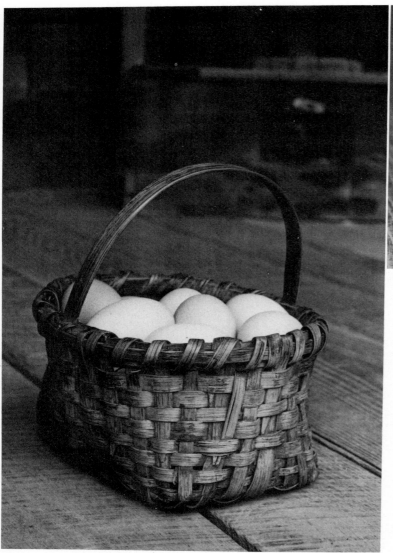

## EGG GATHERING BASKETS
(Union County, Tennessee)

These well-proportioned little baskets were probably used as egg-gathering baskets as they would not have been practical as garden baskets nor for carrying the week's collection of eggs to the store. The splits as well as the handle are of white oak. I acquired them for the Museum from Florence Allred, daughter of Luther Hill. The Hill family of Union County, Tennessee, were descended from Matthew Hill who came to that area in 1812 from Stokes County, North Carolina. His ancestors were from England and had first settled on the James River in Virginia at an early date. Union County, one of the state's smallest, was the home of my ancestors as well as such early country musicians as Roy Acuff, Carl Smith, Chet Atkins, Larry McNeeley and many others. (Photos by Ed Meyer)

## CHARLIE BLEVINS'S HOUSE
## AND GARDEN BASKET
(Fentress County, Tennessee)

This basket was used for many years by my old friend, the late Charlie Blevins and his wife, as a general purpose house and garden basket. It is typical of many found in the upper Cumberland region of Middle Tennessee. It is rectangular, deep, made of white oak, and has a little decoration--one blue split and a red one on each side. The basket is 8" x 13" deep and has an unusually high handle and is made entirely of white oak.

Charlie lived at the end of the meandering dirt road on the Cumberland Plateau in a section known as the Sheep Range in Fentress County. He was one of the last Americans to make and use the wooden rifling machine for rifling the muzzle loading guns. (I once took Eliot Wigginton, editor of the Foxfire Project, to see Charlie and subsequently Charlie was featured extensively in *Foxfire 6* which Doubleday distributed throughout the nation.) (Photo by Ed Meyer)

Charlie Blevins from whom this basket was bought is shown here at his home in an area in Fentress County called the "Sheep Range". He is holding an ancient bow drill which has absolutely nothing to do with baskets. (Photo by Eliot Wigginton)

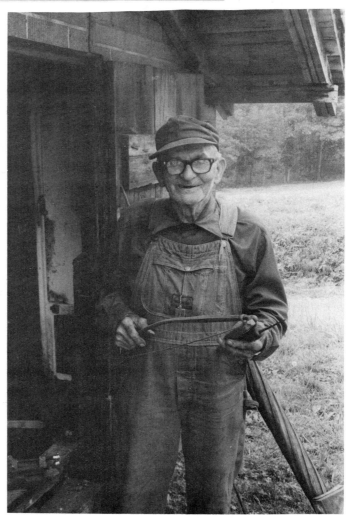

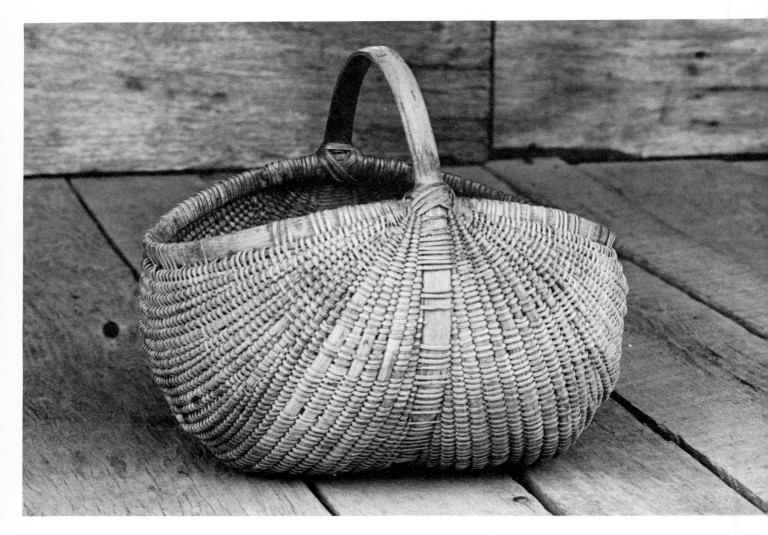

## UNCLE LEWIS STOOKSBURY'S EGG BASKET
### (Union County, Tennessee)

My great uncle Lewis Stooksbury bought this basket about 1912 when his son Hylas was a small boy, and it was from Hylas that I acquired it in 1977. He recalls that Uncle Lewis bought it from Maston King, the man who made it, in a section of Union County appropriately called "Poor Land". (Hylas remembers that Uncle Lewis often said that Maston King was the best basketmaker he ever knew.) It was used by Uncle Lewis for storing eggs through the week and for carrying them to the store on Saturday. And according to Hylas it was used for that purpose only.

The splits are only one-eighth of an inch wide, the smallest I have seen on a basket this size. (The top is 12" x 14" and it will hold approximately one-half bushel.) The bottom ribs are flat while those on the sides become rounded. There are very small short ribs inserted in the spaces between the long ribs and the splits are woven around them the same as if they were full length ribs. I have never observed this technique before. The weave is extremely close and if the basket were soaked, it appears that it would almost hold water. Made entirely of white oak, it has a hint of division between the two halves, but not enough to characterize it as a gizzard basket. While the rim of most baskets of this type is uniformly level, this one sags or sways on each side. (Photo by Gary Hamilton)

24

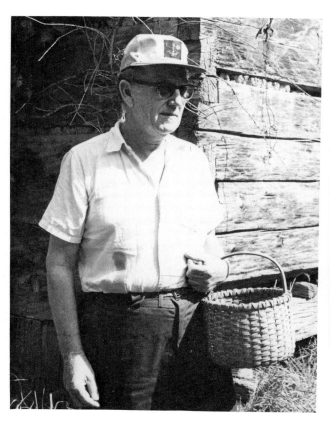

## ALETHA GUINN'S BEAN BASKET
(Mitchell County, N.C.)

For almost three quarters of a century Aletha Mashburn Guinn used this attractive little white oak basket for picking her beans from her garden. I talked with her in 1979 when she was 92 years of age and she said it was made by Gracy Gwinn Tilson, her husband's relative who lived nearby. She stated that she got it when she and her husband first started housekeeping and had used it continuously since. I found it hanging suspended in the smokehouse so that neither rats nor mice could get at it.

Both the upright staves and the horizontally-woven splints are of white oak, and it is round at the top as well as at the bottom. This type basket is not found in great numbers in Appalachia, though it bears close resemblance to baskets found in other sections of the region often referred to as berry baskets.

This pioneer type homeplace with the log structures still in good condition is located in the mountains about fifteen miles southeast of Erwin, Tennessee, on Tilson's Creek near the North Carolina line. Mrs. Guinn's son is shown holding his mother's basket. (Photo by the author)

## MOTHER AND DAUGHTER EGG BASKETS
(Union County, Tennessee)

Seattle Snodderly is shown here on the left with the expertly made white oak egg basket which has been in the Snodderly family for as far back as she can remember. When her daughter, (Mary Evelyn Willett shown at the right of the photograph with her daughter Sarah) was three or four years old Seattle bought the tiny basket for her so she could help with the egg gathering.

"I bought that little basket from an old woman by the name of Cath Nelson", Seattle recalled. "She went around the country selling baskets. She came from over around the Big Springs community and she charged five cents for that little basket. I bought it for Mary Evelyn and she'd go with me to gather the eggs."

The Snodderly home is located about seven miles south of Maynardville in Union County in East Tennessee. The larger basket is made of very narrow white oak splits and is one of the better made baskets in the museum collection. It is similar to, but smaller, than the Lewis Stooksbury basket just discussed. (It had belonged to Nora Snodderly, the mother-in-law of Seattle.) The Snodderly homeplace is only a few miles from where Maston King lived on Poor Land and it may very well have been made by King in the early part of this century.

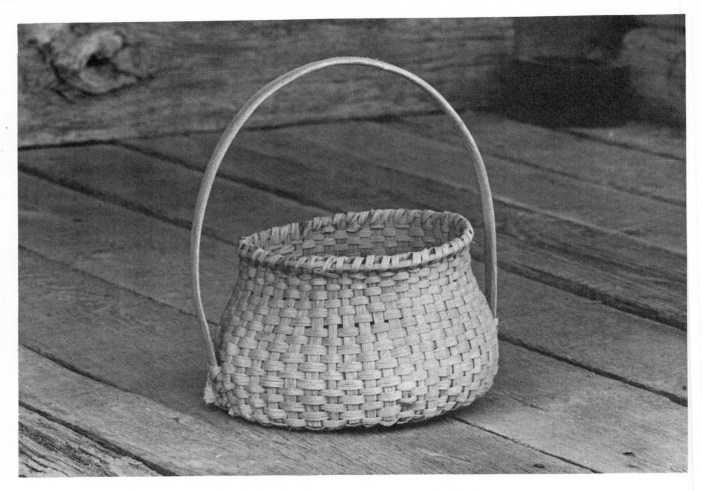

**UNKNOWN PURPOSE BASKET    --FEATHERS, BERRIES?**
(Union County, Tennessee)

In Southern Appalachia the different, the unusual, and even the unique seem to be the rule rather than the exception. This basket is an example.

I found it in a smokehouse on Bryams Fork in Union County, Tennessee, a few miles east of the Museum. Robert Smith, owner of the smokehouse (and the basket) lived there in a frontier type log house, but neither he nor his wife knew where the old basket came from originally.

Because of its small opening some experts have suggested that it was a feather basket; and that it was used for plucking the geese and ducks and that the small opening would minimize the chances of fluffy feathers and down being blown away. Also, the tight weave would prevent the down from escaping. But the old folk of this area usually used a cloth sack with a draw string for containing their feathers.

Robert was the son of Doc and Della Smith who were from the Lead-Mine-Bend section of Union County near the Clinch River. I asked him if he thought the basket could have been used as a feather basket.

"Well, now that jest might be right", he said, "my mother and my grandmother kept a flock of ducks for their feathers". If it were used as a feather basket, it undoubtedly would have had a lid.

The long and lightly attached handle indicates that its intended use was not for heavy items such as eggs. The high handle would serve one well if he were in a standing position and had to move the basket often--such as picking blackberries. One wouldn't have to stoop over quite so far every few minutes when he went to a new briar. But in reality we don't know the original purpose of the little white oak, big-bottomed basket.

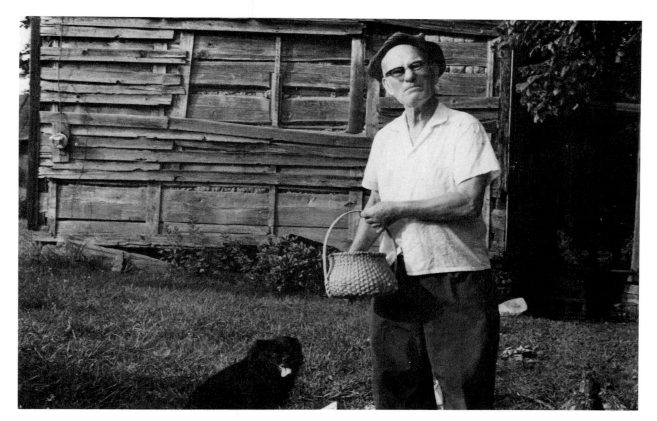

Robert Smith is shown here beside his log house on Bryams Fork in Union County with the basket we found in his smokehouse. (Photo by the author)

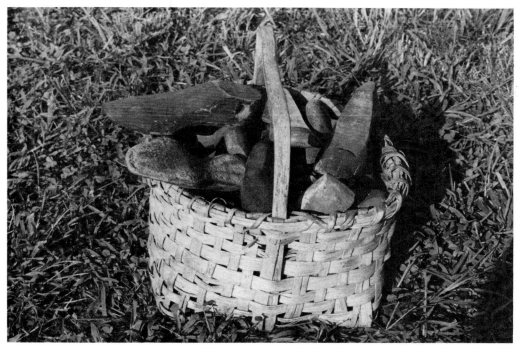

## THE SHOE LAST BASKET
(Sevier County, Tennessee)

Having become worn and tattered as a field and garden basket, this one was put to use as a storage container for wooden shoe lasts. This exemplifies the almost endless uses the baskets served in the everyday lives of the people of Southern Appalachia. (Photo by Gary Hamilton)

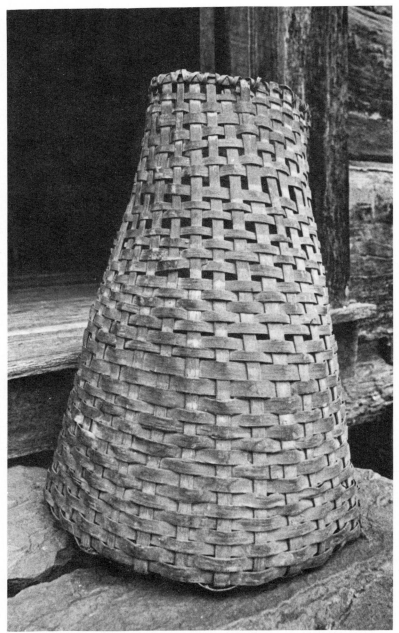

**ROWE MARTIN FEATHER BASKET?**
(Greene County, Tennessee)

This is the only such basket I have found in Southern Appalachia and I can think of no purpose for which it is suited other than for the storing of feathers as they are picked from the geese or ducks. It stands 22 inches high, has a base of 17 inches in diameter and the opening is only 7-½ inches. The bottom is of the spoke-like construction. I acquired it from my 85 year old trader friend, Rowe Martin of the rural Limestone community, birthplace of Davy Crockett.

Some basket enthusiasts have called this a feather plucking basket. But, as inferred ear-lier, all the old folks with whom I've talked in this region recall that a long narrow cloth bag with a draw-string was used for that purpose. In some areas feathers were stored in a basket such as this, with a lid of course, so that one could quickly get enough to stuff a pillow or add to the feather bed. While the bottom portion of this basket is tightly woven, the top is not. This presents a question as to its suita-bility as a feather storage basket, especially if it were filled to capacity. (Photo by Gary Hamilton)

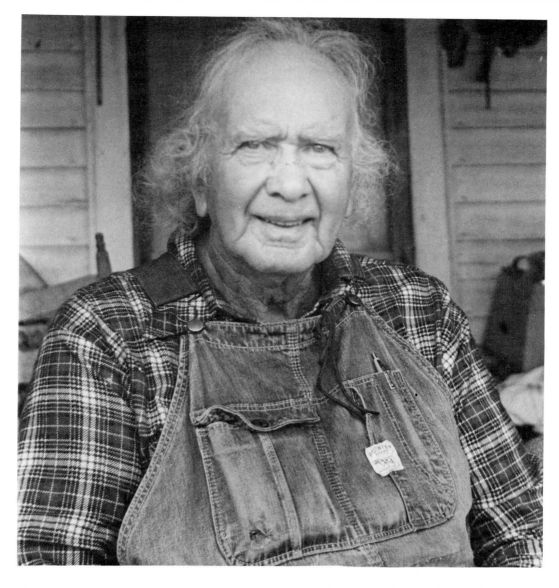

In the cool of the late afternoon Rowe Martin takes a rest on his mule sled outside his barn at his home in Greene County, Tennessee. The "feather" basket, which he had just sold me, sits beside him. Above, he is shown on the porch of his house. (Photographs by the author)

**THE RUFUS ELEDGE PEA BASKET**

This basket is woven or plaited of white oak, square on the bottom (9" x 9"), and has a rounded top ten inches in diameter. (Photo by Gary Hamilton)

## RUFUS ELEDGE BASKETS
### (Sevier County, Tennessee)

When I first knew Rufus and Kellie Eledge in the early 1960's they were living in one of the most colorful and beautiful pioneer settings I have seen in the Smoky Mountains. Their home was in a large log house, surrounded by a score of other log structures on Obie's Branch near Bearwaller Mountain in Sevier County in the extreme eastern part of Tennessee. The homestead had been built by Kellie's grandfather, old Billie Williams, who first settled there and who reared thirteen of his fifteen children to adulthood. Among the multitude of items I purchased from this great old couple over the years were several baskets. Although they ranged from quart-sized to one that held over a bushel, the style and shape were almost identical.

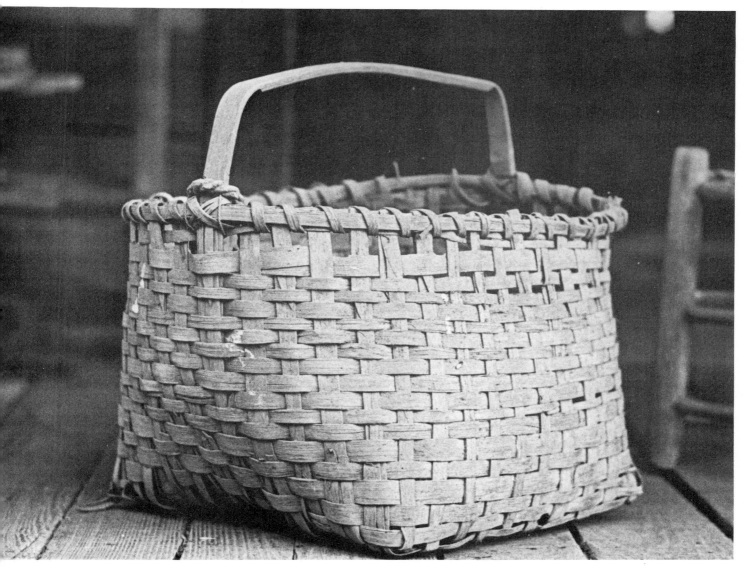

## THE RUFUS ELEDGE FEED BASKET

Except for the size and the condition, this basket is very similar to the pea basket. It is fourteen inches square at the bottom and is a foot deep. It came from the old log building which had always been called the loom house because of its exclusive use for spinning, weaving, and the processing of the cotton, wool, and flax. Hence the basket may have been used to store one or more of these materials. (Photo by Gary Hamilton)

The Rufus Eledge smokehouse or meat house with a covered walk to the kitchen. (Photo taken in 1964 by the author.)

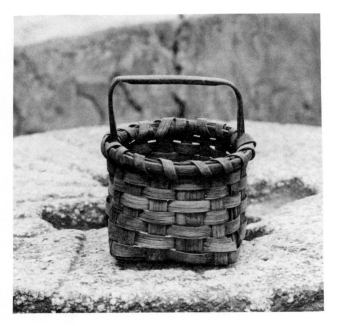

This tiny basket, only five inches in diameter, also came from the Rufus Eledge place and is of the same style as the large one. It may have been used as a berry basket and would have held enough for a couple of cobblers--or it may have been an egg-gathering basket. (Photo by Ed Meyer)

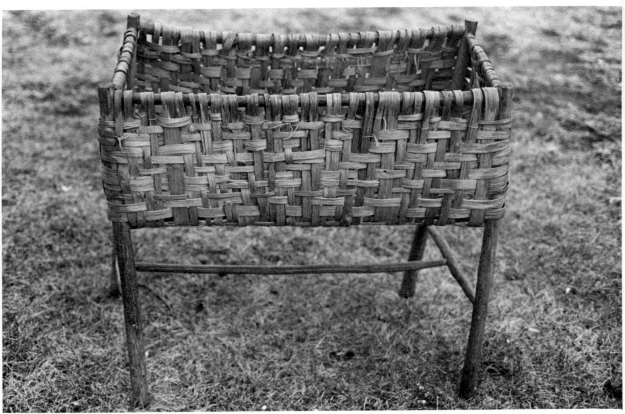

Made from plaited white oak splits, this baby basket or cradle originated in the mountains of northeastern North Carolina near Boone. It was found by Roddy Moore and neither he nor I have ever seen another, although it appears to be most practical from the standpoint of construction and utilization. Carroll Hopf, referred to earlier, notes that a child's basket was listed among the household items of a Rev. Ebenezer Thayer of Roxbury, Massachusetts in 1732. It was referred to as "a small child bed basket". Hopf also mentions and pictures a split basket cradle but lacking legs. The opening of the one shown here measures 29 inches by 16 inches and it is 30 inches in height. (Photo by the author)

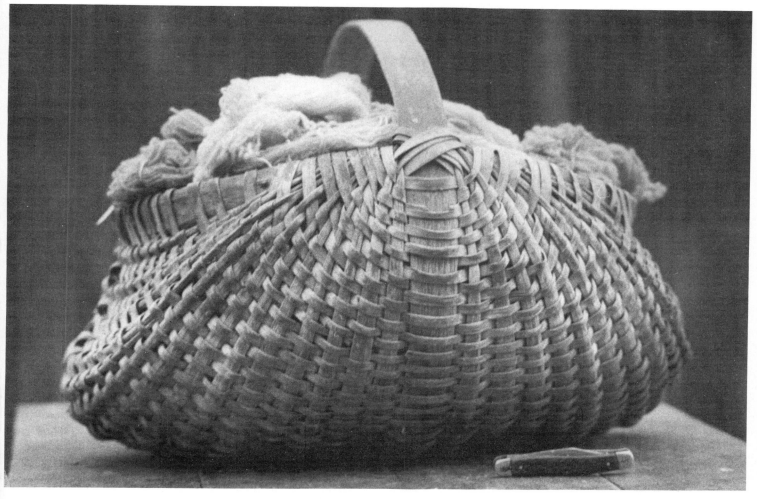

YARN BASKET

This basket is used at the museum as a container for yarn, but its sturdy construction and its size indicate that it was probably designed as a feed basket or garden basket. It was acquired in East Tennessee, but its more precise origin is unknown.

The flattened bottom ribs and the manner in which the side ribs swirl into their terminal point at the handle are reminiscent of the Waldrip basket shown and discussed in Chapter II. The principal difference is that the Waldrip basket has the rounded rib on top and and circling the rim, whereas it is absent in this basket. Russ Rose says that this rim determines the life of the basket. (Photo by Gary Hamilton)

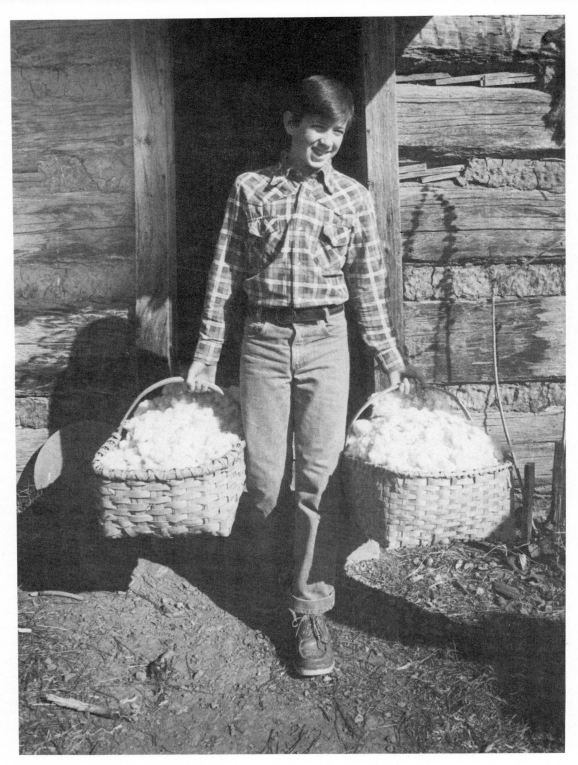

These two large white oak baskets were designed for light weight use such as carrying cotton for which my nephew Rob Irwin is using them at the Museum. Although there is no cotton raised commercially in the Southern Appalachian Mountains today, it was raised for household use a hundred or more years ago, even in Virginia and the northern part of North Carolina. Baskets such as these utilitarian field baskets were made quickly and roughly and with little thought for aesthetics. (Photo by Gary Hamilton)

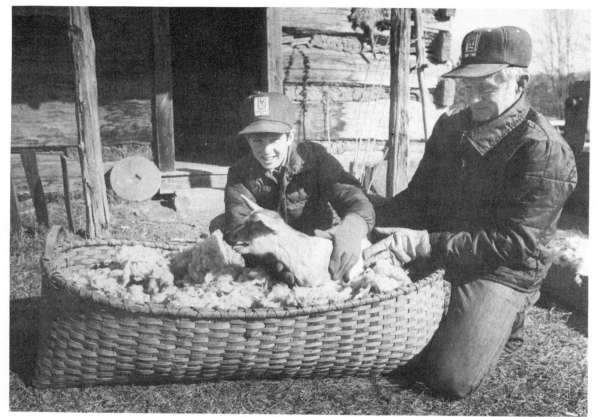

Long "two-men" baskets such as the one shown here could be used only for very light-weight material such as wool or cotton, or perhaps for corn shucks. This one is used at the Museum for carrying cotton. Rob Irwin and his father David are shown with the five foot long white oak basket filled with ginned cotton. The young goat has nothing to do with baskets or basketmaking. (Photo by Gary Hamilton)

##############################

This four-foot long white oak basket never had handles and was apparently made as a storage container rather than for transporting goods. It is used at the Museum in the spinning and weaving room for storing cotton. (Photo by Gary Hamilton)

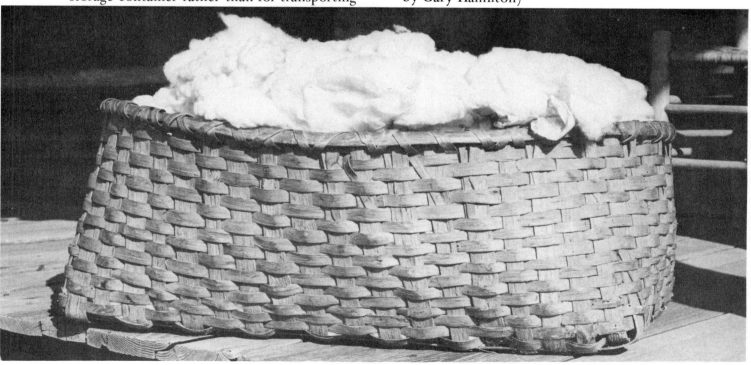

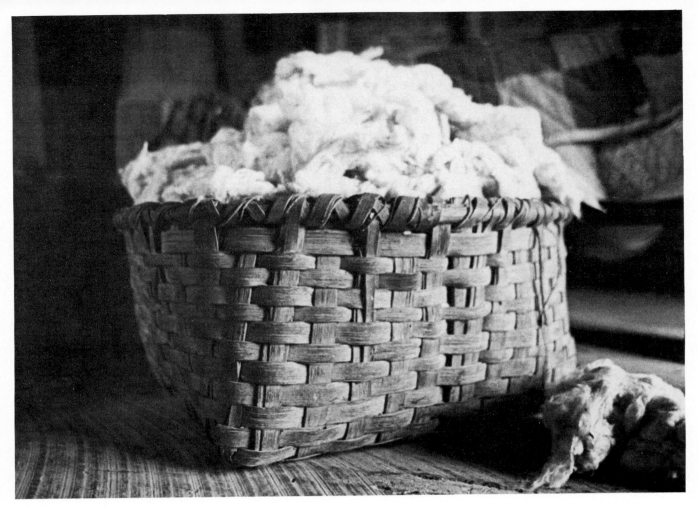

## GRANNY IRWIN'S HOUSE BASKET
### (Union County, Tennessee)

My Grandmother Irwin had egg baskets and garden baskets but this one was used primarily in the house. She may have used it to store quilting material or as a clothes basket. I assume that she and my grandfather brought it from Union County when the Norris Dam, the first of the Tennessee Valley Authority series of dams, inundated their ancestral home there in Big Valley.

The name Dora Farmer is written in longhand on the side of the handle and I assume that she was either a former owner or the maker. The latter is unlikely as we haven't found a single example of a basketmaker of this area signing his work. It is made of white oak, is 13 inches square on the bottom, and has a diameter at the top of 17 inches. (Photo by Ed Meyer)

Common oak split basket being used to store cotton preparatory to carding for making quilts or for spinning. (Photo by Gary Hamilton)

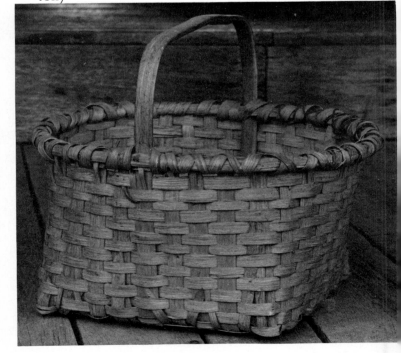

## THE BOYD STEWART BERRY BASKET
### (Hancock County, Tennessee)

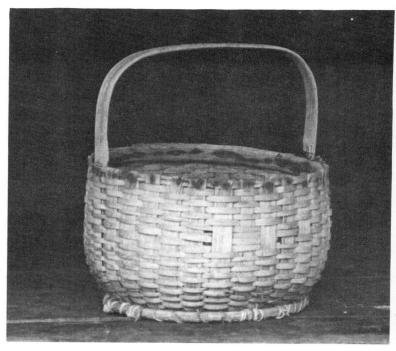

This basket was acquired from my long-time friends Noah Bell and his wife Belle Bell. Belle Bell was reared on top of historic Newman's Ridge in Hancock County, Tennessee, on the Lee County, Virginia line. The now well-known Alex Stewart and his family were neighbors; and Alex's father Boyd Stewart was the only basketmaker in that immediate area. And Alex confirms that he believes this basket was either made by his father or by his grandfather.

Alex says it is a berry basket. It is made entirely of white oak and is of the wagon spoke type, although the bottom is now largely worn away and has been replaced by a cloth sewn to the splits.

It is interesting that such simple beauty and artistic design was produced in that rugged area in the late 1800's and early 1900's. At that time many families were living in dirt-floored, one room log cabins, often with little or no furniture. (Photo by Ed Meyer)

My long time friends, Noah Bell, left, and his wife Belle Bell, are shown here with an unidentified neighbor. When I bought the basket from Belle Bell she said, "Lord, honey, that was Mommy's ole basket. She used it for pickin' berries and sich as that." (Photo by the author)

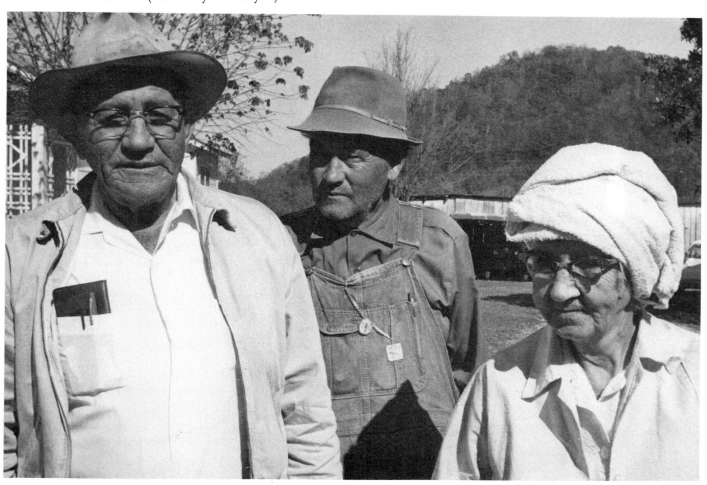

This is the Baker homeplace today after 145 years and several additions. One may note the concrete block chimney which was a replacement of the original made of mud, sticks, and wheat straw. It is now on display at the Museum of Appalachia. (Photo by Gary Hamilton)

## BAKER'S RIVER CANE HOUSE BASKET
### (Knox County, Tennessee)

My cousin, Tiney Baker and her brother Henry (and his wife Eula) still live in the old log home in Knox County, Tennessee, built by the Bakers' great grandfather Christopher Baker in 1836. It is located between two sharp ridges on Bull Run Creek, a half mile from where my Grandfather and Grandmother Rice lived. Henry and Tiney's mother, Aunt Jane, was a sister to my grandfather.

According to family tradition, the little house-basket was used as a sewing basket and perhaps for storing cotton and flax. It still contains flax, a crop which probably hasn't been grown on the Baker farm for almost a century.

The superbly made basket belonged to Susan Branson Baker, wife of Anderson Baker and grandmother of Henry and Tiney. Susan was married in 1841 and Henry and Tiney think she had it at that time.

38

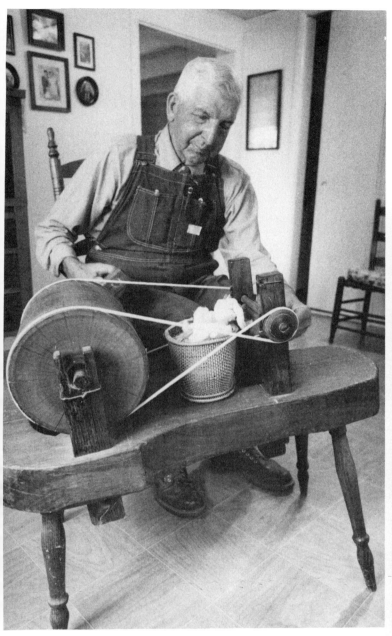

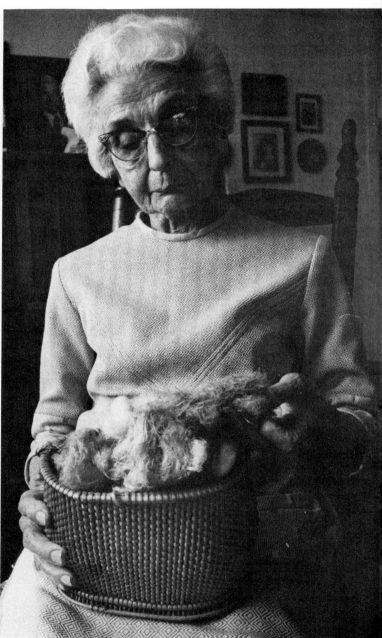

Henry Baker seeding cotton on his great grandfather Christopher Baker's gin. The cane basket catches the cotton fiber. (Photo by Gary Hamilton)

Tiney Baker examining cotton and flax in her grandmother's circa 1840 river cane basket. (Photo by Gary Hamilton)

## HANCOCK COUNTY BERRY BASKET

We refer to this as a berry basket because of its similarity to the berry basket made by Boyd Stewart and because it is also from Hancock County. It is of white oak, measures 8 inches in diameter and is 8 inches deep. The bottom is not of the spoke type weave as one might expect in a flat, round bottom such as this, but rather consists of thick slats bound together by oak splits. (Photo by Gary Hamilton)

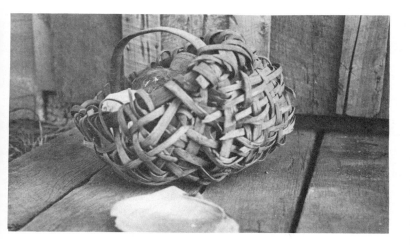

## "THE SORRIEST BASKET THAT EVER WAS"
("Mussel Shell Basket, Cambell County, Tennessee)

The maker of this basket is unknown to me, but even if I did know I would not divulge such information unless I had a desire to discredit him or her. I bought it from the late Jim Dagley of Grantsboro in nearby Campbell County. It had been used to gather muscle shells from Clinch River from which pearls were sought. And the shells themselves made fine buttons which were used throughout the world.

The basket is made of white oak splits but its shape and style is rather indescribable and surely resembles man's first attempt at basketmaking. (Photo by Gary Hamilton)

## WHITE OAK HERB BASKET
(Union County, Tennessee)

Although this split basket came from the Luther Hill homeplace in Union County, Tennessee, and doubtless is locally made, the shape and style seem to indicate that it has "outside" influence. But on the other hand, this type is often called an herb basket, which could be suggestive of its intended purpose. If it were made to store and dry valuable herbs, it could follow that it was native to this region, and not merely a trinket basket made for tourists. It is less than two inches deep, oval shaped, and is eight inches across and ten inches in diameter at the greatest point. (Photo by Gary Hamilton)

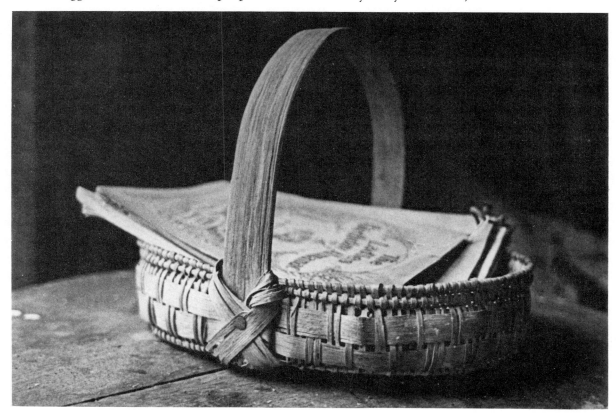

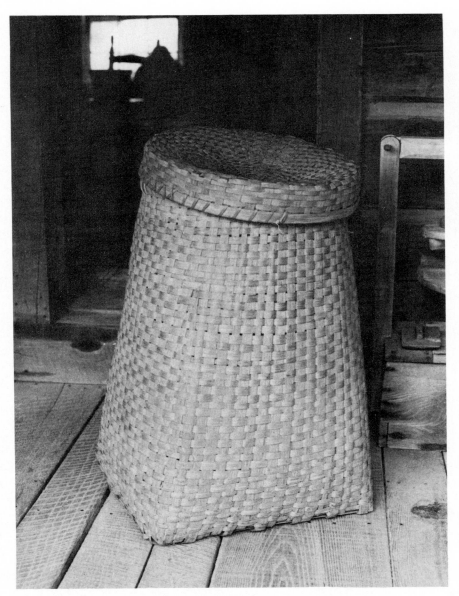

**MARY DAYHUFF'S CLOTHES BASKET**
(Morgan County, Tennessee)

Laundry baskets or clothes baskets were not at all a common household item in Southern Appalachia. I recall finding only three or four in old homes during the quarter century of collecting.

I bought this one from Eva Greer who lives in the community of Burrville on the Cumberland Plateau in Morgan County, Tennessee. Eva is the daughter of J.S. Greer who operated a country store there in Burrville for 52 years.

Eva recalled that the basket had belonged to her grandmother, Mary Dayhuff who was from the nearby community of Pall Mall, home of Sgt. Alvin C. York. (York, whom I knew, became a national hero when he captured 132 German soldiers singlehandedly in World War I, a feat which Marshall Foch, Commander of all British, French, Portugese, Italian and American forces, called, "the greatest thing accomplished by any private soldier in all the armies of Europe".)

Eva stated that her grandmother had owned and used the basket as a clothes basket for as far back as she could remember which would date to the early part of this century. It is made entirely of white oak splits, is 31 inches deep, has an opening 17 inches in diameter, and a base 21 inches square. (Photo by the author).

# Chapter 2
# Types and Styles of Appalachian Baskets

Those people who settled the Southern Appalachian Mountain region represented several different nationalities and brought with them customs peculiar to their ethnic backgrounds. Many of those who migrated down the valleys from Pennsylvania were of German origin and tended to take up land in the more expansive fertile valleys. Those who crossed over the mountains from North Carolina were largely Scotch-Irish and English. The Welsh, especially, followed the coal rich mountains out of Pennsylvania and constituted a large proportion of the population in the coal towns that sprang up later. Also there were a few French Huguenots.

All of these groups brought with them the knowledge of basketmaking, a craft which all authorities agree is one of the oldest known to man. As a matter of fact some archeologists believe that basketry is the oldest handicraft developed by man, occurring even before the making and use of pottery. It also is generally agreed that virtually all civilizations developed the skills of basketmaking and did so independent of one another.

By the time the first pioneers arrived in the Southern Appalachian Mountain region their cultural and handicraft techniques were often already mingled with and imbued by those of other national origins. Then they found that the Indians also were making baskets, a subject discussed more fully in Chapter VI.

Considering the various European influences, coupled with style and construction techniques introduced by the Indians, it is not surprising that so many variations of baskets were developed in this region. It also should be pointed out that a family coming into an isolated section of Southern Appalachia would not likely have brought baskets with them. Hence the baskets they made were based on their recollection of ones they had seen, adding further to the multitude of shapes, styles and designs. Authorities on the subject generally categorize all basket construction techniques into five basic types: the rib-and-split type; the rounded oak rib type; the spoke construction; the coil; and the woven or plaited. But I have discovered and acquired baskets from Southern Appalachia which did not qualify for any of the above categories. We shall treat them in the "other type" category.

## THE RIB AND SPLIT

A very large portion of all baskets I have found in this region have been of the rib-and-split type basic construction. But the variation of style, design and size, even of baskets made using this technique, is great indeed, as will be pictorially illustrated on the following pages.

The most elemental description of the construction of this type basket is that the flat, thin splits are woven over and under the ribs. Both the splits and the ribs are almost always white oak or technically *Quercus alba*; but other materials were used as will be noted later. A somewhat detailed description and a sort of pictorial essay of the making of the rib and split Appalachian basket will be presented in Chapter VI.

Horace M. Mann, the curator of the Doylestown, Pennsylvania museum mentioned earlier, talks about the rib-and-split baskets he encountered in his travels through the Southern Appalachians in 1917. It is interesting that he singled out this type basket for comment. He called it a "hip" basket and described it as follows: "It started in the usual melon shape, but the center rib was deeply indented, forming two lobes. The purpose was to fit firmly over the hip of a woman or the back of a horse and would not jiggle around as

much as the ordinary shape". While this basket was common in most of Appalachia, I have observed that it was not nearly as prevalent in the Cumberland Mountain area which forms the western demarcation of the Tennessee Valley.

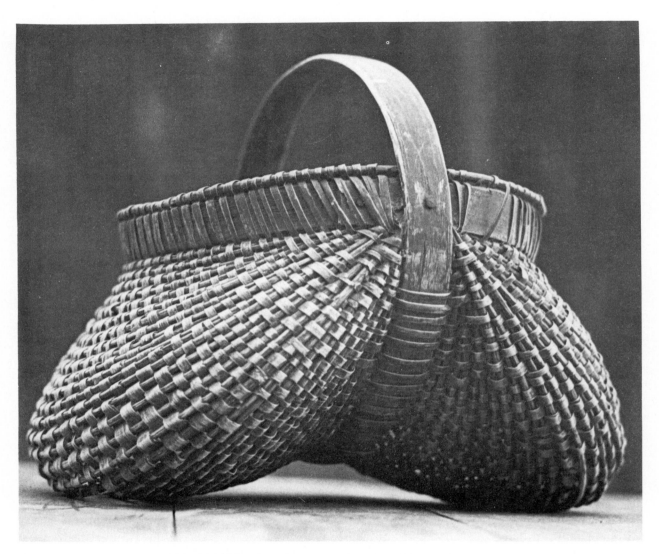

**TYPICAL APPALACHIAN GIZZARD BASKET**
(Yancey County, N.C.)

This classic Southern Appalachian style basket is variously called the gizzard, butt, cheek and hip basket. The deeply depressed center served one well when carrying eggs to the store on the back of a mule or horse.

Like virtually all of the baskets of this type, it is made completely of white oak. It was purchased from David Byrd of the mountainous Tennessee county of Unicoi on the North Carolina border. This basket is average in size and measures ten inches across the top and fourteen inches across the bottom at the extremity of each lobe. It is well made, has all round ribs, was painted red many years ago, and likely dates to the early part of the century. (Photo by Gary Hamilton)

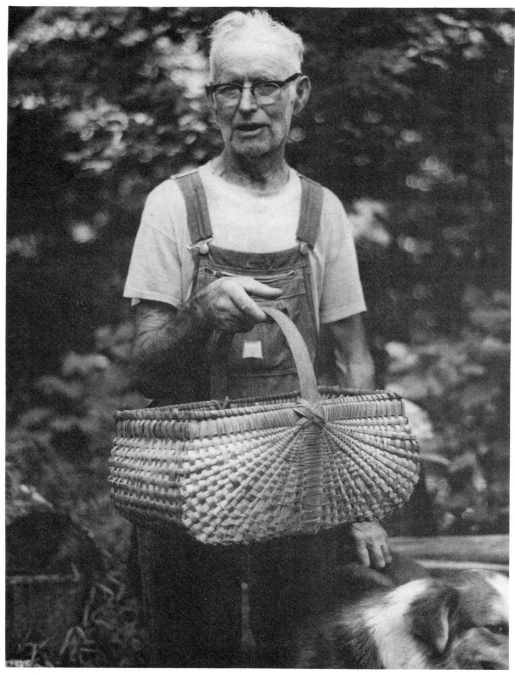

Roy Madden lives at the end of a narrow dirt road in the mountains of East Tennessee in Morgan County on Greasy Creek in the Elizabeth community. Roy is a friendly, but resolute, mountain man who divides his time caring for his invalid wife and working on the 36,000 acre timber lands owned by the Foust family of Knoxville. In going through his father's old homeplace, now abandoned, we found this white oak basket which brought back many fond memories for him.

"One of my brothers, Earl or Bill, I don't recollect which, bought that old basket from a peddler who came through--I guess in the 1920's. I believe they paid $1.50 for it; and my mother used it as an egg basket to carry eggs to the store in for as long as she lived".

This type basket is a sort of cross between the rectangular plaited baskets of the region and the rib-and-split gizzard type baskets so common throughout Appalachia. I have seen few such designs in this area. Although it was bought from a peddler, one would think that it would have been from the general area where the Maddens lived for it is not likely that one unfamiliar with such a remote and isolated area would have gone there to sell baskets. (Photo by the author)

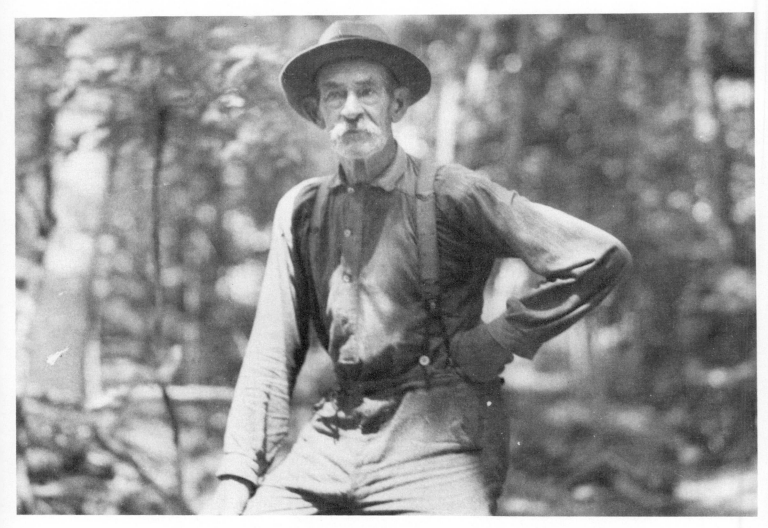

Mountain basketmaker Mack McCarter of Sevier County, Tennessee.

## THE MACK McCARTER BASKETS

Near the foothills of the Great Smoky Mountains in Monroe County, Tennessee, there is a community known as Ball Play. This isolated neighborhood, according to local historians, takes its name from the ball games which were played in that area by the Cherokee.

A couple of miles up one of the many hollows which branches off the Ball Play road live Kenneth McCarter and wife, from whom I have acquired many mountain relics. I was interested in the unusual design of the two baskets, and upon inquiry was told that they had been made by Kenneth's grandfather, Mack McCarter.

"Grandpa McCarter", Kenneth told me, "was a wagonmaker, blacksmith, and wood worker as well as a basketmaker. He had a little place there in the Smoky Mountains near where Gatlinburg is now--about where the Sugarland Welcome Center is located. And the government bought him out whenever they built the Smoky Mountain National Park. He died in 1935, and I believe he was about 77 years old."

A few weeks after I "discovered" the McCarter baskets, I ran across the picture of Mack McCarter in Eaton's *Handicrafts of the Southern Highlands*. He described McCarter as earning his living by making baskets, chairs and from a small plot of land. According to Eaton, Mack learned these crafts from his father who was a pioneer of that area. (The following pictures of McCarter and his baskets are made available by Ed Trout and the Great Smoky Mountain National Park.)

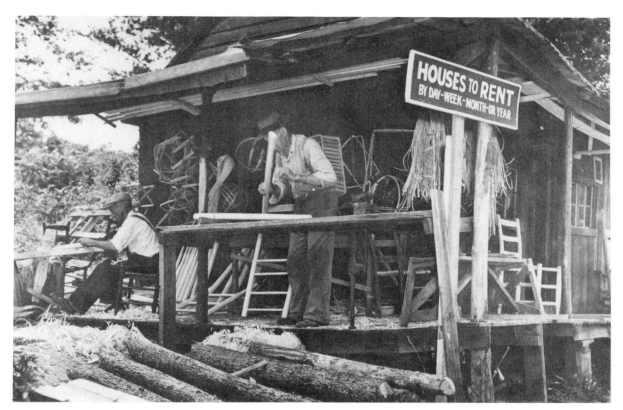

These two photographs show the little shop where McCarter made his baskets, chairs and other crafts just prior to the commercialization of nearby Gatlinburg. The lower photograph seems to have been taken earlier than the one above. In the one below, the cow lot in back looks used, while the picture above shows it taken with weeds and bushes. And Mack has apparently acquired a helper as evidenced in the later photograph. He has started making chairs and has gone into the house renting business--another indication of the beginning of the coming of the tourist which would eventually number in the millions and make the Gatlinburg area of the Great Smoky Mountains the most visited of all national parks.

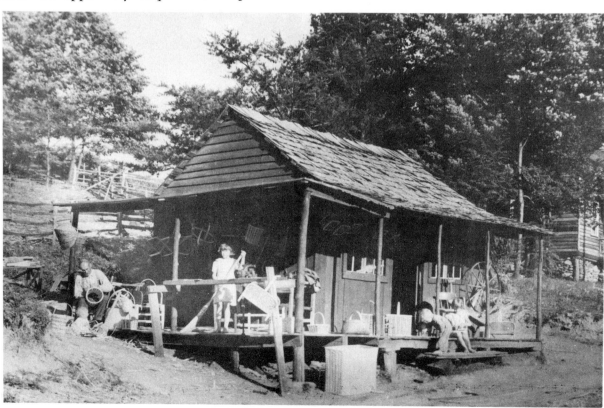

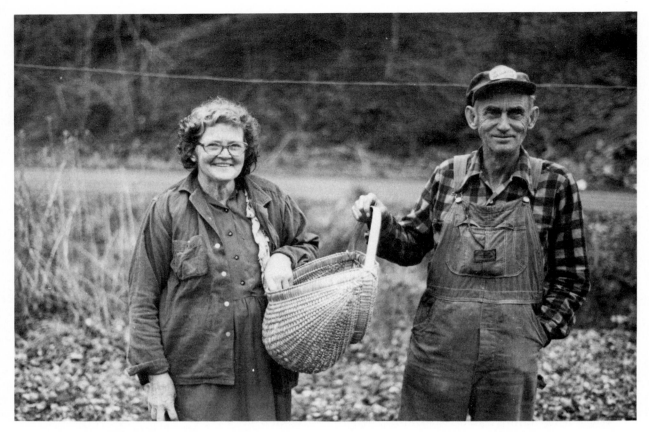

Kenneth McCarter and his wife are shown here with two baskets made by Ken's grandfather, Mack McCarter. The large square basket with the missing handle probably was made as a corn-shuck or nubbin' basket for feeding cattle. The wall-hanging basket may have been the result of influences of the craft schools of the 1920's. They are made from white oak and are the rib-and-split type. (Photo by the author)

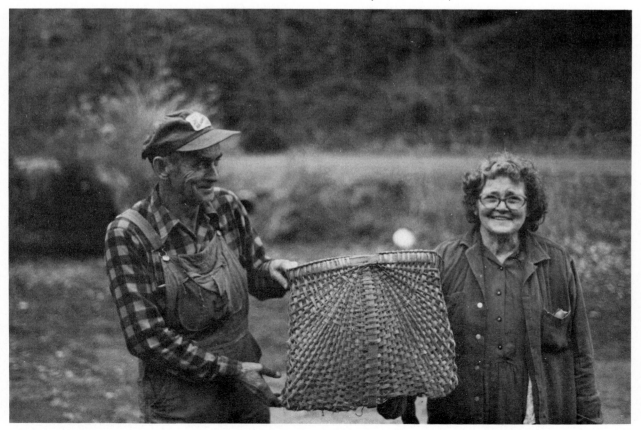

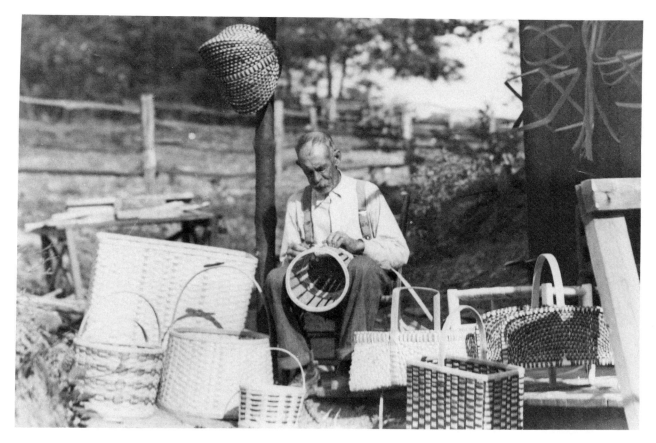

McCarter is shown here with various shapes and styles of white oak baskets. The basket hanging from the porch pole and the round ones at lower left are similar to the style found in old Sevier County, Tennessee homes. The kindling holder or magazine-rack type at the far right suggests outside influence and was probably for the purpose of accommodating the first "tourists" who were starting to come into the region in the early 1930's when this photograph was taken.

### THE DARFUS GIBSON BASKET
### (Hancock County, Tennessee)

Belle Bell who lived on Blackwater Creek in Hancock County and from whom I purchased this unusual little basket recalled that it had been in her family for over half a century.

"Lord, honey that ole basket thar was made by an old man, Dafus Gibson. He didn't have no home, jest wandered around up thar on Newman's Ridge from place to place whar we all lived."

Although it is of the white oak rib-and-split construction, it is more oblong than most. It is very small, measuring only five inches wide and eight inches long. (Photo by Gary Hamilton)

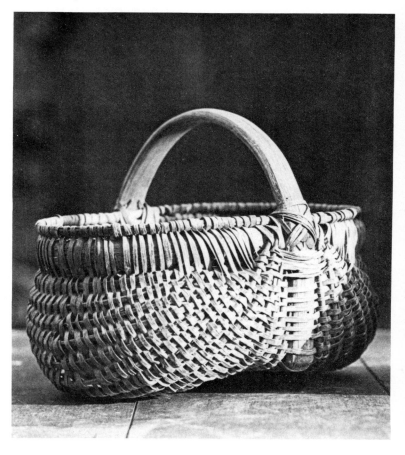

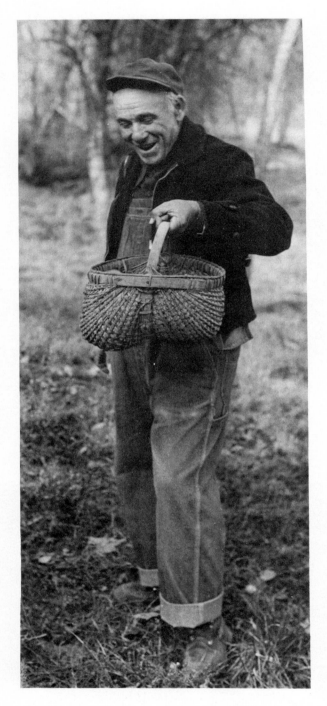

**HARLAN HOSKINS WITH HIS MOTHER'S
RIBBED BASKET**

(Anderson County, Tennessee)

Harlan Hoskins and his brother Jim, two bachelors, live on their 1000 acres of valuable coal, timber and farm land in Hoskins Hollow a few miles from the town of Oliver Springs in Anderson County, Tennessee. In walking over this ancestral place recently with Harlan, I asked about any old baskets they might have.

Although they have a dozen buildings with thousands of the family relics, many of pioneer vintage, Harlan knew precisely where the basket hung, as I knew he would. He brought it out from the dugout basement, shaking off the spider webs and dirt-dobbers' nests.

"That was Mama's old basket. Lord, she used that old basket ever since 'fore I's born. Picked beans in it, grapes, apples, and used it to carry eggs to the store, and butter—back when we sold eggs and butter."

I knew that Harlan would be able to give me the history of the basket for he has an unbelievable capacity for remembering details; and he didn't disappoint me. "It was made in 1912, I believe it was, and it costed seventy-five cents. It was made by old Freeland Ward who lived up on Windrock Mountain."

This is a form of the gizzard basket so common in Appalachia. It obviously was not as carefully made as some, as one lobe is considerably larger than the other. But who can complain about Freeland Ward's work too much--after all, his basket did serve the Hoskins family for a half century at a cost of about a penny per year; and they still have the basket.

I knew the Hoskins family when Jim's and Harlan's mother and father were living and I knew that none of them left the remote hollow very often and that someone always stayed home to watch over the place. "How long has it been", I asked, "since the homeplace was left unguarded?"

"Thirty-six and a half years", Harlan answered quickly and with affirmation. "Me and Jim was way over yonder on the mountain on the back of our place diggin' coal in a little mule mine and we didn't come in for dinner. Mamma thought we wuz trapped in a cave-in, or maybe killed, and she come a'running up there and left the house. And that's the last time that they's been nobody here at the house. Course we were still on the place."

Although the old white oak ribbed basket was used almost daily for strictly utilitarian purposes, it is now kept for sentimental reasons--the fond memories of the happy days in Hoskins Hollow which it evokes. (Photo by the author)

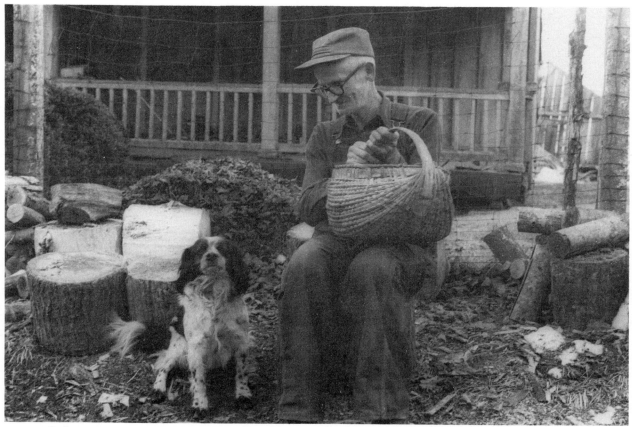

Bachelor Hagan Drinnen in front of his Hancock County, Tennessee home with his dog and the basket made for his father's family by Ikie Johnson. (Photo by the author)

## AN IKIE JOHNSON WHITE OAK BASKET
### (Hancock County, Tennessee)

Hagan Drinnen of Hancock County, Tennessee, is shown here with a rib basket made by Ikie Johnson, a life-long basketmaker who died about 1978 at the reputed age of 106. (Neighbors including the impeccable Alex Stewart say he was indeed that old.)

Ikie lived in Hancock County, Tennessee, on Newman's Ridge, home of the Melungeons, the mysterious people who were living there when the first settlers came and whose origin has never been determined. Alex Stewart, who is now (1981) 90 years old remembers: "My mamma traded a chicken hen to Ikie for a big apple basket when I's jest a boy. And he uz a grown man then."

I asked Alex if Ikie was a good basketmaker and almost before I finished the question he answered, "No, he 'uz a rough basketmaker. He lived up there on top of Newman's Ridge and hit was jest like climbing a tree getting up to his place."

Like many of the mountain basketmakers, Ikie emphasized servicability and practicability rather than style and neatness. His baskets were rough, but they lasted well; and who cared how a basket looked if it were to be used to carry corn to the hogs.

It was a cold day in January when I stopped by to see Hagan Drinnen, a bachelor who was sitting by the stove in his father's old home, some five miles east of Sneedville, near Clinch River. Hagan would not part with any of the family relics; but when we came across the old Johnson basket in the smokehouse, worn and frayed from half a century of use, he decided to sell it to me. "Hit shore ain't doin' me no good layin' out here", he said.

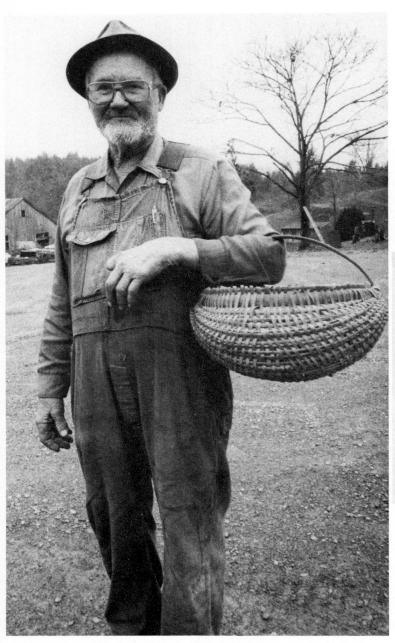

## BILL PARROTT AND HIS EGG BASKET
### (Campbell County, Tennessee)

Bill Parrott, who lives at the foot of Cumberland Mountain near Jacksboro, Tennessee, is shown here holding his old rib-and-split egg basket in the typical fashion used throughout the region. Bill, who operates one of the last old type sawmills in the area, has used the basket for about forty years. He thinks it was made by an old basketmaker who lived nearby by the name of Powell Sweat. It is all white oak and is typical of those found in Southern Appalachia.

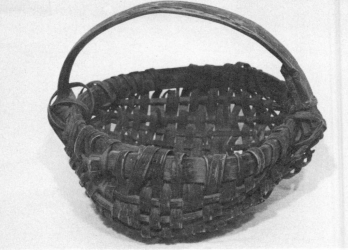

## MOUNTAIN EGG BASKET
### (Campbell County, Tennessee)

As the reader may have deduced, a basket does not have to be of fine quality to be included here; rather an effort is made to include the baskets as they were found and used. It is important to note that specialization of crafts largely stopped with the frontier. Whereas in the European countries and even in the more populated coastal regions of this country, there were specialists for every craft, the settlers in Southern Appalachia had to become self reliant.

It is no surprise that the products of such jacks-of-all-trades were rough such as the basket shown here. This one came from the remote section of Campbell County and could have served the family well for gathering the few eggs from the scattered flock; or for carrying enough potatoes from the garden for supper. It is made of white oak and is only seven inches in diameter. (Photo by Ed Meyer)

52

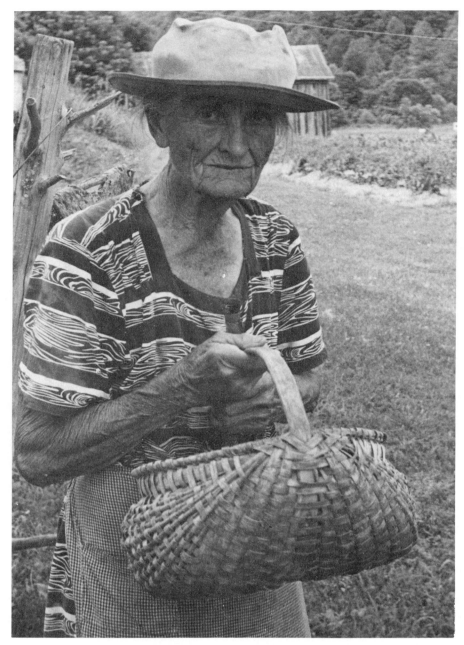

Maud Martin of Hancock County, Tennessee, with her white oak ribbed garden and egg basket. (Photo by the author)

## THE ALL-PURPOSE MARTIN BASKET
### (Hancock County, Tennessee)

Maud Martin, who lives with her two sisters, Net and Ilia Mae, on Panther Creek, a few miles northeast of Sneedville in Hancock County, Tennessee, doesn't know the age of the basket she is holding. "Hit wuz used by my Pap and Mother for about as far back as I can recollect. And I'm 85. We used it fur garden stuff and fur an egg basket and things like that."

Although Maud doesn't recall hearing who made the basket, I am confident that it was made by Ikie Johnson, the old basketmaker discussed on the previous page. Ikie lived within a few miles of the Martins; and of course the shape and style of the basket is very similar to those known to have been made by him.

J. Rufus Rice at his homeplace in Union County about 1935. (Photo by Marshal Wilson)

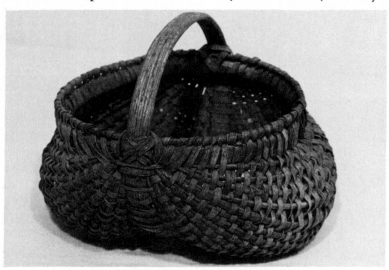

UNCLE RUFIE RICE'S GIZZARD BASKET
(Union County, Tennessee)

This basket belonged to my uncle Rufus Rice who lived at the old Rice homeplace in Big Valley in Union County, Tennessee, where my ancestors settled in the 1780's. I acquired it from my late cousin, Sally Rice, Uncle Rufie's daughter. It is a peck basket made of white oak and quite typical of those found throughout the region. Uncle Rufie was a carpenter, farmer, businessman, inventor, operator of the famous Rice wooden geared grist mill for half a century, and friend of President Teddy Roosevelt, having worked with him on a ranch in Montana. (Photo by Ed Meyer)

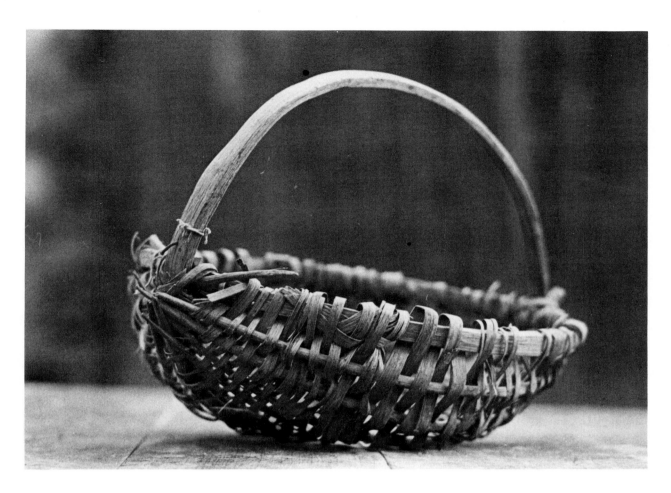

## THE FIRST AND THE LAST,
## OR THE FLASH BASKET
(Union County, Tennessee)

When one is firing the flintlock rifle he must put a pinch of powder in the pan which is ignited when the trigger is pulled and the flint strikes the iron above the powder. This flash of fire is supposed to ignite the main charge inside the barrel, but sometimes it doesn't and all you have is a mere "flash in the pan" or a failure.

Hence, when someone failed miserably at whatever he attempted, he made a "flash in the pan" or simply "a flash". And so it was that when my Grandfather Rice tried to make a basket as a youngster, the outcome was far less than he anticipated. And he told me that he made such "a flash" that he would never try another--it was his first and last. He was a prodigious worker and an expert craftsman and I can imagine his embarrassment. But the basket was kept around for three-quarters of a century and used occasionally for jobs too rough for other baskets. (Photo by Gary Hamilton)

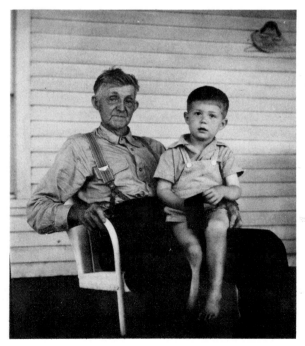

Marcellus Moss Rice is shown here in the 1940's with his grandson, Gordon Little. (Photo by Ruby Rice Little)

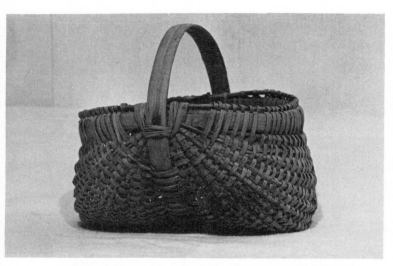

**JOHN MARSHALL SHERWOOD BASKET**
(Anderson County, Tennessee)

When old Bill Courier brought his baskets by the isolated homeplace of John M. Sherwood to sell, he also brought along a sack because he knew he would have to take his pay in corn in the harsh, frontier conditions that existed there in the early part of this century. The Sherwood home was near Clinch River in Anderson County, now a part of Oak Ridge, Tennessee. Courier lived across the ridge in a place called Bear Creek, now the site of the giant Y-12 atomic energy installation.

Three of the Sherwood sons, Elmer, Ed, and Roy, have worked at the Museum of Appalachia since it started and they recall old man Bill Courier coming by selling the baskets he had made. Elmer said, "Corn back then was selling for thirty cents a bushel and when old man Courier sold a basket to Pap they'd fill it with corn and that's what he got for making the basket. Then they'd pour the corn into the sack and old Bill would be on his way."

Since this basket held at most two gallons, and based on the quoted price of thirty cents per bushel, the price of the basket was seven and one-half cents. And even at that price he had to take corn for payment.

Roy Sherwood remembers that Bill Courier, and sometimes his cousin George Courier, would travel "over the country" with a supply of white oak splits and ribs on their back.

They would bottom the old home-made chairs as well as make baskets.

"Them pore ole fellows would come by loaded down with splits and ribs on their backs, and if we had a chair to bottom they'd get out their splits and bottom it. And if my daddy wanted a certain size basket made, why they'd set down and make it. If they's a long way from home, they'd stay all night with somebody. Their wives stayed home and made the splits and the ribs. That's about all they ever did--make baskets and bottom chairs."

This basket was loaned to the Tennessee Valley Authority during the Bicentennial and was included in a traveling exhibit which was viewed by millions. The writer purchased it from Lonnie Sherwood, another of John's sons. It is white oak and measures only seven inches across the top. (Photo by Ed Meyer)

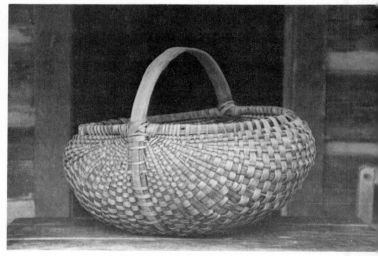

**THE MELON BASKET**
(Sevier County, Tennessee)

Made entirely of white oak, this type basket is sometimes called a melon basket, presumably because of its similarity in shape to a round watermelon. Although most of the ribs are flat, there are six rounded ones on each side, which was the usual number when flat ribs were used. It was acquired in Sevier County, Tennessee, but I am not sure that it originated there. It is strikingly similar to the baskets made by Jessie Jones of Hancock County, Tennessee, shown and discussed in Chapter IV. It is a large basket, having a capacity of one bushel. (Photo by Ed Meyer)

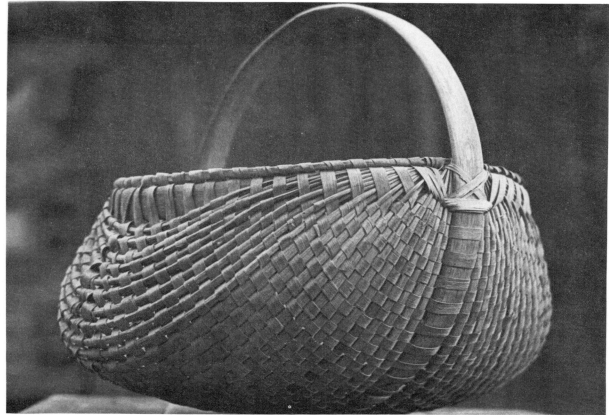

**CLASSIC FLAT RIBBED OAK BASKET**
(Greene County, Tennessee)

This large white oak basket is possibly the best example of the rib-and-split type I have seen. The bottom ribs are flat while those on the sides are rounded, and the round ones flow in a curvaceous manner to their terminal point at the handle, having an artistic as well as a strengthening effect.

I acquired it from the late Guy Bowers my collector friend in Greeneville, Tennessee. He recalled that it was made by a locally well-

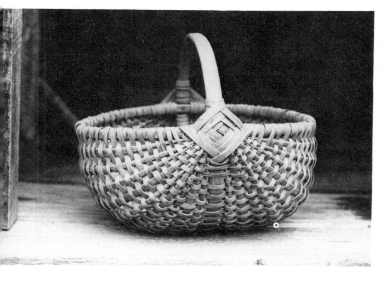

known basketmaker named Waldrip. It was my understanding that Waldrip was a full-time basketmaker and that he was productive in the 1920's and 1930's and perhaps even later.

Although this general type basket is often found in Southern Appalachia, it is not as common as the gizzard-type which has the divided lobes. The top is sixteen inches in diameter and its capacity is about three pecks. (Photo by Gary Hamilton)

**FLAT RIB MELON BASKET**
(Blount and Sevier Counties, Tennessee)

This is the only basket that I recall with all flat ribs. Even those baskets built with the flat ribs usually have several rounded ones near the rim on each side. The square or four-fold binding of the ribs is also unusual for this area and is suggestive of English influence. Some refer to this type binding as the "eye-of-God".

Although its ribs are white oak, the splits apparently are not. My best guess is post oak. This well constructed basket which holds a-bout one-half bushel, was from the Sevier-Blount County area of East Tennessee, but its more precise origin is unknown. (Photo by Ed Meyer)

In the spring of 1980 I was searching for mountain relics and Appalachian artifacts on the western side of the Cumberland Mountain range some 60 miles northwest of Chattanooga. In Coffee County near the tiny village of Hillsboro, Tennessee, I was going through the ancestral relics of the Bob Meadows family when Mrs. Meadows pointed out what I thought to be a large willow basket setting on the kitchen table.

"Now that's an old basket", she said, "And its all made out of white oak", she continued.

Well, I had been in thousands of homes throughout Southern Appalachia and had bought hundreds of baskets and I thought I knew a white oak basket when I saw one. I was accustomed to misinformation on a daily basis; so I paid little attention to her claim. But in the course of the conversation she made repeated references to "the old white oak basket". Finally I decided to examine it closely and at the same time casually asked if she were sure it was white oak. But before she could answer I saw that she was right; it was indeed an oak basket. The ribs or rods were rounded to a uniform size and were woven expertly as if the maker was trying to emulate the willow-type basket. But this was the first one I had seen (or at least recognized) and I wondered if it had been "brought in" to this region from some other part of the country. Further querying of Mrs. Meadows convinced me that it was a "native", having been made by her husband's grandfather, old Jim Meadows, who lived in Henry's Cove at the foot of the Cumberland Mountains in Coffee County, Tennessee.

A little research and a few inquiries revealed that this type basket was known in other parts of the country. Sue H. Stephenson in her *Basketry of the Appalachian Mountains* states that this type, which she calls the "oak rod wicker basket" was scattered throughout the Shenandoah Valley of Virginia and that it was sometimes made of elm. She further states that it is of German origin and that in the old country it was made of hazelwood.

A few months after finding the Meadows basket, I was in the village of Parrotsville at the home of Roy Smith. And while searching through the many early relics in his garage, I opened a large box and behold there was another oak rod basket. The rods were quite similar to the one belonging to the Meadows, but the style was mostly different. The Meadows basket was made in its entirety of the same size rounded rods and its shape and the handle were very similar to the willow baskets one finds in the northeast. But the Parrotsville basket was shaped like the common Appalachian rib basket one found on almost every farm. The ribs were very similar to baskets made with the flat splits. Its top is almost perfectly round and is about fifteen inches in diameter.

Roy told me that this basket, and a smaller one of the same rod construction, came from the old Uncle Mike Blazer place which was located a few miles out of Parrotsville in the Harness Chapel Community of Cocke County, Tennessee. The valley in which the Blazer place was located has always been noted for the strong German influence, perhaps as much so as any section of the state.

I would not purport to know the extent of the use of this type basket in other areas, but in East Tennessee, southwest Virginia, eastern Kentucky, and western North Carolina its occurrence seems seldom indeed. I would speculate not more than two or three in a thousand. But there may be pockets where it was relatively prevalent. My information is that in central and perhaps eastern Virginia it was more common and even more so in Pennsylvania.

Professor Roderick Moore, Director of the Blue Ridge Institute at Ferrum College in Ferrum, Virginia, is an avid basket collector and is most familiar with the baskets and other artifacts of Southern Appalachia. He feels, and I agree, that in years past we may have passed over the "round oak" baskets, thinking they were made of willow as it takes very close inspection to differentiate between the two. He has found a few in that area of Virginia.

The oak rods are so perfectly rounded and uniform as to rule out any probability that

they were whittled or carved by a knife or spoke shave. They were obviously whittled to a rough square, about one quarter of an inch in thickness, and then drawn through a perforated type hole in wrought iron or steel. Jeanette Lasansky in her basket book, *Willow, Oak and Rye,* features a picture of such a tool on that publication's cover; and Professor Moore found an old garden hoe with a hole in its center used for that purpose.

It would appear that the preparation of the material for making this basket would be prodigious. And one wonders what advantages such construction offered over the usual rib-and-flat-split type. Perhaps it was more sturdy and perhaps the tradition of making willow baskets was so entrenched as to motivate the basketmaker to "imitate" the willow osiers by this laborious process. Sue Stephenson, mentioned earlier, tells of an oak rod basket from the Salisbury, North Carolina area which has been in constant use by one family since 1840; and she avers that it remains in perfect condition.

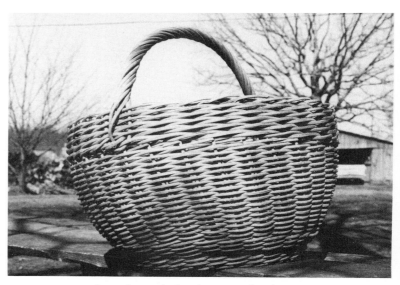

Round oak rod basket made by Jim Meadows (late 1800's) of Henry's Cove, Coffee County, Tennessee. (Photo by the author)

The "Old Uncle" Mike Blazer oak rod basket from Cocke County, Tennessee. (Photo by the author)

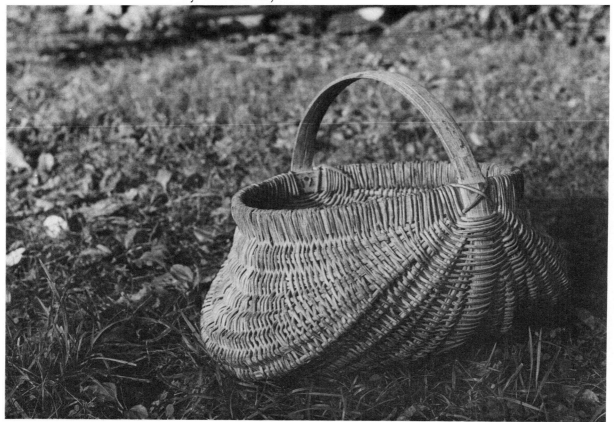

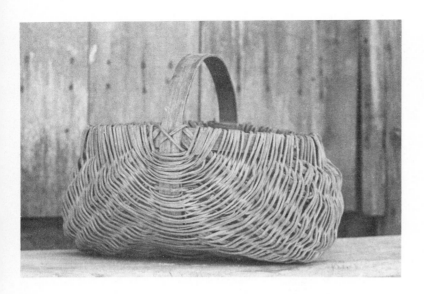

Shown here is another example of the round oak, or pulled, split basket. It came from Rockingham County, Virginia, and measures 10 inches by 14 inches at the top. (Photo by Roddy Moore)

Constructed of round oak, or pulled oak **sp**lits, the basket shown here was made in the extreme western part of North Carolina, near Waynesville. The top binding is of white oak splits and the handle is also made from white oak. It was collected by Roddy Moore who knew the family who made it. It stands 15 inches in height, has a diameter at the top of 15 inches and 10 inches at the base. (Photo by Roddy Moore)

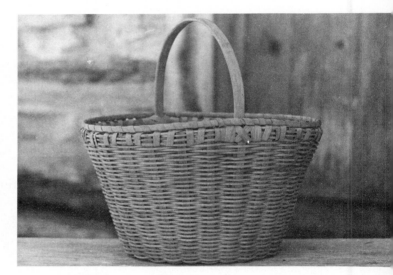

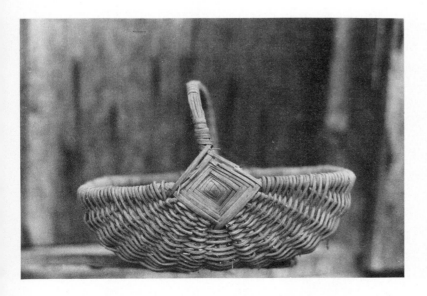

When I found this small basket amidst much debris in an old smokehouse I passed it off as being made of vine. But closer observation revealed that it was made of round, white oak rods. The smokehouse from whence it came had belonged to the old Cox family for many years and was located in Raccoon Valley in north Knox County--only a few miles south of the museum. The prominent squared fourfold "eye-of-God" binding of the handle made from flat splits is said to be of English influence, and is very seldom seen on baskets in Appalachia. Its opening measures 8 inches by 5 inches. (Photo by the author)

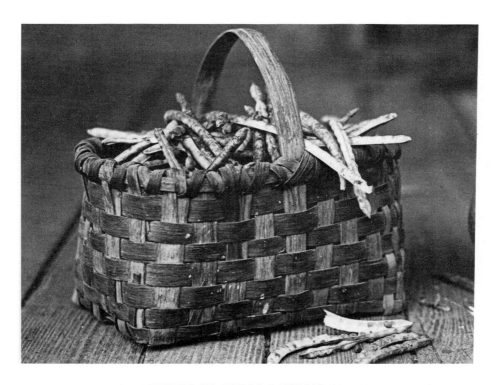

## TYPICAL ALL-PURPOSE APPALACHIAN SPLIT BASKET

Woven from white oak splits, this small basket, 8 by 12 inches, originated either in Union County or Claiborne County in East Tennessee. It was used as an egg gathering basket, as a garden basket, and for general household use. This type basket requires much less skill and considerably less time to make than the rib type and it, or a similar form, is found throughout Southern Appalachia. (Photo by Gary Hamilton)

## THE WOVEN SPLIT BASKETS OF APPALACHIA

The flat bottomed, square and rectangular oak split baskets are perhaps the most prevalent and easiest to make of all the types found in Southern Appalachia. Whereas the rib and split type requires careful measurement, attention to detail, and considerable skill, the woven split basket may be made by almost anyone willing to persevere. The splits in this type basket tend to be much wider which speeds up the basketmaking process appreciably.

Like most basket types, the early history of the plaited basket is unknown, but it was surely one of the first techniques to be used. Homer, the ancient Greek who is considered to be the first known European writer, refers to the plaited baskets in his famous work, the *Iliad*

*And maidens and striplings in childish glee bear the sweet fruit in plaited baskets.*

As stated earlier, this basket seemed to be much more common in the Middle Tennessee area than in East Tennessee, southwestern Virginia, and western North Carolina. In Cumberland County, Tennessee, for example, which lies on the Cumberland Plateau, I have found scarcely any of the rib type baskets, virtually all being the oak split woven type. But in certain areas of upper East Tennessee the reverse is true.

Because of the relative simplicity of the woven baskets, I surmise that they were made by housewives, farmers and other "non-basketmakers". Those who follow the trade for a living more often made the sturdier and more durable ribbed type.

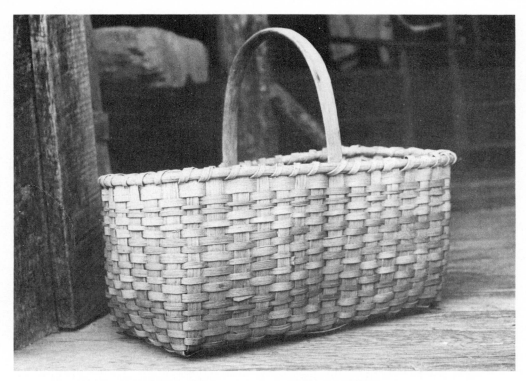

## AUNT NAN RICE'S HOUSE BASKETS
### (Union County, Tennessee)

It is unusual to find a rectangular basket as small as the one shown above. It is 7 by 10 inches deep. I acquired it from my late cousin Sally Rice Northern whose homeplace was in Big Valley, Union County, Tennessee.

"Mommie bought it in the early 1900's from Jim Paul. He was a basketmaker who came from over in Lead Mine Bend", Sally recalled. "She used it around the house for all kinds of things and always took care of it."

Although Sally didn't know the history of the basket shown below, it is quite similar and presumed to have been made by the same person or at least by the same family. It is more rounded on the corners and is 12 inches long, 5 inches wide, 5 inches in depth, and is almost identical to baskets identified by authorities as being Shaker baskets. (Photo by Gary Hamilton)

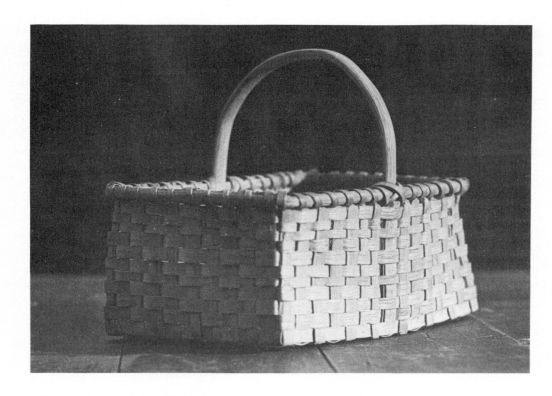

## CUMBERLAND PLATEAU SPLIT BASKET
### (Putnam County, Tennessee)

This all-purpose plaited white oak split basket is typical of many found on the Cumberland Mountain range which serves as the demarcation between East and Middle Tennessee. A basketmaker could make three or four of these simple constructed baskets in the time it would take to make a good rib-and-split type. The one shown here was purchased in Monterey in Putnam County from Major Ina Copeland. (Photo by Gary Hamilton)

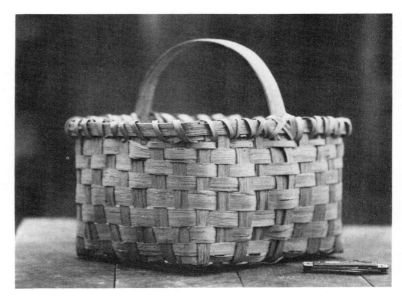

## FANNIE WYATT BASKET
### (Cumberland County, Tennessee)

Fannie Wyatt, the mother of twelve children, was a basketmaker in the Midway Community of Cumberland County, Tennessee on the Cumberland Plateau. I purchased the basket from Edna Gossage Blue who lives nearby at Cumberland Homestead near Crossville. Edna was largely responsible for starting the now well-known Daniel Arthur Rehabilitation Center located in Oak Ridge. It is named for her son, Daniel Arthur Gossage.

According to Edna, Fannie would go to the woods and cut her own basket timber, and would even make her own dye--from what Edna called red oak ooze. Characteristic of the Tennessee Cumberland Mountain baskets, this one is rectangular and has the woven splits dyed alternately bluish-brown and reddish. It is 12 by 16 inches and is 7 inches deep. (Photo by Ed Meyer)

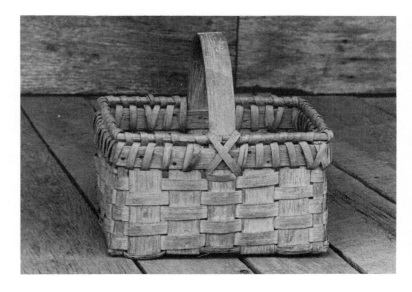

## EASTERN KENTUCKY SPLIT BASKET

This all white oak basket was acquired in southeastern Kentucky and is signed "Mrs. Ray Nance" in an old and faded longhand. I would assume that Mrs. Nance was the owner and not the maker of the basket.

The vertical splits are thick and unusually wide--about one and a half inches. The top rim is round and bent at a 90 degree angle at each of the four corners. It is 10 by 12 inches and 8 inches deep. It would have served well as an egg or garden basket. (Photo by Ed Meyer)

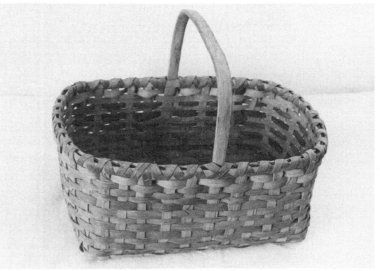

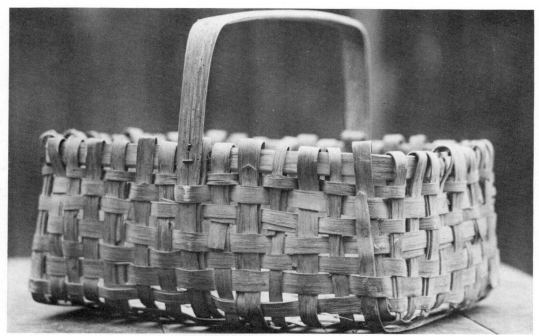

## CUMBERLAND MOUNTAIN BASKET

This all-purpose basket is so simple in design and construction that it could be made by anyone with a touch of dexterity. It is of white oak splits and was acquired in either Cumberland or Putnam Counties on the Cumberland Plateau in Middle Tennessee. It is rough and simple, yet sturdy enough for several years' use. It will be noted that there is no extra rim for reinforcement at the top, nor is there extra binding--both very unusual omissions. The handle and the bottom rim is a single heavy split joined by two small nails. It measures 8 by 12 inches and is 8 inches deep. (Photo by **Gary Hamilton**)

## GRANNY IRWIN'S BUSHEL BASKET
### (Union County, Tennessee)

The square bottom and perfectly rounded top of this white oak woven split basket distinguishes it from most baskets of this region. It was acquired from my Uncle Morrell Irwin and belonged to my grandmother, Sarah Stooksbury Irwin. I assume that it came from her native Union County, in East Tennessee. It is two feet in diameter at the top and has a holding capacity of at least a bushel. Because of its size one might assume that it was intended as a feed basket. But my grandmother had used it as a house basket, I believe, for storing quilt pieces, old clothing and so forth. (Photo by **Gary Hamilton**)

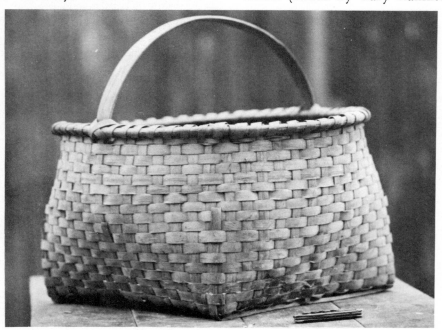

## SHARP FAMILY EGG BASKET
### (Union County, Tennessee)

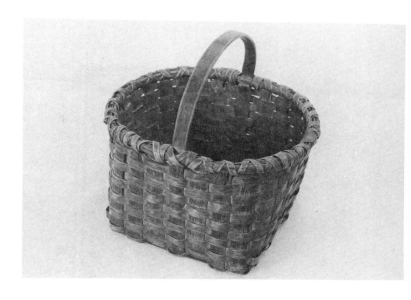

This well made peck basket came from the woodshed of one of the oldest homesteads in Big Valley, Union County, Tennessee. The Sharps built the large two-story white-columned brick homestead in the early part of the 19th Century and their descendants and relatives have lived there ever since. I purchased it from Marie Irwin Ousley who still lives in the stately and impressive old home.

This basket is similar to the Hill baskets which also were from Union County and which are shown in Chapter I. It seems they may have been made by the same person. This one is of oak, has an eight inch square bottom, is almost round at the top and is seven inches deep. (Photo by Ed Meyer)

The old Sharp homeplace in Union County, Tennessee, from which the egg basket came. (Photo by Bill & Pat Miller)

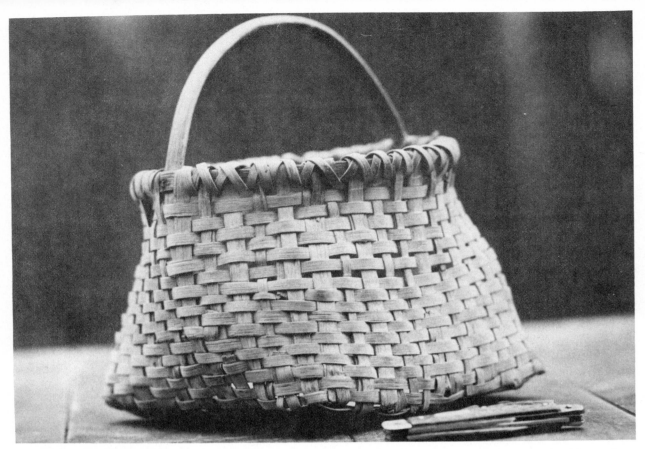

## SCOTT ROSENBALM BASKET
(Claiborne County, Tennessee)

This basket was made by Scott Rosenbalm who lived in the village of Springdale near Tazewell in East Tennessee. Scott was a carpenter, but after his retirement he carved hundreds of frontier characters and artifacts. After his death these articles became quite sought after and many were acquired by serious collectors of folk art in such places as New York City and Washington, D.C.

I bought the basket from Scott's son-in-law, Roy Hays, of the same community. It is eight inches square at the bottom and has a diameter at the top of six inches. It is made of unusually narrow white oak strips. (Photo by Gary Hamilton)

## MAJOR INA COPELAND'S BLUING BASKET
(Putnam County, Tennessee)

This rectangular oak split basket was purchased from my friend, the late Major Ina Copeland, who lived in the upper Cumberland town of Monterey in Putnam County, Tennessee. It is typical of the baskets I have found in that area.

Ina told me that she bought it from an old man who lived in that area, its maker, but whose name she could not recall. Note that every other weaver split has been dyed with bluing which was widely used until recently in washing white clothes. The basket is 14 by 18 inches and is 8 inches deep. (Photo by Ed Meyer)

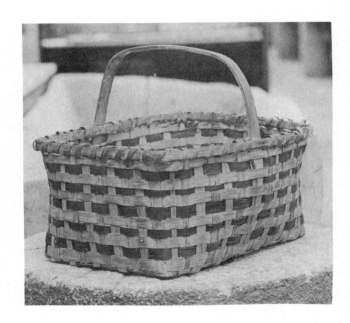

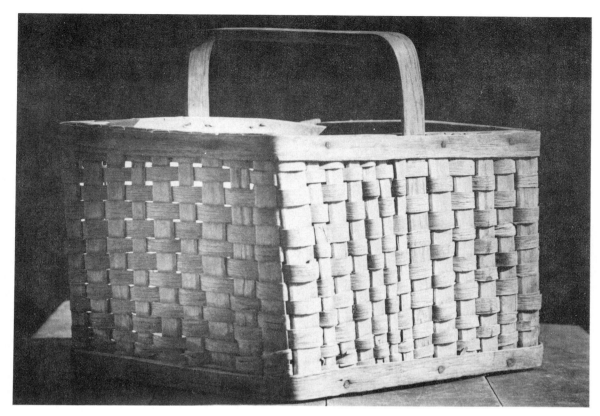

## STAVE AND SPLIT EGG BASKET
### (Lee County, Virginia)

This basket was acquired from Mrs. John Burchett who lives in Lee County, Virginia, near the Hancock County, Tennessee line in a hollow on Lone Mountain. It had belonged to her grandmother, Elizabeth Minor, who lived in the nearby community of Beech Grove.

The vertical members here should be classified as staves rather than splits because of their thickness--about one-fourth inch. The splits are white oak, but the staves are made of poplar, a material I don't recall having seen in baskets before--though I have seen poplar bark used both for baskets and for bottoming chairs. This rectangular basket measures 10 inches by 14 inches. (Photo by Ed Meyer)

## MULLINS' STAVE AND SPLIT CLOTHES BASKET
### (Dickenson County, Virginia)

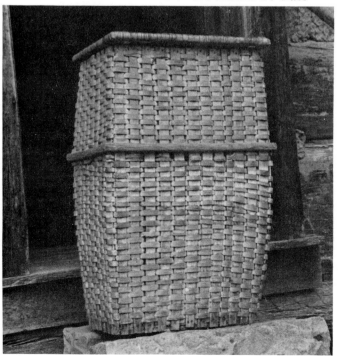

This three-foot high clothes basket was made by one of the twenty-six children of Mousey Mullins who lived in the mountains of Dickenson County, Virginia, near Clintwood. The flat white oak staves are an inch wide and over a quarter-inch thick, and are nailed to the three hoops. All the splits in the basket are white oak, but the lid is woven in the twill pattern with a combination of hickory and poplar bark. The bottom is of cedar slats. I purchased the basket from Fred Carter of Clintwood who has an impressive collection of mountain relics and art, and who was a close friend of the Mullins family. (Photo by Ed Meyer)

## STAVED BASKETS
### (Grainger County, Tennessee)

In the late 1960's I purchased several early relics from Sherman Campbell who lived near the village of Washburn in Grainger County, some forty miles north of Knoxville. But he wouldn't consider selling the old basket which had been in his family for so long.

It had several unusual features. The vertical members were wide and thick and would be classified as staves like the Burchett and the Mullins basket shown on the previous page; the bottom was of solid wood; and the weaver splits were of white oak.

Several years later I was going through the smokehouse of my long-time friend, Flod Beeler, when I found a basket almost identical to the Sherman Campbell basket. Although I had bought many items from the Beelers, Mrs. Beeler understandably drew the line on the basket as it had belonged to her mother. Although Mrs. Beeler could not recall its maker, she was sure that it was made in the community. The Beeler place is located about four miles from where the Campbells lived. There seems little doubt that the two were made by the same person.

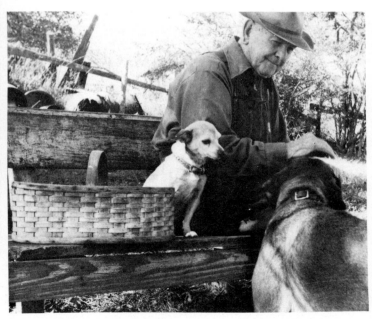

Mrs. Flod Beeler with her mother's egg and garden basket. Note that she holds it in the crook of her arm and that this arm is supported by the right arm, an effective method when carrying heavy loads such as potatoes, apples or eggs. (Photo by Steve Jernigan)

The late Sherman Campbell of Grainger County, Tennessee, with his dogs and the family basket. (Photo by the author)

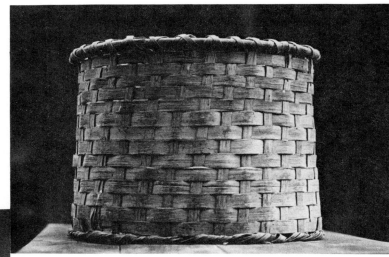

## THE SPOKE DESIGNED BASKET
### (From Middle Tennessee)

This basket, an unusual type for this area, was acquired in Middle Tennessee, and was used apparently as a storage basket as it has no handles. Or it may have been used for a measuring basket for grain as it appears to hold a bushel. The spoke-like construction of the bottom, considered to be one of the very basic designs of basketmaking, likewise is not often found in the Southern Appalachian region. It is 16 inches in diameter and 13 inches in depth. (Photo by Gary Hamilton)

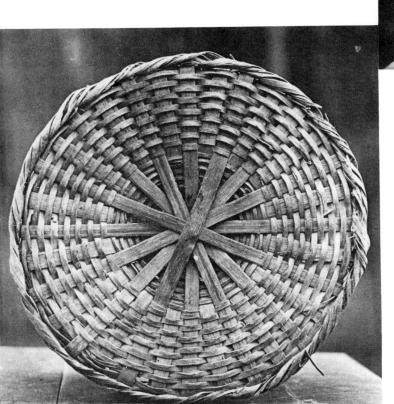

## THE SPOKED BASKET

The spoke type basket is so called because of a series of flat splits radiating outward from the center of the bottom where the construction begins. The weaving is started near the intersection of the "spokes" and is continued in a circuitous manner until the bottom, or diameter, is the desired size. Then the "spokes" are uprighted at 90 degree angles and the weaving continued to form the body of the basket.

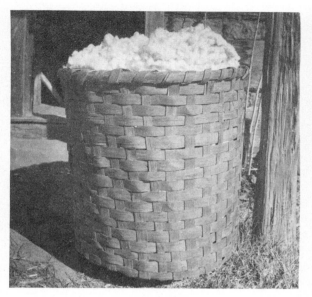

## SPOKE DESIGNED COTTON BASKET
### (Putnam County, Tennessee)

This large white oak split basket more closely resembles the cotton picking baskets one tends to associate with the deep south. It was acquired from Thurman Tinch of Monterey, Tennessee, about 1970. Whether or not it was made in that immediate area is not known. And it may have been made as a clothes hamper rather than a cotton basket. (Photo by Gary Hamilton)

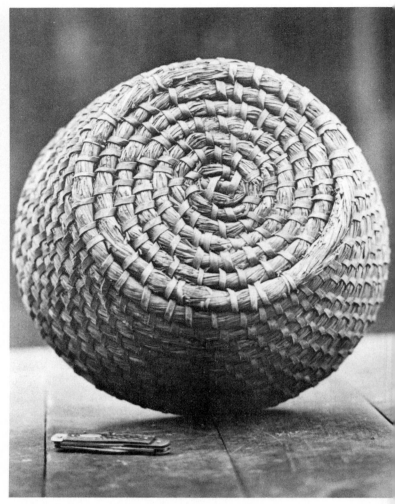

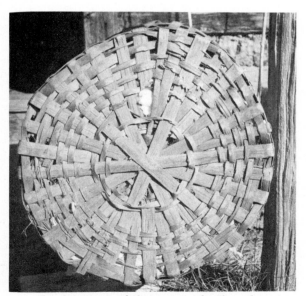

The bottom of the cotton basket showing the spoke-type construction.

## HACKER MARTIN'S
### COILED STRAW BASKET
### (Washington County, Tennessee)

Shown here is the bottom view of the only coil type constructed basket that I have ever found in Southern Appalachia. It came from the attic of Hacker Martin's mill house on Cedar Creek near Johnson City, Tennessee. But Hacker had operated a similar grist mill, and plied his trade as a gunsmith in Appomattox, Virginia, for a number of years and it is possible that it was brought to Tennessee from that area.

Close observation will reveal that the bundles of straw (rye, I presume) are bound by white oak splits similar to the type used in the ordinary baskets of the region. This basket is pictured and discussed more fully in Chapter III as it relates to basket material. (Photo by Gary Hamilton)

## NEST OF BASKETS
### (Blue Ridge of Virginia)

These unusual tray-like baskets are made of willow woven through the vertical white oak ribs. Likewise the handles are wound with willow. They were acquired by Roddy Moore in the Blue Ridge section of Virginia. Neither he nor I know what specific purpose, if any, they were designed to serve. The depth of the largest basket is less than 2 inches. It is 5½ inches wide and 9½ inches in length. (Photo by Roddy Moore)

## FOOTED WHITE OAK BASKET
### (Sevier County, Tennessee)

This small basket, whose rounded top is only eight inches in diameter, is the only one in the entire museum collection having six tiny feet on two parallel runners. Some have suggested that the purpose of this basket was for drying wool and that the feet would allow the water to drain. But considering the very small size of the basket one can see that it would not be practical for this purpose.

If one examines very old baskets, he will note that the bottom very often is the first to go. Perhaps the addition of these runners and feet were merely to protect the basket from continued wetting when it was rested on the damp grass or the wet ground. Also, this slight elevation would allow the bottom to dry more quickly if it were to become wet.

This exceptionally well constructed basket is made entirely of white oak. It was acquired in the extreme eastern section of East Tennessee, in Sevier County, near the Great Smoky Mountains and appears to be quite old—mid to late 1800's, I would think. (Photo by Gary Hamilton)

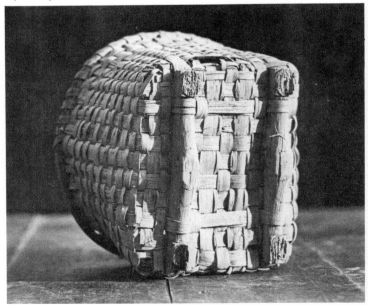

The Enos McDonald homeplace. The higher portion of the structure on the right is made of hewn logs.

Enos McDonald's Overton County, Tennessee woven white oak split basket. The photo above shows the reinforced bottom runners or skids and the details of construction. These skids are quite common among the middle Tennessee or Cumberland Plateau baskets.

## ENOS McDONALD BASKET

This basket originated in Overton County in what is called the Upper Cumberland section of Middle Tennessee. I found it in the log smokehouse of one of the oldest type homesteads I have encountered in a long while. This style, quite common in the Cumberland Mountain region of Middle Tennessee, is all plaited white oak splits and has heavy runners on the bottom.

The old homestead from which it came belonged to sisters Avis McDonald and Mavis McDonald Norrod. Their father was Enos McDonald and the old log house had been the home of Enos's wife's grandparents, Isaac and Mary Ann Smith. The builder of the house, according to family accounts, was one Cy McNeeley.

The location of the place is a few miles east of Livingston in the Dog Walk community. This small mountain community is near the birthplace and home of Cordell Hull, certainly one of this century's most influential Americans. The title of "Father of the United Nations" represents but one of many of his great accomplishments.

┼┼┼┼┼┼┼┼┼┼┼┼┼┼┼┼┼┼┼┼┼┼┼┼┼┼┼

## TIP IRVIN PRICE'S CEDAR SLAT
## UNDERWEAR BASKET
(Hawkins County, Tennessee)

On October 27, 1979, I left the main road in Mountain Valley in Hawkins County, Tennessee, near the Hancock County line and drove up a rough dirt lane for a couple of miles. There were no houses in sight and the road finally became impassable. I left the van and walked to the end of the road which led

through the passageway of an old barn and there at the foot of the Clinch Mountain was a little three-room house and an old lady with her bonnet on out working in her yard. It was a most picturesque scene and there was no sign or sound of civilization in any direction.

The jolly little lady's name was Nealie Price and the Mountain near her house she had appropriately named "Nealie's Mountain". "Hit's so purdy here in the spring time--all the flowers and trees a'bloomin--jest as purdy as a peach."

The Price family, like many of the renters of this area, had moved around a good deal, but all within a few miles. Some of her brothers and sisters were born in Lee Valley on Richardsons Creek; then they moved to a remote area on Clinch Mountain, two miles from the nearest road in an area called Clondike. Their address is, and was, Treadway. The nearest community to where Nealie now lives is Friendship.

The basket was made by Tip Irvin Price who was the brother of Nealie and the oldest of ten children. He was born May 16, 1885 and made the basket in the 1940's.

"He made a few baskets like that and he made that un fer us to carry eggs to the store—but hit was allus so heavy we never used it for that."

When I first saw the basket it was sitting on the bed and had clothes in it. After I bought it, Nealie's nephew who lived with her said laughingly, "Now, ain't that somethin'—Aunt Nealie's done sold my underwear basket. What will I keep my underwear in now?"

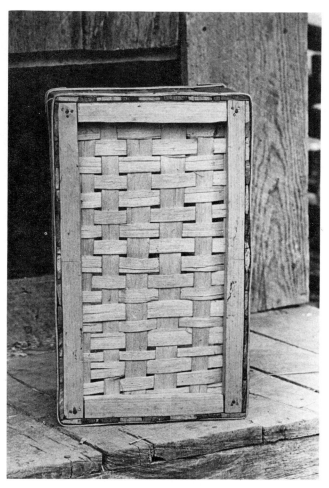

View of the Price's cedar slat basket showing the bottom constructed of white oak splits. (Photo by Gary Hamilton)

This is the only basket of this type I have seen. The slats are of the native red cedar. The white slats were rived from the sap portion of the same tree. The handle is of hickory and the bottom is made of white oak splits. (Photo by Ed Meyer)

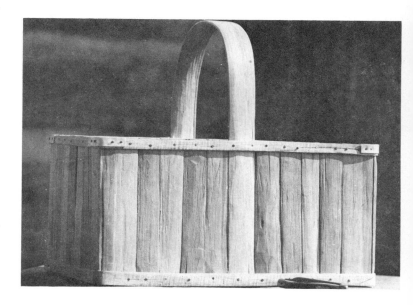

73

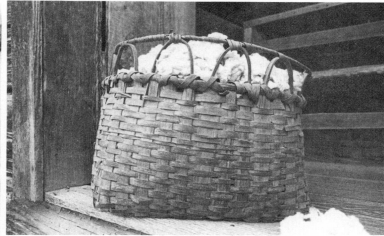

## MULTI-HANDLED COTTON BASKET
### (Putnam County, Tennessee)

This basket came from the loft of the woodshed of the old B.M. Carr homeplace located on Buffalo Valley Road near Cookeville in Middle Tennessee. I bought it at public auction about 1976.

Although I have seen a few baskets similar to this one, I have never seen a handle construction that even resembles this type. The entire basket is made of split white oak and the individual handles are deeply notched and fitted into the rim. The top rim, secured to the tops of the handles, appears to be superfluous.

Because of its large size and because of the many handles we surmise that it may have been a basket for picking cotton. Its lightweight construction would not have supported a heavy load such as apples or tomatoes. Cotton was grown regularly even in the mountains for home use. (Photo by Gary Hamilton)

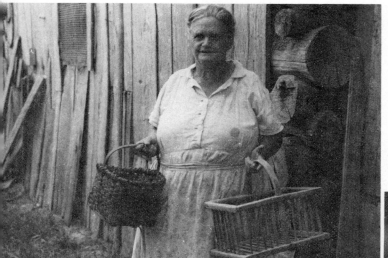

Alice Gibson at her home in Scott County, Tennessee with her chicken coop basket and her mother's egg basket. (Photo by the author)

## ALICE GIBSON'S CHICKEN COOP BASKET
### (Scott County, Tennessee)

As is true with virtually all items in the mountains of Southern Appalachia, one finds in baskets the odd, the unusual and the never-heard-of. Although most of the baskets in this region were made of white oak splits (Sue Stephenson guesses ninety-five percent), there were other materials and types.

In the 1960's I found a basket almost identical, as I recall, to the Gibson basket shown here. (I called it a chicken coop basket because of its resemblance to the old type chicken coop found in every country store in the region.) It does not fall into any one of what are considered to be the four major types of construction mentioned earlier.

It was in one of the area's most isolated sections, near the community of Smoky Junction in the small mountainous county of Scott in East Tennessee, home of Congressman John Duncan and Senator Howard Baker. Starling Mason, an old logger, was showing me through his pioneer log barn when we found the basket. He was willing to sell, but his wife emphatically said "No"; and the negotiations came to an abrupt end.

Fifteen years later I was visiting with Alice Gibson who lives within a few miles of the Mason's home. I had bought an old table from Alice and was removing it from the woodshed when, to my great and pleasant surprise, we discovered this basket barely visible from the debris which covered it; and Alice gladly sold it because it had no sentimental or utilitarian value to her. (Her two keepsake baskets she would not sell at any price.)

One's initial thought might be that the basket was never finished--that splits were intended to be woven through the rods. But both this basket and the Mason basket had never had splits, according to their respective owners, and they had been used in this manner for many years.

Upon inquiring, Alice told me: "That was made by Condy Lowe. He lived way up above Smoky Junction--way on past Starling Mason's place. Starling's wife was a sister to Condy. Well, Condy got sick in his old days and I let him move in here in the old log house with me and I took care of him til he died nine years ago last May. And he give me the old basket."

The basket is 8 by 14 inches and is 7 inches in depth. All construction members are oak except the handle which is hickory. It would make a good garden basket and could well have been used as an egg basket. The Mason basket was in the crib portion of the barn so it may have been used as a corn basket for feeding the mules or the fattening hogs.

## TWILL WEAVE EGG BASKET
### (Putnam County, Tennessee)

The weaving process whereby the split is woven "over two and under two", called the twill weave, was not common in Southern Appalachia. In the entire museum collection the basket shown here is the only one woven in this manner. But this type weaving is quite common in chair bottoming throughout the region.

It is made of white oak and measures 14 by 8 inches. I bought it from Major Ina Copeland who lived in the Cumberland Mountain Plateau town of Monterey in Middle Tennessee. (Photo by Gary Hamilton)

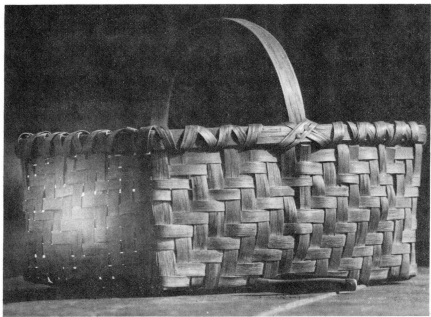

## THE TRUGE OR BOAT BASKET
### (Bath County, Virginia)

It is claimed that "baskets" similar to this one, sometimes called the Sussex truge, were used in Britain since William the Conqueror came to England in 1066. The word "truge", in old English, referred to a basket-like container which could be carried in the crook of the arm by one harvesting in the field, garden, or vineyard. A small dug-out boat was also referred to as a truge.

I acquired the basket from Roddy Moore whose research concluded that it came from a basketmaker named George Gillet who lived in Bath County, Virginia near the West Virginia line. He learned that Gillet died in the 1950's when in his nineties; so the basket could easily have been made in the 1880's. He reportedly had several stored in an old building at the time of his death.

The bail, or handle, and the frame are made from small split hickory saplings while the body is made from rived oak. The width of these oak slats varies from three inches in the center, tapering to less than an inch wide on the ends. They are less than a quarter inch in thickness and are attached to the frame by rosehead, handmade nails. This type nail was common in the 1700's, and in the first part of the 1800's; but started to be replaced by the more mass produced square or cut nails in the 1830's. It is possible that the basket was made before Gillet's time by his ancestors. But it is also possible that he continued to make nails by hand in that mountainous region long after the cheap, factory-made square nails were available. If he did indeed make the nails as a young man in the years after the Civil War, then he probably spent more time in so doing than was required to make the basket itself.

Tom and Nancy Walton, who live near Knoxville, own a basket which is almost identical to the one shown here. They have no information relative to its history except that they bought it in a "junk" store in East Tennessee. The one shown here measured from the top is 27 inches in length and 16 inches wide. (Photo by Roddy Moore)

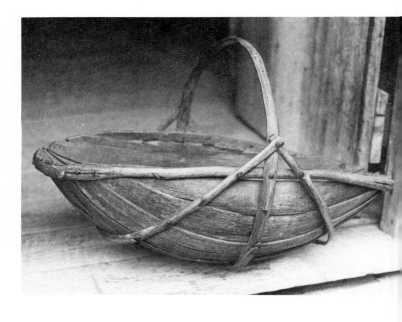

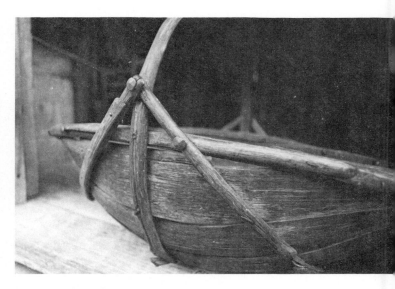

This close-up view shows the heads of the hand-made rosehead nails.

# Chapter 3
# Basket Materials

Although a dozen different types of materials were used in Southern Appalachia for making baskets, only one source, the white oak, stands out as being *the* material for basket making. Eaton, writing in the 1930's, gave a six to one ratio of white oak baskets over the combined number made from all other materials; and Sue Stephenson in her book *Basketry of the Appalachian Mountains* goes even further, as noted earlier, estimating that ninety-five percent of the baskets of the region were made from white oak splits. The Museum collection of a few hundred which were gathered randomly from the region suggests that these claims were reasonable and valid especially outside the relatively small area on the North Carolina-Tennessee border where one finds heavy Indian influence and where river cane was a popular material. But some authorities are positive that even the Indians were using splits (or splints) before their association with the whites and that the whites learned this technique from the Indians.

But it seems most unreasonable to assume that the white man was not already familiar with the split making. Hopf, mentioned earlier in his thesis on early basketry in this country, points out that a split cane chair was discovered in the Egyptian tomb of Tut-ankh-amen. He further points out that the English used split willow in the mid 1700's.

The white oak, which this writer nominates as the most beautiful tree in Appalachia when it reaches maturity, is found scattered throughout the region. It usually grows in the higher elevations on the ridges and mountains and it is sometimes found in groves. The young tree is very similar in appearance to the post oak and even the old-time basketmakers sometimes have difficulty in distinguishing one from the other, especially during the winter when the leaves are gone.

Why is the white oak the favorite basket material in this region and in other sections of the country as well? First, it rives well and can be made into paper-thin splits. And when one uses a sapling from four to six inches in diameter, it makes a split as flexible and willowy as a well-tanned piece of rawhide. If made into narrow splits it can be tied into knots, which was sometimes done and used instead of cotton strings.

The other major advantage of the white oak is its tremendous strength. A single split, a half inch wide and only 1/32 of an inch thick, will support several pounds of weight. And white oak is a lasting wood. Hickory, considered to be the toughest and strongest wood in the mountains, will decay quickly when exposed to the weather, but not white oak. Many old timers have stated that a roof made of white oak shingles would effectively turn water for over 50 years. A fuller discussion of the white oak and its qualities as basket timber will be pursued in Chapter IV.

Following the popularity of white oak as basket material in Southern Appalachia, the willow may be a distant second. It seems that the willow basket was more often made by women; and it was definitely more frequently used by women as a house basket. I don't recall ever seeing one used as a farm and garden type basket. The honeysuckle basket, also, was used mainly inside the home to contain sewing materials, trinkets, and so forth.

Other materials which I have found in the baskets I have collected include cane, hickory bark, poplar bark, broom corn, straw, ash, cedar, and a few other innovatively contrived types such as leather, brass strips from an A-model Ford, and dynamite ignition wire. Various examples of how these materials were used in the construction of the baskets of Southern Appalachia appear on the following pages.

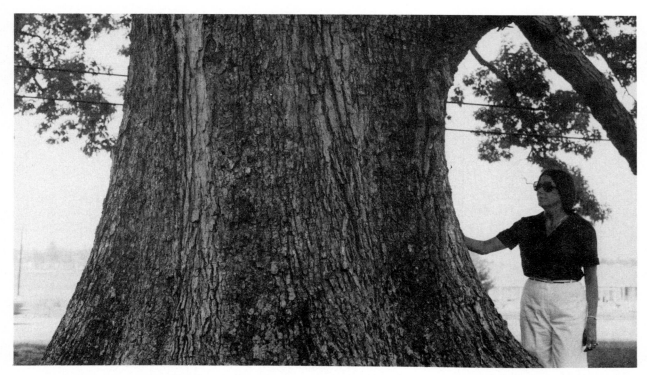

The writer's wife, Elizabeth Irwin, stands beside the historic white oak in McMinnville, Tennessee, near the white oak basketmaking "capitol" of Tennessee. (Photo by the author)

┼┼┼┼┼┼┼┼┼┼┼┼┼┼┼┼┼┼┼┼┼┼┼

The countryside around the small Middle Tennessee town of Woodbury has long been known for its white oak baskets and until a few years ago there were "basket stands" along Highway 70-S where the craftsmen sold their wares. On a recent trip to that area my wife Elizabeth and I purchased about forty extremely fine baskets from Mildred Youngblood who is discussed at length in Chapter IV. On our way home on the outskirts of the town of McMinnville, we noticed the great white oak, the type used in making practically all the baskets in Southern Appalachia-and in this writer's opinion one of the most beautiful trees which ever grew. (It is the official state tree of Connecticut and Maryland.)

Because of my interest in baskets and because of my long admiration of the white oak, I was especially impressed by this outstanding specimen. When I returned home I wrote the Chamber of Commerce in McMinnville, thinking surely this tree was singularly beautiful as to have stirred some local interest.

The Chamber referred me to an old gentleman by the name of Hobart V. Massey, who indeed was familiar with the "baby oak" as he called it. Not only had he painted pictures of the patriarch of McMinnville oaks, but for the past fifty years he had researched its history. In a letter to me on September 12, 1980, Mr. Massey wrote:

"The history for years now gone, I do not fully know, but I do know of some incidents and events from mid 1800 to now. In 1845 a family from North Carolina was on their way to Kentucky. They came from Yadkin Territory in North Carolina via Hiawassee on the "Hill's Trace" (named that about 1803) and came to Warren County. They had to detour via Tanyard Springs near here and forded Barren Fork River at the present Clement Memorial Bridge. Thus a mile east to the grove of white oaks. A spring is near, so the family spent the night in a covered wagon. Thus on November 11, 1845, a little girl was born to the Miltons while under *the* tree. This family went on to Kentucky and learning from me in 1945 of this tree, the grand and great grand-children came here and had a dinner under the "Baby Tree".

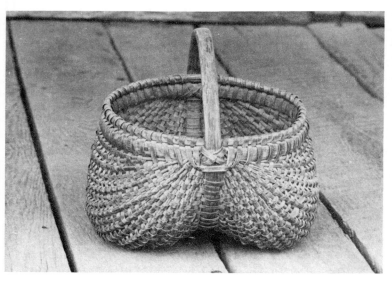

### PETE ELLISON'S WHITE OAK
### GIZZARD BASKET
(Claiborne County, Tennessee)

This small white oak gizzard basket is one of the sturdiest and most tightly woven I have found. I acquired it from the Lambert family who lived in Claiborne County, Tennessee, near the Lee County, Virginia line.

"That basket was made by an old sawmill man, Pete Ellison, years ago", Lambert told me. "He'd work a week on a basket--had to have everything jest right." The diameter of the perfectly round top is less than eight inches and the capacity is slightly more than a gallon. Pete Ellison presumably was no relation to Albert Ellison whose baskets are shown in the accompanying photograph. Their respective homes were over 100 mountain miles apart.

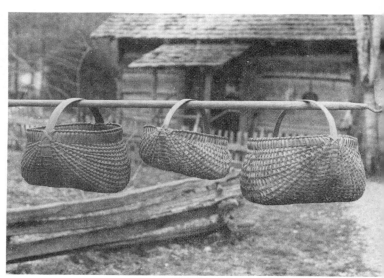

### ALBERT ELLISON'S
### WHITE OAK BASKETS
(Carter County, Tennessee)

These three white oak split baskets were purchased from Albert Ellison of near Hampton in Carter County, Tennessee. He had used them as feed and garden baskets for almost fifty years. They were made, according to Ellison, by one Grant Woody, who lived near Simerly Creek on Woody Hill in Carter County. It is worthy to note that the three baskets are very similar with regard to the size and shape of the ribs, splits and handles. Yet the overall form of the baskets vary considerably.

## RYE STRAW BASKETS IN SOUTHERN APPALACHIA

The straw from rye and to a lesser extent from wheat, barley and oats has been used for making baskets at least since Egyptian times when such baskets were used in underground tombs. The rye straw basket, along with the straw bee skep, was common throughout most of Europe, perhaps more especially in Germany; and it became well established in the northeastern part of the country. (Jeannette Lasansky in her book *Willow, Oak and Rye* states that remnants of rye straw baskets were found in Europe which were made 12,000 years ago.)

For whatever reason, straw was very seldom used in the Southern Appalachian Mountains for making baskets. I have personally found perhaps a few thousand old baskets in the woodsheds, smokehouses and attics of East Tennessee, southwestern Virginia, and western North Carolina homesteads and I have found only one basket that was made of rye straw. It was in the millhouse loft which had belonged to gunmaker Hacker Martin. It is pictured and discussed elsewhere in this chapter.

It is enigmatic that rye straw was not used in this region. Many of the earliest settlers were the German and related families who came directly from Pennsylvania down the valleys of Virginia; and rye straw was a favorite material used by those Germans, called Penn-

sylvania Dutch, in basket making. The Palentine Germans, we are told, were especially fond of the rye straw baskets. And it was from this group that so many of the early settlers in the valleys of Southern Appalachia sprang.

Rye, of course, was used mainly for bread and for making whiskey, and the straw was a by-product. It was long and tough and had been used in Europe for thatching the roofs, for making honey bee hives, or skeps, as well as baskets for their bread. It was much preferred over other straw such as barley, oats or wheat.

The Pennsylvania Dutch made various types of straw baskets. They had large deep baskets for storing dried fruit and vegetables, round flat bread baskets, seed sewing baskets, and various other types used for a multitude of purposes.

Since many valleys in East Tennessee, for example, were settled by German families coming directly from Pennsylvania, one would think that the custom, at least to some extent, would have continued.

There is a small, beautiful valley here in Anderson County lying between ridges and the mighty Cumberland Mountains which has largely been protected from outside influences. It was settled about 1799 when that area was still a wilderness frequented by the Indians. It was appropriately named Dutch Valley for the Pennsylvania Dutch families who pioneered the area. (There are "Dutch" valleys throughout the region corrupted from the proper Deutsch or German.) This valley was settled by one Frederick Sadler who according to Katherine Hoskins, historian for Anderson County, was a wagon maker from York, Pennsylvania. He brought with him his seven daughters and sons-in-law and their families and with the possible exception of one son-in-law named Claxton, they bore German names: Bumgartner, Clodfelter, Leinart, Lieb, Shinliver, and Spessard. Many of the residents of the valley today are direct descendants from those early families.

For many years I have purchased items and observed countless others that I did not acquire in this valley, but I never saw nor heard of a rye straw basket. Now one might conclude that such baskets did exist and were worn out and discarded. Perhaps that is true. But these people took great care of their chattels and kept almost everything, even after they were no longer serviceable, stored away in the attic or in some out-building.

Ralph Shanliver, a descendant of these early German immigrants, and a lifelong resident of Dutch Valley, is related to many of the residents and knows the other old-time residents. I called him recently and asked if he had ever heard mention of any straw baskets. He assured me that he had not.

The findings of Roddy Moore, in his study in and around his Ferrum College area located south of Roanoke in the Blue Ridge region of Virginia, is somewhat contradictory to mine. He has found a few rye straw baskets in that region which are included in the photographs of this chapter.

Our friend Clara Smith from Blount County, Tennessee, is an animal-farm-garden oriented girl and has become interested in the rye straw bee skep. She was disillusioned when she learned that I was not including this item in a book of Appalachian basketry, but I told her that neither I nor any of my compatriots had ever found one. I promised that I would keep looking and when I attended an auction sale in the southern part of Virginia, east of Galax there were, sure enough, three rye straw bee skeps. But it was quickly learned that they were recent European imports. And likewise Roddy Moore has failed to find an old one, even in the Shenandoah region, perhaps the most likely place since this was the major route for the many thousands of Germans coming from Pennsylvania into the mountains of Southern Appalachia.

It is generally agreed that the "domesticated" honey bee was introduced into this country from England as early as 1622. It can almost certainly be assumed that the straw bee skep was also introduced at the same time. Carroll Hopf in his well-documented thesis on the history of baskets (mentioned earlier) states: "One item made of straw that seems to have been universally adopted by all people was the bee hive." But the fact remains that the people of Southern Appalachia used them little if at all--and the question of "why?" still remains.

**HACKER MARTIN STRAW BASKET**
(Washington County, Tennessee)

Hacker Martin, who is generally considered to have been the best known old time Kentucky rifle maker of this century, lived on Cedar Creek near Johnson City, Tennessee. It was from the attic of his old water-powered mill that I found this straw basket.

Some of Hacker's ancestors, including the Kefauvers, came from Pennsylvania at an early date; so perhaps the basket, or the knowledge of how to make it, came from some of those settlers. But as stated earlier, Hacker had lived for several years near Appomattox, Virginia; so perhaps he brought it back to Tennessee with him from that area.

The basket is 14 inches across the top, has a 6 inch opening and is about 8 inches tall. Its holding capacity is approximately three gallon. The bunches of straw are ¾ of an inch in diameter and are bound together with uniformly made white oak splits. (Photo by Ed Meyer)

Although rye straw baskets were all but unknown in the East Tennessee area, they apparently were more common in the Shenandoah Valley of Virginia and in the Blue Ridge Mountains region. Those pictured here were collected in that general area by Roddy Moore. Most students of the subject agree that the flat straw baskets were used for containing bread dough while it rose and before baking-- hence bread-raising baskets. But they probably served other purposes as well. (Photo by Roddy Moore)

## GLEN G. IRWIN
## AND HIS "DINNER" BASKET

Although this basket is probably not Appalachian made, it and others like it were commonly used in the early part of this century. It is included for this reason and because it was my father's "dinner" basket when he attended the one-room Oaks Chapel School in Union County, Tennessee. He used this basket, to the best of his memory, during his entire years of schooling when he carried his individual "dinner". But sometimes he and his brothers would take only one big basket in which food for all was carried. "We carried sweet potatoes, roasting ears, ham meat, biscuits, and so on."

It is made by plaiting several fine straws to make a single weaver; and the uprights are vine. My father said that it was a "hand-me-down" from his older brother and that he does not know its origin. (Photo by Gary Hamilton)

"Well, it's been seventy years or more since I first carried my dinner to school in this little gentleman", my father recalled. "I've eat a many a ham-n-biscuit and baked sweet potatoes out of him." (Photo by the author)

## WILLOW BASKETS

The practice of cultivating a type of willow known as basket willow has been practiced in Europe, apparently for centuries, and it is claimed that this species was introduced in America. (Even prior to this the Romans had used the willow extensively as a material for making baskets; and some authorities say it was their favorite material.) The willow was cultivated in the northeastern part of this country in the 18th and 19th century for the purpose of producing osiers or willow shoots from which the baskets were made.

The long "willowy" switches could be cut from the stump every year or two. They were sometimes neatly bundled and sold commercially in nearby towns, or to local basketmakers, or to those making other wicker articles--chairs, tables, desks, swings, and a multitude of other items. In 1861 the periodical, *The Rural New Yorker,* reported that farmers could get one hundred ten dollars per ton for willow osiers or switches.

But there were no domestic osier or willow beds in Southern Appalachia. The banks of myriad streams are covered with willow, especially those streams flowing through cleared meadows and fields. This probably was not true in frontier times when the same streams flowed through stands of virgin timber.

Although one finds a few willow baskets throughout Appalachia, this material never rivaled the white oak. And, as stated earlier, willow was mainly used in this region for making sewing baskets and other house baskets.

The "wild" willow which grew along the streams was probably inferior to the cultivated type growing in Europe and in the northeastern part of this country. It did grow in profusion, however, and was used mainly by women, it seems, for constructing more artistic than utilitarian little baskets.

### BETTY BIRD CASSADY'S
### WILLOW BASKETS
#### (Union County, Tennessee)

"Them two little willer baskets belonged to Mama", Harve Cassady recalled. "They was made by an ole woman--Rhoda Sands--who lived here in Beard Valley. I've seen her come down the road a many a time with her bonnet on when I's jest a kid, looking for willers to make her baskets. Mamma used the little basket for sewing--a sort of thread basket. She kept her quilting materials in the bigger one."

The old Cassady place is located in Beard Valley some four miles south of Maynardville in Union County--about 20 miles north of Knoxville. Old Fate Cassady was a noted fiddlemaker, his son Dick a part-time country lawyer, and the four sons of Dick have just stayed on the old place. These four bachelors (Tom, Harve, Lance and Jarvis) are among the friendliest and kindest mountain people I know. They each have their separate home (Tom's is only eight feet wide). They play music, raise a little garden, keep a few chickens and mainly just leisurely enjoy their ancestral home.

They have maintained their grandfather's old home as a sort of headquarters and it is there that the two little baskets are kept. They were willing to part with a few items, but not the two little willow baskets which belonged to their mother.

⧉⧉⧉⧉⧉⧉⧉⧉⧉⧉⧉⧉⧉⧉⧉⧉⧉⧉⧉⧉

Harve Cassady with the willow baskets old Rhoda Sands made for his mother over half a century ago. (Photo by Gary Hamilton)

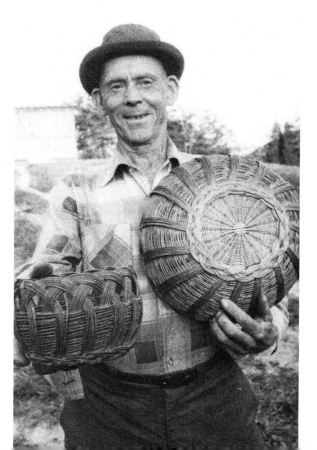

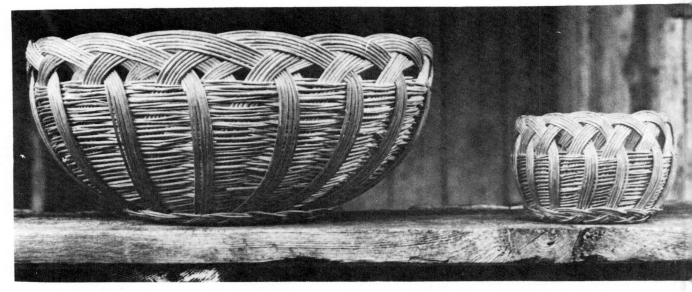

Betty Bird Cassady's willow sewing baskets made for her by her neighbor Rhoda Sands in the early part of this century--in Beard Valley, Union County, Tennessee. (Photo by Gary Hamilton)

The old Cassidy homeplace.

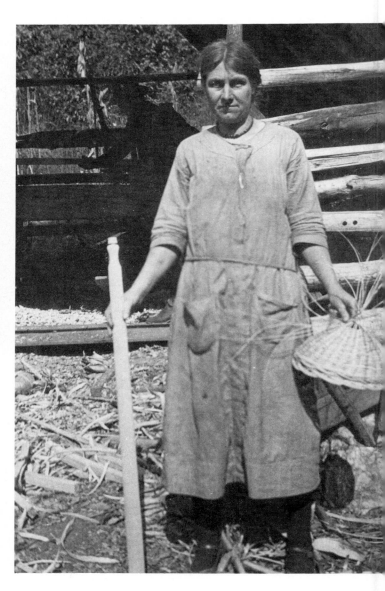

Mary Owenby is shown in the circa 1936 photo with a turned chair post and an incompleted, and most unusual, basket. It may be the result of the craft revival movement brought on partially by the mission schools of the early part of this century; and it appears to be made from willow. Mary and her husband lived in the Glades community just north of Gatlinburg. (Photo courtesy of Ed Trout and the Great Smoky Mountain National Park)

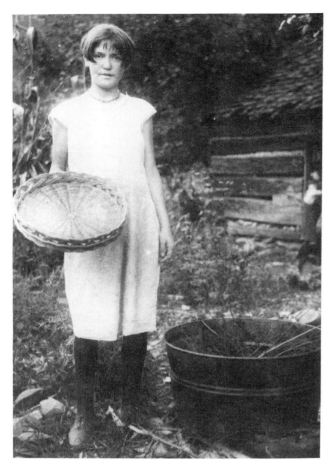

This basket, like the one being made by Mary Owenby, is obviously the result of outside influence. It is made of willow and the osiers or willow switches are being soaked in the tub of water. This mountain girl, shown in front of what is presumably her log home, is likely the maker of this well constructed basket. (Photo courtesy of Ed Trout and the Great Smoky Mountains National Park)

### HONEYSUCKLE BASKETS

I have often wondered whether the honeysuckle vine was used in early Appalachia by our forefathers to make baskets or whether it was introduced by outside inspired craft centers which were established in various parts of the region in the early part of this century. I recall that one of my elementary teachers tried to teach us to make honeysuckle baskets in the late 1930's--an experience which contributed nothing toward my later interest in the subject.

Alex Stewart, whose community on Newman's Ridge in Hancock County was surely immune from any outside influence at the turn of the century, remembered an old lady who made honeysuckle baskets when he was a young boy in the 1890's. Other rather old honeysuckle baskets have been found recently—enough to convince one that it was indeed used in the early days of Appalachian culture.

In some cases the vines were gathered in fifteen to twenty foot lengths, wound into rolls and then boiled for several hours. This served to loosen the outside peel which then could be easily removed with a cloth.

The few honeysuckle baskets I have found were small, house-trinket baskets, and are very similar to those made of the slender willow switches. Often one has difficulty distinguishing one from the other.

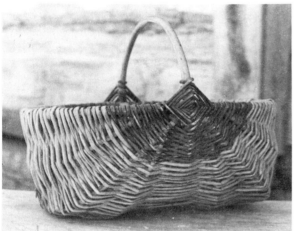

In her book *Basketry of the Appalachian Mountains* Sue H. Stephenson shows a Scottish basket made of willow which appears to be quite similar to the one shown here. This one is also made of willow and has a similar handle-lashing technique. It was found by Roddy Moore in Botetourt County near Roanoke, Virginia. The dark portion of the basket is made of the unpeeled willow osiers while the remaining whiter portion is of the peeled willow withes. It has a depth of 12 inches and has an opening of 10 by 12 inches. (Photo by the author)

**LULA CANNON'S MOTHER'S
HONEYSUCKLE BASKET**
(Yancy County, North Carolina)

"We was all settin' around the fireplace one cold winter day and nothin' much to do", Lula recalled. "And Mama went down to Aunt Sally's and got a little Indian basket made out of honeysuckle vine to use as a pattern, and she made herself this here little basket. That was about 1915 and she made 'em for years after that."

The basket, for about as far back as Lula can remember, has served no purpose other than as a resting place for the little handmade rag doll. This ingenious mountain woman from Yancey County, North Carolina, and her baskets are discussed at length in Chapter IV. (Photo by the author)

## CANE BASKETS

It is paradoxical that the most plentiful and readily available material for basket making, the common "river" cane, was seldom used for that purpose by the whites. My Grandfather Irwin used to tell stories by the hour which he had heard from the old pioneers of the East Tennessee Mountains relating to the profusion of cane when the whites first arrived. No matter if the story concerned bears, wolves, panthers, or heroic deeds of the first settlers, there would invariably, it seemed, be a reference to the canebreak.

Apparently the creek and river bottom land, as well as most of the valleys, were covered with cane so rank and thick that it could not be penetrated by man or beast, except by way of the trails made by the buffalo and other animals.

Alex Stewart pointed out that the rich lands along Panther Creek in Hancock County was considered worthless for a hundred years after the settlement of the rugged Newman's Ridge because the heavy growth of cane rendered it virtually impregnable. It was considered to be such a nuisance that the one object was to destroy and completely eradicate it. But the Indians had been using it for centuries to make a most beautiful and durable basket. This subject is discussed more fully in Chapter VI in connection with Indian baskets.

In the eastern part of Tennessee, in western North Carolina, and perhaps in other areas where the Indian influence was greater, one finds several old cane baskets. It is assumed that most of them were made by the Cherokee or that they were directly influenced by them.

Cane is considered to be a hard fiber to work with and it must be kept wet at all times if it is to be worked properly. It is also a difficult and slow material to prepare. The Southern Highlands Handicraft Guild of Asheville, North Carolina, in one of their official pamphlets states that 20 stalks of cane the size of a fishing pole is required to make one cane basket.

86

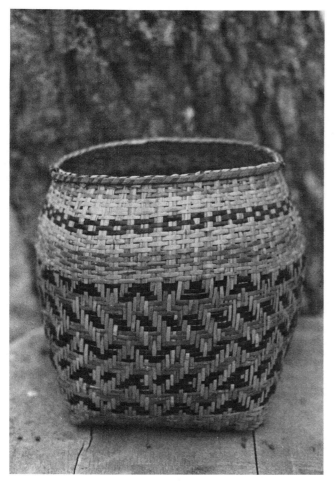

This Cherokee river cane basket was acquired in western North Carolina by Roddy Moore for his collection. The chain-like pattern which decorates the top portion of the basket apparently appealed to the whites as we see several examples of where it was used by them. Additional cane baskets are shown and discussed in Chapter VI which is devoted to Indian baskets. (Photo by Prof. R. Moore)

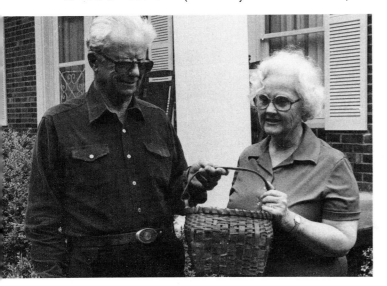

## ASH SPLIT EGG BASKET
### (Polk County, Tennessee)

This is the only ash split basket I have found from an old homestead in Southern Appalachia. It was acquired from Mr. and Mrs. Russell Harper, from their palatial home near Decatur in McMinn County in East Tennessee, about 45 miles north of Chattanooga. Russell, who died only a few weeks after I bought the basket, recalled that it had been used by his mother for as long as he could remember. It had belonged to Russell's grandfather, George Shamblin, before that. Shamblin lived in nearby Polk County near Reliance on Greasy Creek. He ran a grist mill there during and after the Civil War. Russell said he wasn't sure what use the basket had served during the time his grandfather had owned it, but he remembered that it was used by his mother as an egg basket.

The vertical splits are about three-quarters of an inch wide and the horizontal ones are only a quarter of an inch in width. There are two inch-wide horizontal splits in the center of the basket. The individual splits are uniform in width and thickness, indicating that a shaping tool of some type may have been used. (Veneering machines were being used in the early 1850's and were springing up in various parts of the country by the beginning of the Civil War.) The movable handle and the ears to which it is attached are of hickory. The bottom is 7 inches square, the top 8 inches in diameter, and the depth is 7 inches. Faintly visible on the bottom is a $1.00 price written in pencil, an indication that it was sold, possibly by itinerants who wandered through that area from the 1880's until the 1930's.

Russell Harper and Mrs. Harper holding the egg basket which belonged to his mother and earlier to his grandfather George Shamblin of Polk County, Tennessee. (Photo by the author)

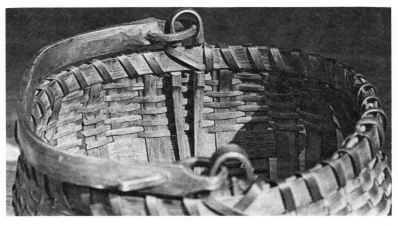

Close up view of the movable handle on the ash split egg basket showing the interesting method of connecting the handle to the ears. This reportedly is a Cherokee Indian technique, and the fact that the origin of the basket is near the Cherokee Indian reservation in the Great Smoky Mountains may give credence to this claim. This technique, however, is known in other parts of the country as well and it may have been an early import from the northeast, possibly New England. (Photo by Gary Hamilton)

## PAWPAW BARK BASKET
### (Monroe County, Tennessee)

When Roy Muir of Monroe County, Tennessee retired he took up various crafts and became expertly accomplished in animal carvings, as a cooper, as a turner, and in several other wood-related crafts including basket making. The one shown here is made completely of pawpaw bark. (Photo by Gary Hamilton)

## HICKORY, BARK, LEATHER, WHITE OAK AND PINE BASKET
### (Hancock County, Tennessee)

Some authors describe many of the baskets they picture as being made of hickory splits. But I must say that I have never seen one; and Alex Stewart, the great mountain man referred to earlier, says you can't make thin basket splits from hickory.

But the horizontal weavers in this basket are made of hickory bark, prepared in the same manner as for bottoming chairs. (The bark is actually split, the rough exterior portion discarded, and only the interior used.) The vertical splits, the bottom and the handle are all made of white oak. The top and bottom rims are made of squared white pine and it is reinforced at the top and bottom with well-tanned cowhide.

This basket, which was acquired in Hancock County in East Tennessee, is 10" x 14" and is 10 inches deep. It was made with one side of the handle some three inches higher than the other which would seem to make carrying easier in the crook of one's arm. Whether this was done by design or the result of poor workmanship is not known--though the maker would probably aver the former. (Photo by Gary Hamilton)

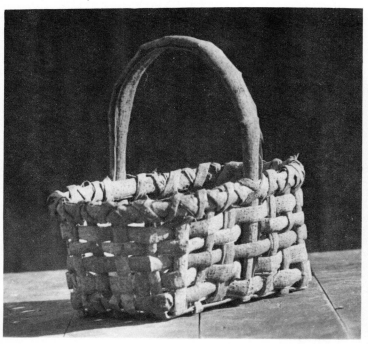

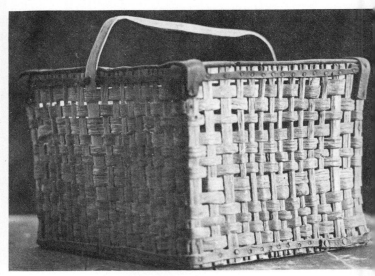

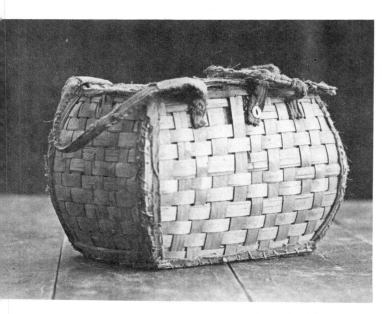

## THE HENRY WEST BROOMCORN
## AND BROOM STRAW BASKET
### (Clay County, Tennessee)

This basket is similar to the Carden basket in many respects. The broomcorn stalk splits are attached at the corners by sewn cloth; they are both lined with cardboard; and they both have hinged lids connoting, possibly, that they were used as dinner baskets or picnic baskets. But the primary difference is that the West basket, shown here, has long handles made from the straw of the broomcorn, ordinarily used for making brooms.

I found this interesting specimen in the attic of an old home near the community of Pleasant Shade, a few miles north of the middle Tennessee town of Carthage and a few miles south of the Kentucky line. The home had once been occupied by the Henry West family and the present owners stated that the basket had belonged to the West family. The bottom is lined, over the cardboard, with a copy of the *Nashville Banner* dated 1934. It was a practice to reline the baskets periodically--hence the basket could very well be much older than the 1934 paper would indicate. It measures 6" x 8" and is 4" deep. (Photo by Gary Hamilton)

## LIZZA CARDEN'S BROOMCORN BASKET
### (Anderson County, Tennessee)

This basket is made from what I believe to be splits from broomcorn. Almost every family grew broomcorn for the straw which was used to make brooms; but the stalk had little or no use. I had heard and Alex Stewart confirmed that the stalk was sometimes used in the mountains to make lightweight baskets. Alex pointed out that only the matured green stalks would serve for basket making as those dried would be too brittle.

The material is not bent at the corners as is the case in baskets made from white oak and other materials; but the weavers are merely butted against one another and are held together by cloth sewn over the two sections. This one is lined with cardboard attached by thread and the handles are made of old cloth (calico). It has a lid made also of broomcorn and secured by a single pearl button.

It is 6" x 8" and is 6" deep. It was found in the attic of the old John and Lizza Carden place, now the home of Burton Minga, which is located about one mile south of the Museum. It was acquired from Sally Scruggs by W.G. Lenoir from whom I purchased it.

In Chapter IV Lula Cannon is shown with a basket made from the stalk of broomcorn by her grandmother. (Photo by Gary Hamilton)

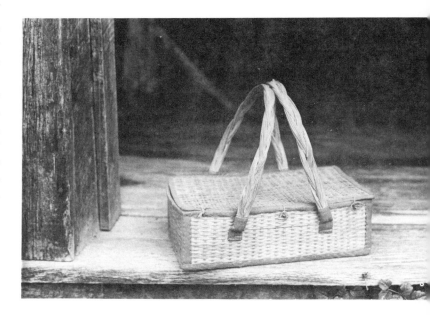

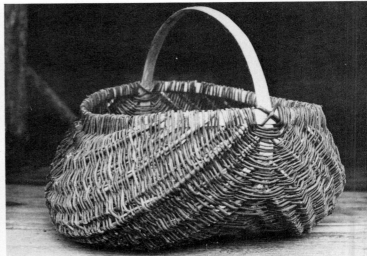

## LULA CANNON'S
### BIRDSEYE SWITCH BASKET
(Yancey County, North Carolina)

Lula is the only person I've known who made baskets from a shrub-like plant she calls birdseye. Her father was grubbing birdseye, she told me, from his cornfield when he noticed how tough and willowy the sprouts were. He suggested that Lula try them as basket material. She did and found them to be quite satisfactory. This one is, needless to say, the only one in the Museum collection made of birdseye switches.

The handle is made of hickory, the larger birdseye rods are used for the ribs and the smaller ones as the weavers. (Photo by the author)

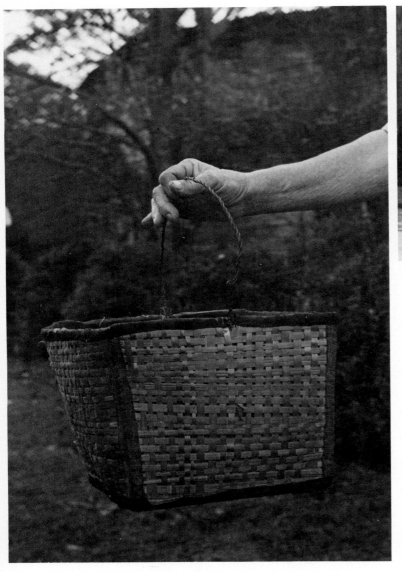

## NAN RADFORD'S BROOMCORN BASKET
(Yancey County, North Carolina)

Apparently the very few broomcorn baskets made in Southern Appalachia were not confined to a single locality. The West basket came from Middle Tennessee, the Carden basket from East Tennessee, and this one was made in western North Carolina. It was made in the early part of this century by Nan Edwards Radford, grandmother of Lula Cannon, herself a noted basketmaker discussed in Chapter IV. Lula lives, as did her grandmother, on Dogwood Branch, some sixteen miles west of Burnsville, North Carolina. Note the type weave and the cloth reinforced corners are similar on all three of the baskets made from broomcorn stalks. (Photo by the author)

## THE DEERSKIN BASKET
### (West Virginia)

The odd, the unusual, and the unexpected artifact seems to be the rule in Southern Appalachia as is exemplified by this deerskin basket which Roddy Moore found in the mountains of West Virginia. The rim, the handle, and the ribs are made of white oak.

Although I have seen a few chairs bottomed with either solid or strips of leather, this is the first leather basket I've encountered. There are probably several reasons why such a basket is somewhat impractical.

First, leather has always been a valuable and a relatively expensive material, even in pioneer times, because of the many useful purposes which it served. Secondly, the tanning and processing of green hides is long and arduous and requires other materials such as tannic acid which had to be obtained from grinding and soaking certain oak barks. And even after one completed a leather basket it could be a prime target for rats and mice, not to mention the family pup. (Photo by Roddy Moore)

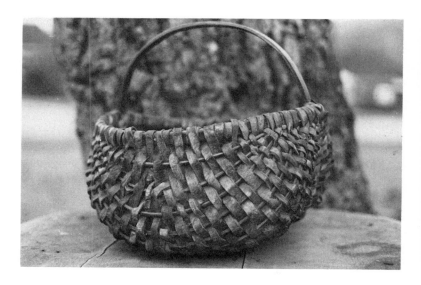

Nellie Baird Armistead on her back porch with some of the baskets which have been in the Baird and Armistead families for generations. (Photo by the author)

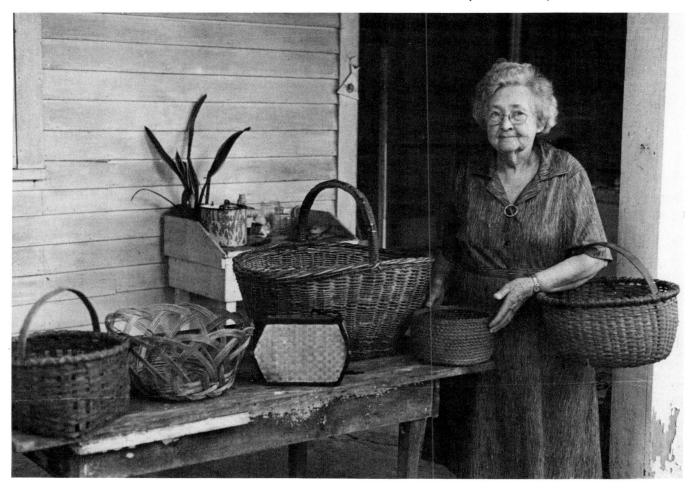

"Law me, that was Mama's old egg basket! I didn't know where it had got to", Nellie said as I retrieved it from the darkness of the attic. It had taken me years to persuade her to allow me upstairs and only then with the assistance of her granddaughter Jeanie Bass.

The basket is of white oak and is the only one in the lot that I would classify as a typical Middle Tennessee basket. Her mother, born in 1860, was named Betty Gill Baird and lived near the present Armistead homeplace in Smith County in Middle Tennessee. Nellie continued to reminisce: "We'd use that basket to gather the eggs and then to take them to the peddler. He (the peddler) had a horn he'd blow as he came through the country and we could hear it two miles away. And when we heard it, we'd start down the creek toward the public road and by the time the peddler got to our lane, we'd be there with our basket of eggs to trade for salt, sugar, coal oil and so forth."

Not only does the type, style and material of baskets vary widely in the Southern Appalachian region, but it varies greatly within one community and indeed within the confines of a single homestead. The photograph the preceding page of Mrs. Zack (Nellie) Armistead with the family baskets graphically illustrates the point.

The ancestral homestead of this family is in the community of Gordonsville near the middle Tennessee town of Carthage, some 50 miles east of Nashville. (One of Nellie's early neighbors and friends was United States Senator Albert Gore; and the world famous Cordell Hull, discussed earlier, lived just two doors from where Nellie now lives with her daughter in Carthage.)

It is remarkable that so many almost unrelated types of baskets could come from one family. And two of Nellie's most prized baskets are not shown here. They are the family sacrament basket and her mother's tiny Sunday School basket which are pictured and discussed in Chapter V. These baskets, made of wheat straw, white oak, willow, and honeysuckle, are discussed individually on the following pages.

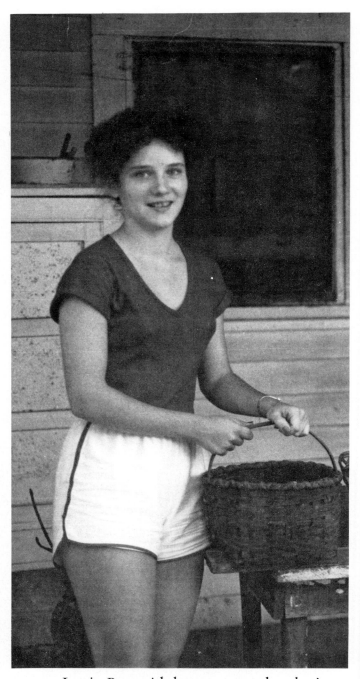

Jeanie Bass with her great grandmother's egg basket. (Photo by the author)

## THE WHEAT STRAW BASKET
### (Smith County, Tennessee)

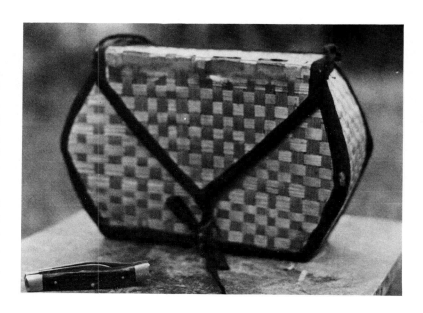

"This little basket is made of wheat straw", Nellie volunteered. "It was made by my aunt long before I was born. Her name was Serelda Melvina Pope Paris. I've always been told that they took the wheat straw, soaked it in water, split it open, then ironed it with a sad iron. It was a little handbag, a pocketbook, used by Mother."

This is the first authentic indication I've had that wheat straw was used as basket material in this region. The individual straw weavers, as in the case of the broomcorn baskets, do not turn the corners, but are sewn together by means of cloth strips. It is not the coil method of construction which one found among Pennsylvania Dutch and which was common in other parts of the country. It is rather a plaited type done in a manner similar to the way in which many of the white oak baskets were done. (Photo by the author)

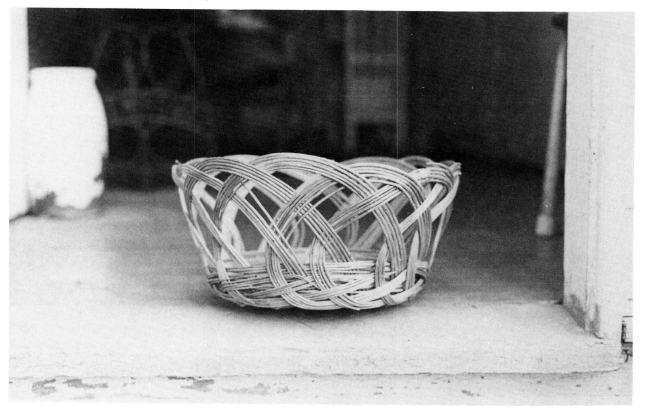

The honeysuckle basket had been used as her mother's sewing and trinket basket for as long as Nellie could remember. It was doubtless made in Middle Tennessee. (Photo by the author.)

## ROUND STRAW BASKET

Although Nellie wasn't sure, one might deduce that this round straw basket, like the other, was made by her aunt Serelda Melvina Pope Paris. It appears to be made of wheat straw and is hand-stitched throughout. It has tiny legs, also made of straw, sewn to the bottom. The small honeysuckle basket, along with its mate, was found in one of the outbuildings and appears to have been the result of classwork endeavors.

NELLIE'S GRANDMOTHER'S WILLOW BASKET

"That big (willow) basket belonged to my Grandmother Gill here in Smith County. She kept her material and her quilt pieces in it", Nellie recalled. Since her grandmother started her family before the Civil War, the basket, too, may date to that period. Interestingly, it still contained "material and quilt pieces" when I found it in the closet of one of the downstairs bedrooms. (Photo by the author)

THE FARM AND GARDEN BASKET

Nellie recalls that this basket came from her father's side of the family, the Bairds. Since it was used mainly as a field basket, she was less knowledgeable and less interested than she was in the house baskets. The perfectly round bottom, and the round top are not at all common in the area. Although it is made of white oak, the bottom is of the spoke type construction discussed later in this chapter. It is similar, some authorities point out, to the Shenandoah Valley baskets of Virginia.

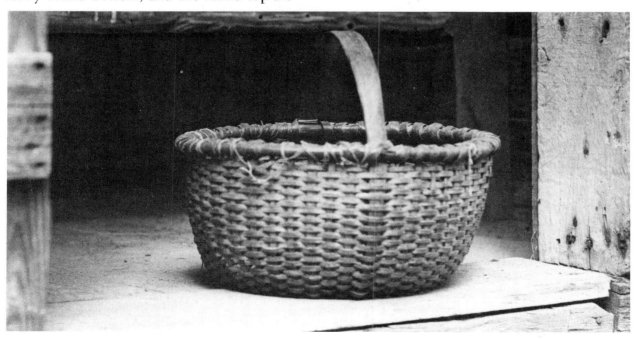

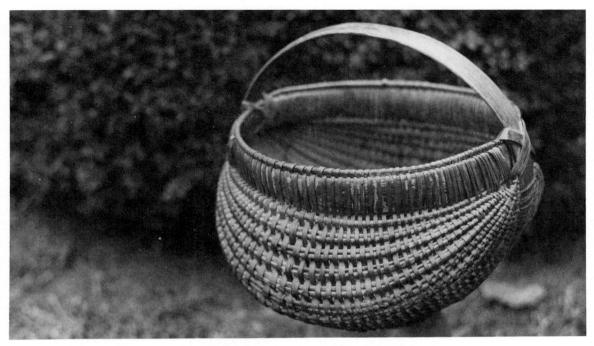

RIB AND SPLIT EGG BASKET

This typically Southern Appalachian rib and white oak split basket was another with which Mrs. Armistead would not part. "That was Mother's old basket--she used it for eggs and for other purposes around the house." (Photo by the author)

MIDDLE TENNESSEE EGG AND GARDEN
BASKET

This is the type basket one would most expect to find on a middle Tennessee farm homestead, and is one of the many types found on the Armistead place.

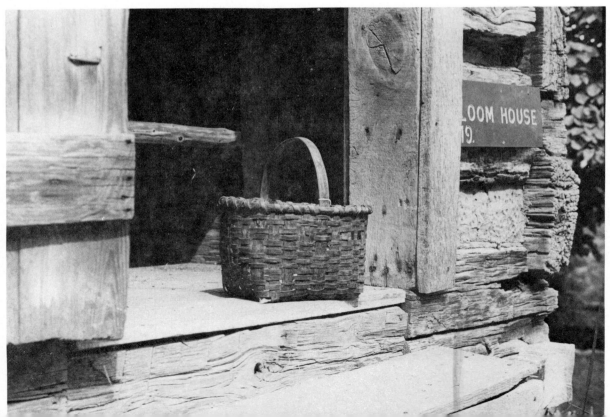

# Chapter 4

# Portraits of the Mountain Basketmakers

In this chapter we take a look into the lives of a number of old-time mountain basketmakers and some not so "old-time" who learned the craft from their forebears. It will be noted that emphasis is placed on the social and community aspects of their lives as well as on their traits relating directly to basketmaking. This is in keeping with the idea of making this a "people" oriented book and not one that is merely technical and craft oriented.

We are most fortunate for a chance to look briefly into the lives of such a varied and interesting group of basketmakers and from a rather wide geographical area. They include some of the very last old time Appalachian basketmakers and they include some younger ones who hopefully will have success in passing to others their ancient craft.

## RUSS AND NANCY ROSE, MOUNTAIN BASKETMAKERS

Although Russ and Nancy Rose have made baskets at the Museum of Appalachia for the past several years having learned the art from Russ's father and grandfather, basketmaking has not been the chief source of livelihood for them. They mainly were tenant farmers or sharecroppers and farm laborers. But they and their kinfolk were the only basketmakers I knew of in the immediate area where I was brought up on Mountain Road only two miles from where the Museum is located. I think their lifestyle, their socio-economic status, and their outlook on life coincides with many of the rural Appalachians who supplemented their income by making baskets.

Although they have never lived more than a few miles from where they were born in the northern part of Anderson County, they have moved continuously from one tenant house to another. Nancy was the daughter of Ike Bumgardner whose family, like the Roses, came into this region in the latter part of the last century from Lee County in southwestern Virginia.

As far as she knows, none of Nancy's family made baskets, but Russ's father, Hirham, or "Harm", made baskets all his life. He lived here in Anderson County, moving every few years or sometimes every few months from one place to another.

I recall visiting him once when I was a lad and when Harm lived at the head of Foust Hollow. It was an extremely cold day and he sat inside his one room abode, cooking a pot of potatoes. He had on an old overcoat and his hat, and he was as close to the tiny stove as he could get. But the front door stood wide open and the blustery wind blew tiny snowflakes throughout the cabin. I asked him if it wouldn't be warmer if he closed the door and he agreed that it probably would, but he never bothered to shut it. He liked the fresh air and he didn't like to be "penned up like a pig".

Russ recalled that his father would carry his baskets over the country trading them for meat, chickens, or other food. If a person had ordered a basket he would often have it delivered by one of his children and the farmer receiving the basket would go to the smokehouse and cut off a piece of middlin' meat as payment. I asked Russ how much meat his father received for a basket.

"Well, it depended on the size of the basket and the kind of meat. But most of the time we jest took whatever they'd give us. Some people would give us more than others."

Russ was exposed to basketmaking, not only by his father, but also by his maternal grandfather, Jess Sanders. "He lived over here behind the mountains from Andersonville in what they called the Irwin Hollow. They wudn't no roads in there, jest a trail. He'd made baskets for people and bottomed chairs

97

and sich as that. Now my Granny Sanders, she 'uz a worker. Kept busy all the time. She was what they called a midwife. Went around the country delivering babies."

"Grandpa, he never put no rib around the top of the rim of his baskets like Pap did. And that's the life of a basket. If you don't put a rib on top, then your splits will break in carrying heavy loads and then your basket is ruint."

Nancy learned to make baskets from watching Hirham. "I never seed nothin' I couldn't do if I set my mind to it", Nancy said. "I reckon Harm learned to make baskets from his daddy, old Uncle Tommy Rose. They said he come into this country from Virginia."

Russ and Nancy spent most of their lives working as farm hands and made few baskets until they were pretty much unable to perform the rigors of a 12-hour work day, forking hay or cutting tobacco. I first knew them when we moved to the old Sam Hill place on the Mountain Road, some seven miles east of Clinton and a mile from the Museum. I was 13 years old at the time and soon started exploring the dark and mysterious woods which lay behind our house. I ventured farther each trip and one day I encountered an opening in the forest and in that clearing stood a tiny board and batten shack which I learned was the home of the Roses.

Russ started working for us on the farm at certain busy times and he sharpened our saws on rainy days. During the winter months I sometimes hired him to skin the fur-bearing animals for me when I was busy with the farm chores and with school. I believe he charged ten cents for skinning a 'possum or a skunk.

They were an honest, hardworking family and they were, I think, typical of so many basketmaking families. They were always on the move from one farm to another, sometimes coming back to the same little shanty where they had lived previously. Nancy recalls one old house where her family lived on three different occasions.

I asked them how many times they had moved since they had been married. They didn't know, but they started counting. Russ started off.

"I's a living back here in the holler on the old Brooks place by myself. I'd lived there seven years before ever we wuz married. Then we got married and lived there for about six months after that."

"Then we moved on up in Hyde Hollar, but we didn't stay long. Our baby died there and she (Nancy) didn't want to stay there anymore. We bought a little scrap of land back of the Millard Ray place down here close to Deep Springs Church on Brushy Valley road and we built us a little log house."

Nancy joined in. "Hit wasn't as big as this here room, the whole thing wasn't. Made out of poles."

"Hit was jest twelve by twelve", Russ said. "Wudn't no more than half as big as this room."

"Well, we never could get a deed to the land, so adder a year or so we moved on over in the river ridges to a little place that belonged to Uncle Bob Smith." (Uncle Bob Smith was sheriff of this county for many years and was doubtless the most colorful lawman this county has ever produced) "We lived thar about three year, then we moved to Dick Hick's down here and we stayed there a while; and then we moved to that old house on Sam Hill's place for a year. Then we moved out just before your Daddy bought it down to Fletch Alley's place where you knowed about— down behind where you all lived. That was in '41. We stayed there for six years and then moved down on R. B.'s (Wallace) place--right across from Glen Alpine schoolhouse. Stayed there six years from '46 to '52.

"From there we went over here on Joe Owen's place in Brushy Valley. We stayed there on Joe's place for two years. Then we went down to the Kennedy place--bought a little piece of land up above the Moore's Gap Church[1] and built a house, but never did get a deed. So we moved down to Wolfe Valley on old man West's place."

Nancy recalled that place especially well. "We stayed thar two year. Stayed thar 'til that big copperhead got in the house with us. I swept about a foot of his tail out from under the wallpaper and he got away. You could see

[1] This picturesque little church now faces I-75, some three miles south of the Norris-Clinton exit and is viewed by millions annually. Before the Interstate it was quite isolated.

him a'crawling around in under that old loose wallpaper. And you could smell him. They smell jest like a cucumber whenever they get mad."

"Well, a few nights later I thought I heered him a'crawlin around overhead. Russ said, 'Oh, go to sleep; they ain't no snake in here' and jest about that time I heered somethin' go 'co-plump!'. I said, 'Lord, Russ, that snake's fell out on the floor'. And it got away sommers thar in the house.

"We killed quite a few right thar in the house. Wanda walked in and set down on the couch and set right next to a big copperhead and hit quiled up there right beside her. Me and Jean wuz on the back porch washing and we grabbed a frog gig and a hoe and run in there, and tried to kill it, and it got away and we turned the couch upside down, but we never did find it. Why I don't know at the snakes we killed right there in the house. I says I'm a gettin' out of here whether Russ goes or not. And we moved from thar down here to Clinton. But we didn't like town and we jest stayed there six months."

Russ continued, "We come up here to Foust Holler and lived in Ike Bumgartner's old place for something like a year."

"Then where to?" I asked.

"Over on the River (Clinch) on the Homer Williams place. We wuz there about two year and then we moved over here on Daugherty's place--over in the field next to the creek."

"How long did you stay there on the Daugherty place? I know I was there a few times when you lived there."

"I guess we's there about seven years", Russ said. "That wuz the best house we ever lived in."

After the Roses left the Daugherty place they moved into a house over on the Knox County line.

"We didn't get all the way moved in when the old man that owned the house come out and run us off", Nancy said. "He said, 'You 'uns ain't got nothin' but a bunch of junk here, and I don't want you in my house'."

It was at this point that the Roses got in touch with me. Nancy said they had all their belongings piled on an old truck and had no place to sleep. I made provisions for them to move into an old log house I owned over in Hinds Creek Valley. They stayed there their usual two years or so, then moved back on the Mountain Road on Roy Bowling's place within two miles of a half a dozen places they had previously lived. And that is where they are living at the present time (1981).

In forty-seven years of married life, Nancy and Russ moved twenty-one times. But they never moved more than a few miles and they are now within two miles of where they started out twenty-one moves ago. They are still making baskets at the Museum when they feel like it and talk with people from all over the world. They have met the President of Twentieth Century Fox, Hollywood producers, several C.B.S. vice-presidents, other actors and actresses such as Patricia Neal, and many other celebrities. But they are totally unimpressed. To them a person is a person and that's that! They enjoy talking and never seem to get tired of meeting new people and answering the same questions over and over.

## THE ROSES MAKE A WHITE OAK BASKET

In the following series of photographs of the Roses one can follow the various steps of basketmaking from the preparation of the material to the finished product. Note that they do not use a wedge, a board break, or a froe in the splitting and riving process, as suggested by Jessie Jones. It will also be noted that they use no flat ribs whatever. (All photographs in this series by Ed Meyer.)

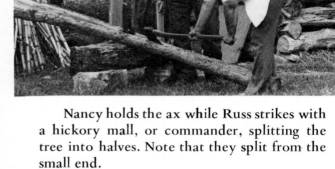

Nancy holds the ax while Russ strikes with a hickory mall, or commander, splitting the tree into halves. Note that they split from the small end.

Russ is shown here with the white oak sapling he has just selected and cut with an ax from the woods at the Museum. It is straight, has no limbs whatever, and is about five inches in diameter at the big end.

Russ pulls while Nancy, who can use the ax as well as he, cuts the splinters.

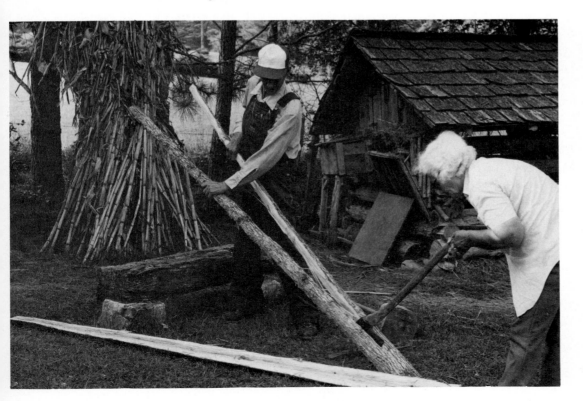

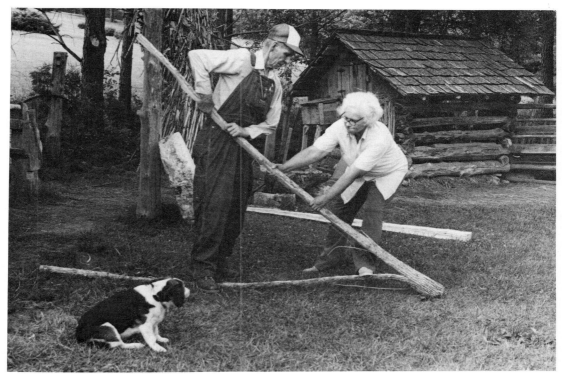

One of the halves is split into quarter sections, requiring all the strength of both Russ and Nancy. The split can be controlled by either pulling the top section, or by pushing down on the bottom section. Freddie observes carefully.

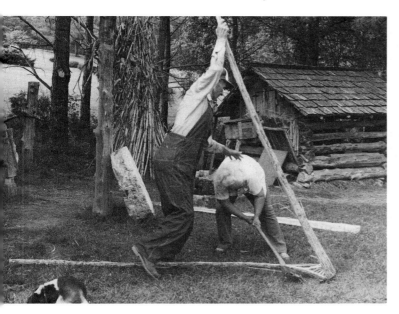

Nancy gives one final blow with the ax and the half section becomes two quarters.

After the heart portion of the quarter is removed, Russ peels off the bark.

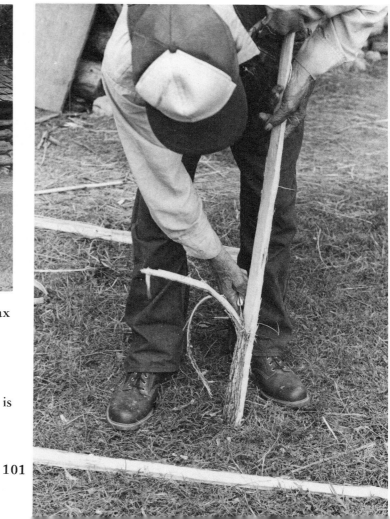

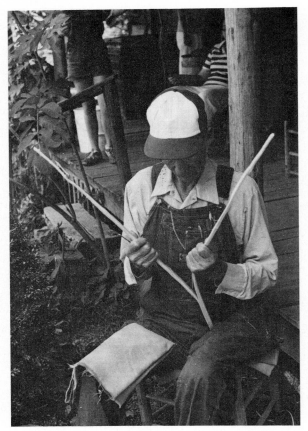

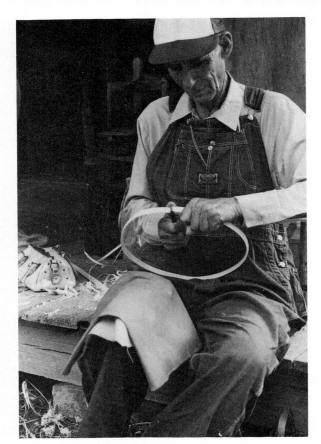

Russ has continued the riving until he has sections sufficiently small to make the basket handle and the rim. In making splits he would split each of these sections twice more. Then he would scrape the splits with his knife until they were paper-thin. If the split in his right hand starts running too thin, he merely holds it steady and pulls the split in his left hand. The split in his right hand will then become thicker as the riving continues.

Russ uses a piece of copper wire to tie the handle hoop. In earlier times a thin, narrow white oak string, or a spun flax or cotton string would likely have been used.

The handle hoop is formed and a notch cut where the two ends will be tied.

The handle hoop and the rim are joined, and the rim-rib is put into place.

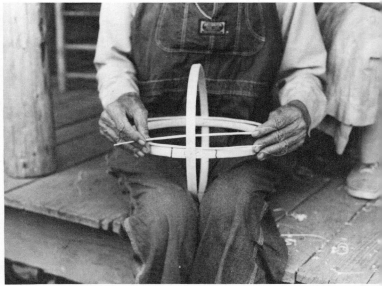

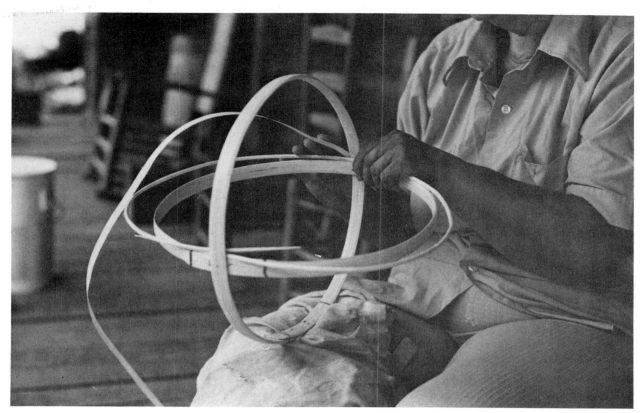

Nancy has taken over and is using a thin
split to tie the handle, the rim, and the rim-
rib together.

Russ makes a rib by holding his knife
stationary and pulling the timber. The pad is
to protect his overalls and his leg.

As Nancy ties the two hoops together with
splits, she inserts her ribs.

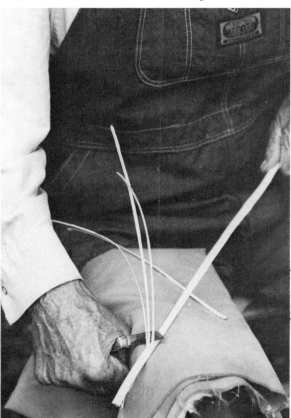

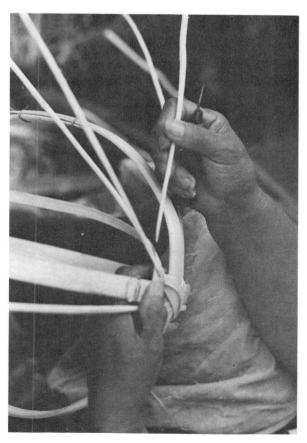

103

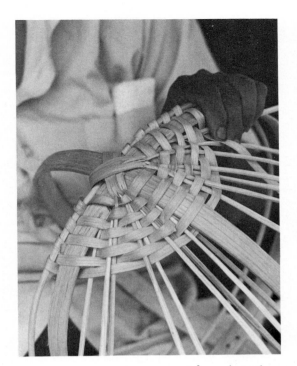 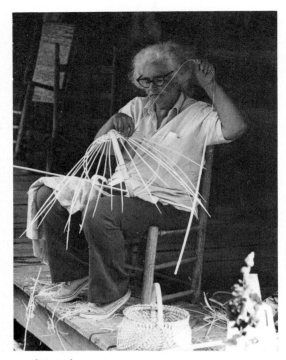

After the ribs are inserted in the weave, they are fully secured before the opposite ends are bent and tied in similar fashion.

After fourteen hours of weaving (on two different days) Nancy is almost completed. The sense of pride, accomplishment, and happiness is expressed in her smile.

"Well, hit's done. Maybe a little bit whopper-jawed, but hit'll last longer than any of you 'uns.

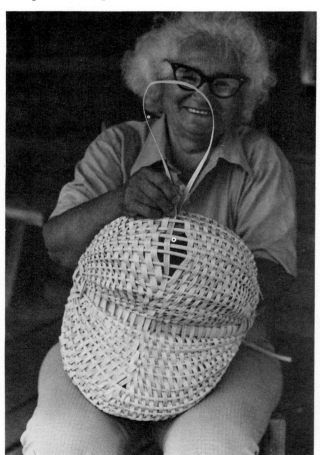 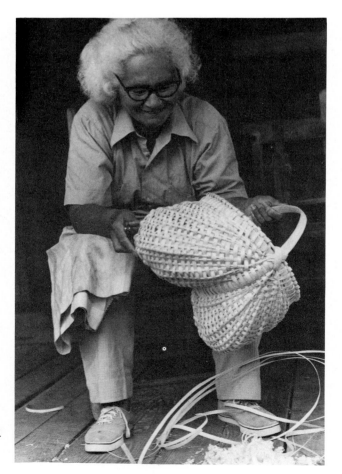

## PURSE BASKET AND WALL HANGING BASKET

The basket at left was made in the Depression by Nancy Rose for her own use as a purse. It has a flat side and the lid is hinged.

The wall hanging basket at right was purchased from the attic of the old L.M. Kennedy place. Since the Roses lived there many years ago, and since the style is similar, I'm sure that it was also made by Nancy. (Photo by Gary Hamilton)

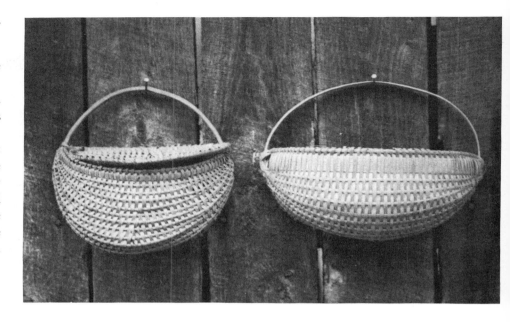

The basket Nancy is shown completing here is much more shallow than her regular baskets--almost flat. I asked her where she acquired the idea for the style, and I got the following answer.

"Well, I's trying to get a basket finished up one day and I's in a big hurry to get it done and I kept having trouble with it. And finally I got so aggravated that I jest throwed the dogged thing down and stomped on it. And adder I got through stompin' it, I picked it up and it was all flattened out and hit looked purdy good, and I says 'Well, I'll jest make some flat ones on that order and see how people like' em'."

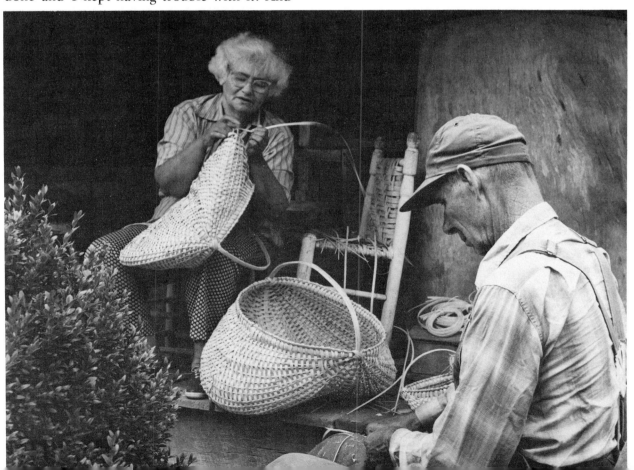

## THE JESS SANDERS BASKETS
### (Anderson County, Tennessee)

Bonnie Irwin Carden of the village of Andersonville is shown here with four baskets made by Jess Sanders for her father, Boss Irwin and his family. The reader will recall that Jess was the grandfather of basketmaker Russ Rose.

Bonnie recalls that the Jess Sanders family lived directly across Lone Mountain from where her father and his family lived. They would walk across the mountain over a winding trail as there was no road of any sort. The women would come to wash for the valley people and Jess would often bring his baskets. (The Sanders women, Bonnie recalls, would take a week's washing from a large family, carry it across the mountain to their home where they washed it, and then they would deliver it for fifty cents or a piece of bacon.)

"We used baskets for just about everything on the farm," Bonnie pointed out. "For gathering eggs and taking them to the store, for carrying corn to the hogs and the horses, as garden baskets, taking nubbins to the cows and so forth." These baskets have slight variations one from another, but their similarity verifies that they were made by the same hands. They are entirely of white oak. (Photo by the author)

## THE WORLD'S LARGEST
## WHITE OAK BASKET

Every time Nancy and Russ finished a basket at the Museum they would ask what size I wanted next. I would always tell them to make whatever size they wanted to, but they would nevertheless wait until we discussed it thoroughly before they would start. On one occasion after Nancy had sent for me several times, I finally got a chance to stop by and I was soon set straight.

"Now you set down here Rice Irwin; you've been a runnin' here and thar like a chicken with hit's head cut off. Now we want to know what kind of a basket you want us to make next. And don't you go wandering off til you decide on something."

Well, I thought I'd put a stop to having to have a consultation every day or so on the

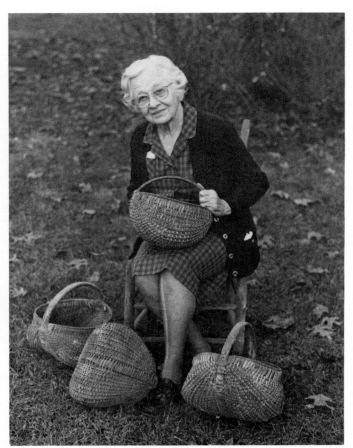

size and shape of the next basket. "I want you to make the world's largest basket", I said. "Make it big enough for me to get inside."

That very day they started and pestered me constantly about finding enough trees to make all the splits. I think they spent half their time answering queries from the tourists about the giant basket. Nancy was, I found out, telling them that she was indeed making it big enough for John Rice to get into, and that she was, "unbeknownst" to me, making a lid for it. "And whenever we get it done, he'll come nosing around and see if he can get inside. And when he crawls in it, I'm aiming to slap that lid down and fasten him up. Maybe that'll take care of some of his grippin' "

All summer long she and Russ worked on the huge basket and all summer she told the tourists, hundreds of them, about her secret plans to lock me inside. But by the time late fall came and the basket was finished, she and Russ were so tired of working on the "world's largest basket" that she gave up her plans for making the lid.

I don't know whether or not it is the world's largest white oak basket, but it is certainly the largest I've seen.

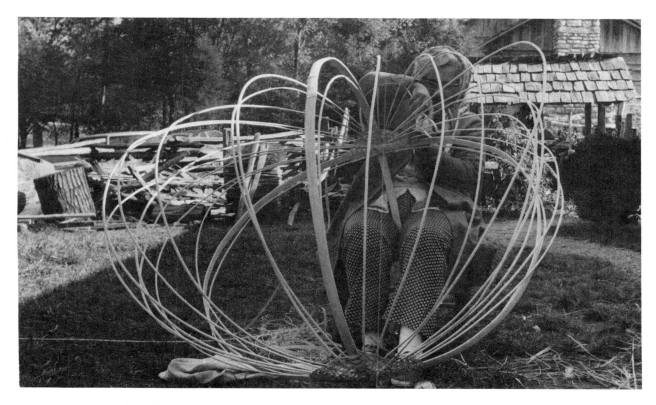

"That's the hatefulest thing ever I seed--
trying to get them ribs put in right and weave
your splits."

"Now adder you once get it a'goin it ain't
so bad", Nancy said. It was so big that she
had to work on it in the yard. She is shown
here in front of the Bunch House.

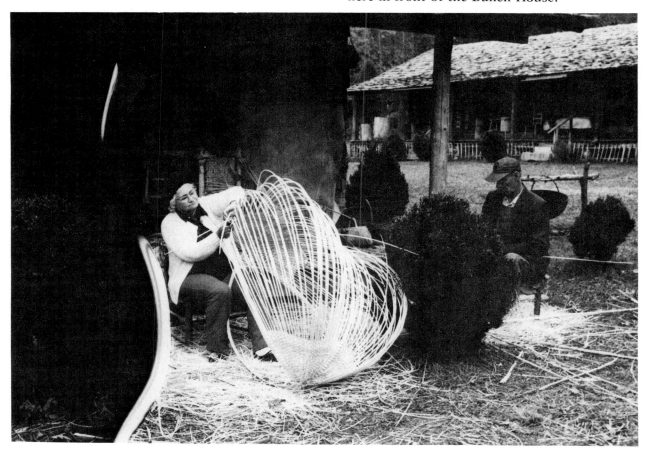

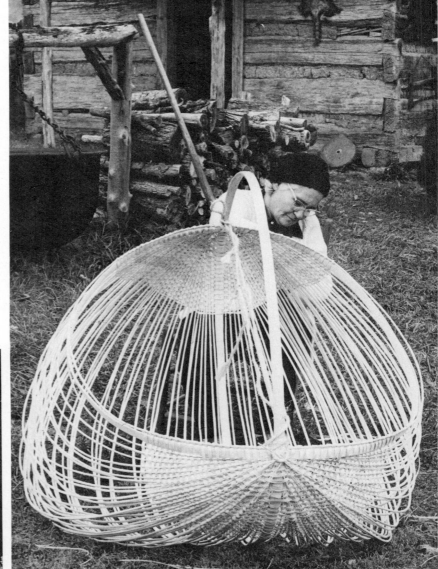

After several days of "wallering around" with it, it started looking like a basket.

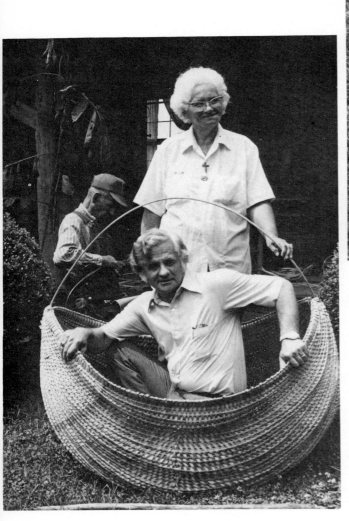

After several months the Roses had indeed made a basket large enough for me to sit inside, as I had jokingly requested. Here "yours truly" sits in the basket, Nancy beams with a confident and self-satisfied smile, and Russ ignores our exchange and quietly starts another basket. (Photo by Joe Adair)

## LULA CANNON, BASKET WOMAN FROM YANCY COUNTY, NORTH CAROLINA

Lula Cannon, a fourth generation mountain basketmaker, is still most active in the practice of her craft. She lives alone in the mountainous section of the extreme western part of North Carolina in Yancy County near the Tennessee border. More specifically, she lives about sixteen miles west of Burnsville in a remote area near Cane River on Dogwood Branch.

Her little house, although modest, is comfortable and is located in a beautiful mountain setting. The day we visited her in 1979 she had potted flowers on the porch and various types of flowering plants planted in her yard and around the house. There had been intermittent rain throughout the day and Lula was working on baskets in her front room. There was basket material everywhere, partially made baskets, and a few which she had completed. As we talked, she continued to work and at a feverish pace; for her basketmaking was no slow, leisurely process. It was a chore to be completed and she had to keep doggedly at it if she were to make a showing. But her talk was as rapid as her work and she recalled with fondness her basketmaking ancestors and her own childhood.

"My daddy's name was William Radford and him and mother had twelve children and I was the fifth child--and I had nine children of my own. When I was a girl it was sixteen miles to the nearest drug store--over in Burnsville. The first time ever I walked it to get medicine for my daddy, I thought I'd never get there and back, across all them mountains and ridges."

I asked her how many baskets she had made.

"Oh, that's an unreasonable question to ask--don't know how many. Made them most of my life--hundreds of them."

Lula, like her ancestors, is an unusually versatile basketmaker, not only from the standpoint of style, but with regard to the materials she uses. She has made baskets using white oak, hickory, broomcorn, bark, cane, honeysuckle, birds eye switches, and even the "dynamite" wire left by the road crew.

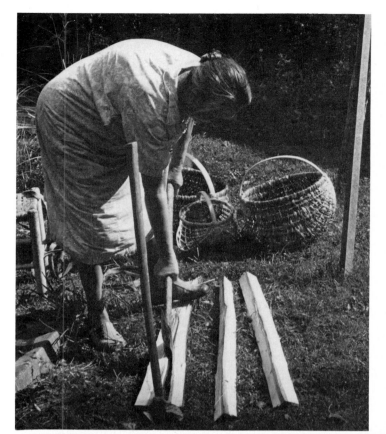

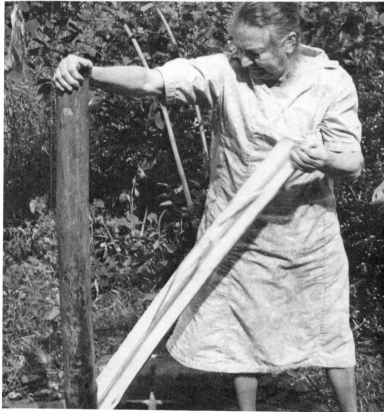

After starting the split with her axes, Lula finishes the clevage of the hickory sapling by hand. (Photo by the author)

"My daddy was a grubbin' (digging sprouts from the pasture field) and he was talking about how strong them little birds eye switches were and I started making baskets from them. Hit really lasts longer than the honeysuckle." Then she took me out back and showed me a large clump of birds eye, long willowy, almost vine-like shoots four or five feet in length.

When I asked if I could get some pictures of her outside preparing the splits, she put her basketweaving down and went to the woodshed where she brought out two pole axes. And before I could get my camera ready, she started flailing away with the two large axes, using one as a pry, and the other with her free hand to split the sapling, as few men of any age could do. She had all the qualities required for a good mountain basketmaker. She had determination and confidence and one gets the idea, as she grabs one ax, then the other, swinging, flailing, beating, jumping from one step to another, that no mere tree could ever subdue her. When riving with the ax got too tedious, she flung it aside, grabbed the timber with both hands and ripped it apart as if it were an attacking animal.

In less than five minutes she had split the tough hickory sapling (to be used as ribs and for the bail) into thin, narrow pieces, ready for refinement with her knife. But Lula has imagination and originality and an eye for simplistic beauty also. I don't think there will be many Lula Cannons coming on.

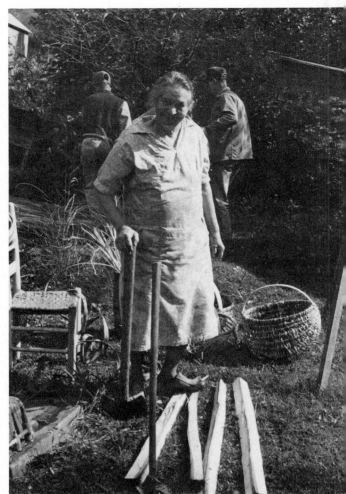

After starting the split, always from the small end, Lula finishes the process with the double-bitted ax. In the top right photograph she observes, with a faint smile, the tough hickory which she has rendered into quarters. In the bottom photograph she removes the heart, which is tough and stringy and not satisfactory for making handles, rims, or ribs. (Photo by the author)

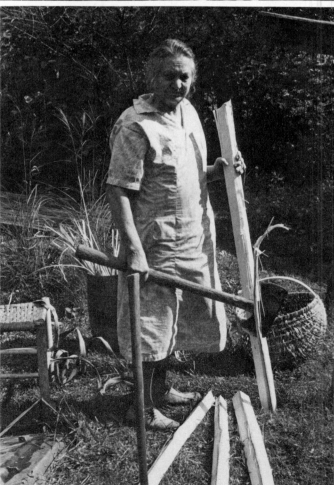

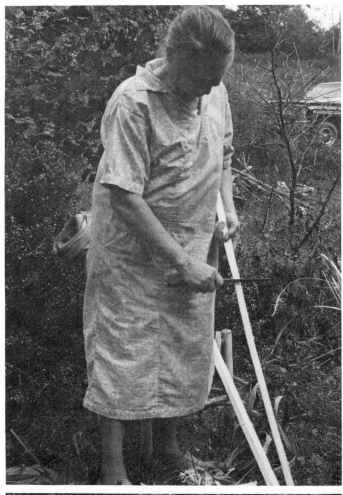

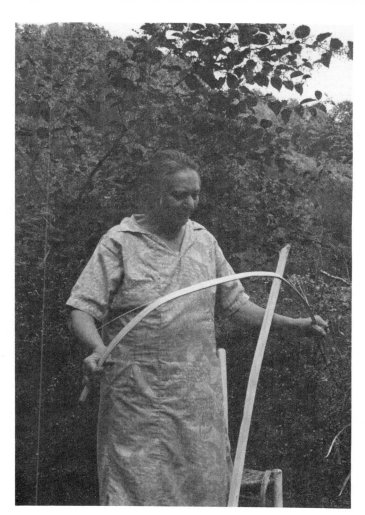

After riving the timber into eights, then sixteenths, using only a knife and her hands, Lula uses a butcher knife to scrape smooth the split to be used as a basket handle or bail. She is the only person I know of who uses a butcher knife, rather than a pocket knife for this purpose. In the photo at right she is bending the quarter-inch thick split into a circular shape to be used either as the horizontal rim or as the handle-bottom rim combination. (Photo by the author)

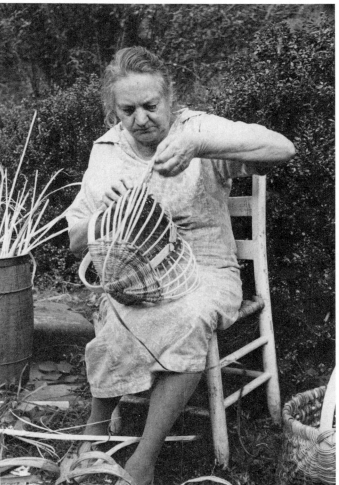

The intentness of Lula's expression indicates the need for concentration in making a basket. Here she has used hickory for the ribs, handle and rim, and honeysuckle vine as the starting weavers. She then switched to white oak splits for the main body of the basket. (Photo by the author)

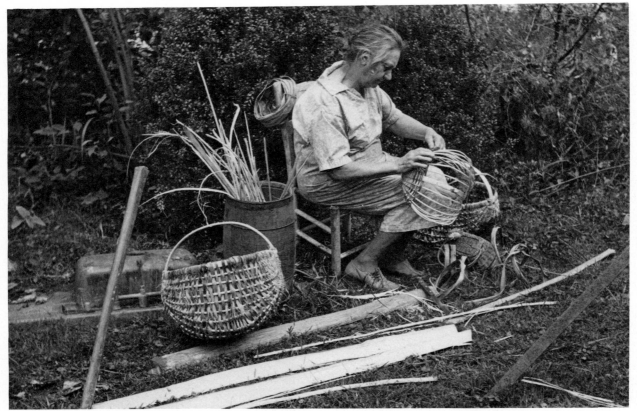

With an ax and a knife as her only working tools, Lula makes baskets from a half dozen different materials at her North Carolina mountain home. The completed basket, as well as the one she is making, is of hickory bark and honeysuckle.

╫╫╫╫╫╫╫╫╫╫╫╫╫╫╫╫╫╫╫╫╫

Lula's capacity for imaginativeness in making baskets has already been demonstrated relative to the various natural materials she has used--hickory bark, honeysuckle, willow, birds eye switches, and white oak. And when the road builders finished their blasting and left pieces of the ignition wire, she gathered them up; and what else would one do with such scraps but make them into a basket? She even used the different colors of the wire to create a pattern. (Photo by Ed Meyer)

## BARK AND VINE BASKET

"My husband asked me one day how come I didn't make a basket out of bark", Lula recalled. "So I started makin' one once in a while out uv hickory bark." This one has the ends made from honeysuckle vine and the rim, the ribs, and the handle are all made from hickory. (Photo by the author)

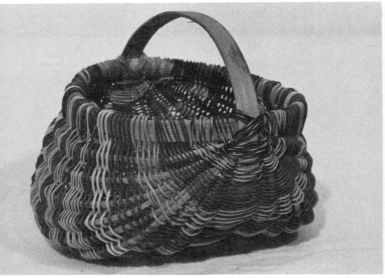

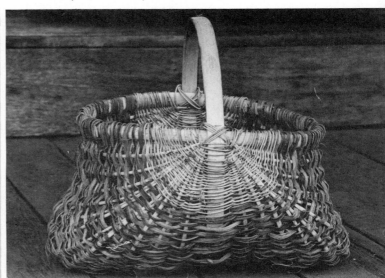

## JESSIE JONES, THE LAST OF THE
## OLD TIME BASKETMAKERS

To my knowledge Jessie Jones is the only living old time mountain basketmaker who has continued uninterrupted this subtle art which he learned as a child. Some traditional basketmakers have resumed the craft after many years' respite, and after the new interest in baskets developed. But Jessie never stopped— slowed down a bit--but never stopped altogether.

By way of an introduction, I would provide the reader with a little information relative to Jessie Jones and his home on the Hancock County, Tennessee and Scott County, Virginia line. Hancock County perhaps is best known as being the home of the Melungeons, a group of people who, according to early Tennessee historians, were living there on Newman's Ridge when the first white settlers arrived, and whose origin has never been determined. Hancock County also is known as an isolated mountainous county in East Tennessee, lying on the Virginia border. Recently, U. S. Senator Jim Sasser's office called me and asked for suggestions as to how they could help Hancock County since they had learned that the United States government had statistically rated it as the third poorest county in America.

I have spent twenty years traveling in, through, and about the county and found little dire poverty. The people are warm, friendly, and generally live on small farms and are better off economically than most urban dwellers, though their financial income may be very low, explaining the government's poverty rating. I had always heard of a place in the northeastern section of the county which was often described as the most isolated section of the state. It was hemmed in by the unbridged Clinch River on one side and by rugged mountains on the other. The river and the mountains ran parallel with one another, getting closer and closer together until the rugged mountain cliffs finally thrust themselves to the very water's edge, making it impossible to travel down the valleys and hollows beyond this point. In order to get out of the area it was necessary to travel northeast for

many miles into Virginia and then make a circuitous route through Virginia in order to get to Sneedville, Tennessee, the county seat.

This is the home of Jessie and Bertha Jones. Both Jessie and Bertha are as kind, gracious, and friendly as any couple you could hope to meet. Although their small farm is largely hilly and extremely rocky, they have a most comfortable little home, a large cattle and tobacco barn, and a number of smaller buildings, such as the smokehouse, woodshed, garage, and chicken house.

Their homestead is in a quiet and beautiful setting and there is no other home in view of their place. They continue to grow most of their food and know how to live almost completely off the land, the forest, and the nearby river.

Kyle and Dora Bowlin, my long-time friends from Hancock County and leaders in efforts to revive and perpetuate the traditional crafts and mountain lifestyles of the area, first introduced me to the Joneses several years ago. Since that time, I have visited with them several times and they, in turn, visited the Museum.

I asked Jessie where he learned to make baskets. "From my Daddy, and he learned it from his Daddy. Grandpa Jones made 'em, and I suppose his Daddy before him."

"Where were your people from?", I asked.

"North Carolina, part of them. Grandma was from North Carolina. I don't know where Grandpa was from. That's something I can't tell you. Grandma was from North Carolina-- she was a Vansaint. Someone here lately studying the family says they came from Holland. I don't know--and I don't know whether they know or not."

Jessie pointed out that his mother did most of the weaving of baskets, and that his father was responsible for getting the timber.

"When Daddy did make a basket there was nothing shoddy about it. He'd put six or seven big baskets on a rope and carry them over the country and sell them for, I believe, about 60 cents or 75 cents a basket, for people

to feed in. People used to buy them to carry corn from their cribs to their stock and their hogs. And Grandpa Jones, I've heard it said, made a shuck basket (meaning a basket for carrying shucks) for someone and it was so big that he had to put one of the kids down inside it to push the splits back through because it was so big he couldn't reach around it. That's what they said and I guess it was so."

The admiration and respect which I have developed for the Joneses is apparently shared by all who know them. I recently spent a couple of hours with Charlie and Eva Cox, lifelong neighbors and friends of the Jones family. We were in the Cox barn while they were grading tobacco, and when the name of Jessie Jones came up, both Charlie and Eva Cox started talking at the same time. Eva said, "Jessie's daddy, Enoch Jones, was one of the best old men that ever lived."

Charlie remembered when he operated a country store and bought baskets from Enoch Jones and from Jessie's granddaddy as well. Charlie told me the following story about Jessie's father, Enoch.

"Me and my sister was a comin' down the road away in the night--we'd been to something to do over in Robinette Valley. I had an old T-Model Ford car and we met old Enoch coming up the road there in the middle of the night. And the road was knee-deep with mud, and Enoch was headin' for Clinchport (Va.) over eight miles away to get the doctor for his boy, Charlie, who he thought was about to die. I said, 'Enoch, why didn't you stop and get one of my Daddy's horses out of the barn?' And he said, 'Well, I didn't have the money to pay him.' And I said, 'You wouldn't have had to pay nothing.'

"Well, I made him get in the car and we went and got the doctor and he spent the night there with his boy, Charlie, and he got better. And the next morning I took the doctor back to Clinchport. And Enoch jest went on because he didn't have any money to pay me, and I said. 'You don't owe me any money.'

"He never did forget that as long as he lived. Well, I guess it did save the boy's life."

In the following pages is Jessie's own explanation of how to make a basket. It was written by Jessie in longhand and illustrated by his own drawings. Again, he is the only old-time basketmaker I've known of to put in writing the detailed description of the entire process. Many writers have explained the various steps; but it was information acquired from another person, or at best information acquired by a person learning the art. Jessie's manner of presenting the rather long and somewhat complex procedure is done with clarity and completeness and should be a source of careful study for those who would learn the art. It will hopefully give insight into and appreciation for the old time mountain basketmakers of Southern Appalachia, not only for those interested in baskets, but for those interested in the people of our region as well.

## WHITE OAK RIB-TYPE SPLIT BASKETS OF THE APPALACHIANS
### by: Jessie Jones

*I am the third generation of basket makers that I know of. Probably further back that I do not know of. This work of the art of basket making is fast disappearing among our young generation of people. In this small Book, I am trying to tell how to start from the bush to making a Basket. Basket making is a fascinating work, and one to be proud of.*

*It requires very little more work to make a nice Basket than one that is rough and of poor quality. Take a little more time and do it right, Put Pride in your work and make a good quality product. A basket if taken care of and kept in the dry will last from one generation to another. How many hundred of years a good Basket will last I do not know.*

*Just think, go to the forest, select and cut a bush, from this bush make several of the most beautiful baskets, just using an ax some wedges, a mall and a froe and a pocket knife, and your hands.*

*I sincerely hope our young people does not let this work of art be forgotten.*

*It is not difficult to make a basket.*

*Just follow the rules on the following pages, and in a short time I think you can learn to make a basket.*

*Tools needed to make a Basket.*

*You will need a single bit, or Pole ax as this type of ax is used for cutting down the bush also for splitting out the bush for various parts of a basket.*

*Also you will need a metal wedge or two hardwood wedges. A froe is one of the best tools to use in splitting out the bolts of wood for the different parts of a basket.*

*A board break is awful good to have in using the froe, to make a board break, get a forked bush about six inches through, the forked end should not be spread too wide apart.*

*To set up a board break, put the non-forked end about eighteen inches above the ground, use two poles three or four inches through, about six feet long. Raise the forked end of the break up, run one pole over the fork next to you and under the one away from you.*

*Now use the other pole, put it over the forked end of the break away from you and under the end of the break next to you. Now fasten down the non-forked end of the break down by using a heavy weight on it, and you are ready to go to work.*

*After you have split the bush into eight parts is when you need to use the froe and board break. Fur such as taking out the heart-wood, splitting the red wood and white wood apart, also to split the different widths of wood into bolts for basketmaking.*

### SELECTING BASKET WOOD

*Go to the forest where soil is fairly good. Avoid poor gravely spurs.*

*You are looking for a white oak bush from four to about seven inches through. One that does not have any knots or limbs or twigs on the part to be used. This is only about five to six feet above the ground.*

*The bark should run straight up and down the bush, do not get a bush that the bark twists around the bush, or one that has swell places around the bush. Try to get a bush that has fairly flat scaley bark and a kind of yellow color. Do not get a bush that has coarse bark, such as a tan oak, also do not select one with a real flat white bark, these bushes usually are of poor quality. You will get only one log from a bush, this is usually five to six feet long.*

*Cut the bush near the ground, be careful not to bust or crack the bush, as this will damage it very much, be sure to not cut into the part to be used, you can also damage it by draping the log on a sharp rock.*

### SPLITTING OUT THE WOOD FOR THE BASKET

*First split the log into two halves. Then split the halves into quarters. Then split a quarter open into one eighth pieces, all these splits are from heart of log to bark. This is called splitting board fashion. Make all splits as near the center of each piece of wood as possible.*

*Now is where you begin to use the froe and board break to control the splitting of each piece of wood.*

*Take a one eighth piece of wood, set the froe one inch to two inches from the heart, or sharp edge of wood, strike the froe with a wood mallet (never use a metal hammer on a froe as this will quickly ruin a froe), split out the heart wood by prizing on the froe handle, with the board break holding the piece of wood, another rule in taking out the heart wood is to leave about as much red wood as there is white wood. Now set the froe between the white wood and the red wood and split open, following between the white wood and red wood.*

*These last two splits are known as bastard or grain wise splits, in other words, the way the bark lays on the bush. All ways split the wood board fashion to get the thickness you want for different parts of a basket, split bastard or grainwise this is the only way the wood will bend true, after whittling down the parts of wood to the right thickness, bend it toward the bark side of wood, it bends much better this way.*

*First, let's split out a pair of hoops for a basket that holds near one half of a bushel. Bolt out about one and a half to one and three quarters of an inch wide. Then using the white wood, split open in center, bastard ways, or you can use the red wood that was taken from the white wood and split open bastard ways for hoops. The finished hoops should be near one quarter of an inch thick by near one and a half inch wide.*

*For a half bushel basket the hoop wood must be about fifty to fifty one inches long.*

There is four different parts (or bolts) used in making a basket; namely: the hoops, the flat ribs, the round ribs, and the splits.

Now for the first ribs, they should be near the width of the hoops. Split these down near one eighth of an inch thick. Split bastard ways for thickness. The flat ribs need be thirty inches long.

After splitting the hoops and flat ribs to the desired thickness, whittle down to remove all splinters and rough places. Sharpen one end, beginning back from end about twelve inches, sharpen to a sharp point, also bevel the edges to prevent tearing up of the splits as you lace them in the basket.

For the round ribs, use red wood only. This split down to pieces about three-eighths of an inch square. And whittle down about the size of a lead pencil, as near round as possible. Sharpen one end to a sharp point, taper back six or eight inches from end.

After you have whittled down a pair of hoops to the right size, begin back eight inches from each end and taper down to a little less one eighth of an inch thick at the end of the hoop. Be sure this is done flat ways. Do not taper the edges of the hoops. These tapered ends are for lapping the hoops together for nailing to hold the desired size of the hoops.

MAKING THE SPLITS

First let me say, when you get a bush that will make splits, use the white wood of this bush for making splits only, as not many bushes will make good splits. And the white wood is the only part of a bush that will make splits.

No one can make the splits if the bush does not split real good.

The split bolts should be five to six feet long. Do not try to remove the red wood from split bolts more than an inch wide, as you will damage the white wood of the split bolts.

Split the split bolts down to about one half of an inch wide, then whittle off each side. Remember: Board fashion--to about three eighths of an inch wide. Keep as near the same width as possible all the way through. Remove the bark before you split the white wood from the red wood. Be careful not to cut into the wood when removing the bark.

Now take the finished split bolt, set your knife in the center of the small end of the bolt. Be sure to do this Bastard or grain ways, as this is the only way you can split out splits. Split the end down far enough so you can pull the wood apart with your hands. Always split as near the center as possible just keep splitting in the center each time. You should get sixteen splits from each bolt.

After you get the splits down as thin as you can, lay a piece of heavy tightly woven cloth on your knee, lay the split on the cloth, set a sharp knife blade near straight up and down, hold the knife still, pull the split towards you, scrape both sides of the split to remove all splinters, also scrape the split down to the right thickness. Use the same method for all whittling out basket wood, except turn the cutting edge of the Knife forward.

Catch a split between your thumb and two fingers. Pull the split through your hold, it is easy to find any thick spots this way.

Scrape the splits down until they are very flexible. You seldom get one too thin.

You can Keep splits for years before working them into a basket. Just wet them for a little while before useing them and they are all right.      Other parts of a basket should be fairly well seasoned before using, as this makes a much better basket. Do all of the wood splitting and whittling while the wood is green, or not seasoned. As seasoned wood will not split to do any good.

You can keep basket wood for a long time if you will Keep it in water to prevent it from drying out. A word on bending a set of hoops. After you have them finished, bend around your knee, bending towards the bark side of the wood. If they do not bend true, bend the thick, flat places some more. You will finally get them right.

Work each end of Basket **exactly** alike.

In Baskets I have three length of hoops that I use most. They are (1) 50 inches long, lap 8 inches. (2) 44 inches long, lap 8 inches. (3) 40 inches long, lap 7 inches. For smaller Baskets make the hoops shorter.

First make the handle hoop, this will be the outside hoop, (as in sketch 5 in sketch section,) now make the Rim hoop to fit tight inside the handle hoop when crossed at Right angles.

Make the bottom half near one inch deeper than the top half. Place the Rim hoop in place, mark for center, now take a split measure one half of hoop from mark to mark. Now measure the other half. Any difference must be halved, so the Rim hoop is the same on each side of the handle hoop. See sketch 4. A basket has no ends, but I will call where hoops cross the ends.

First put one end of a long split in between the handle hoop and Rim hoop, near the bottom edge of Rim hoop, on the right side of the handle hoop, bend to left over outside of the bottom hoop, now across this hoop, now inside and up of the Rim hoop. Now out and across handle hoop, now down and inside of Rim hoop and out and over where you started go around the hoops once more. You can run the split up under the Wrap-around split just to hold it until you put in the first set of Ribs. (as in sketch 6.)

Now put one end of a round Rib between the wrap-around split and handle loop in side of the handle hoop, first bend the Rib in shape of Rim hoop. Measure around one side of Rim hoop, to across handle hoop, cut off and shape the end, put in place and tie at center of Rim hoop. Do other side same way. Now put one end of a flat rib up beside the handle hoop outside the Rim hoop, under the wrap-around split, as shown in sketch 6. Now put one flat Rib on the other side of the bottom hoop. This makes four (4) ribs in place two Round and two flat Ribs. Now you are ready to work them out as in sketch 7. Pull the split from under where you run it for holding. Turn the Basket Bottom side up, hold it between your knees (so you will have both hands to work with) do not unwrap any of the split, tie the flat Ribs to bottom center of the bottom hoop, leave a one eighth inch crack between ribs and hoop. Then tie each Rib you put in to the one already in place, leave same size space between Ribs. Now to start working out the first set of Ribs, with Basket bottom side up, Bring the split over the flat Rib, now through inside the bottom hoop, now out and over the other flat Rib. Now inside of Rim hoop and between Round Rib and Rim hoop, Be sure to go around the Round Rib once. Then go back across to other Rim hoop, then back once more to other

Rim hoop, the splits must run just opposite each other, not side by side. See sketch 7.

Now you are ready for two (2) more flat Ribs on each side of the Basket this making four (4) flat Ribs for the second set. After each work out always add four ribs, two (2) on each side.

Everytime you add Ribs the ends must exactly follow the last Ribs you have worked out. The ends of the second set of flat Ribs does not go above the top edge of the Rim hoop.

Pull the splits fairly tight and keep the edges close to each other at all times. Seven (7) flat Ribs on each side of the basket are usually enough flat Ribs. Six (6) Round ribs usually fills out the space from the flat Ribs up to the Rim hoop. The Round Ribs go in and work out same as the flat Ribs. You will probably have to work more between each set of Round Ribs than you did in the flat Ribs. The splits will fill up on Center of the Rim hoop and at the Center of the bottom of the basket first, then you must turn in the Ribs to fill up the spaces on each side.

Making a basket is no puzzle, not near as hard as you might think, just study this "Book" and follow directions accurately. The more you make the better you will do. Experience is a wonderful teacher. Do your work good from start to finish, have a neat Basket, I'm sure you will be glad you did.

# Drawings by basketmaker Jessie Jones

### Sketch 1

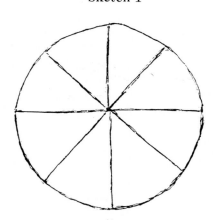

*This sketch shows how to split a log in eight pieces. These splits are board fashion.*

### Sketch 2

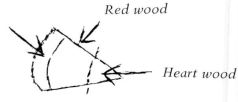

White wood from solid line to bark.

Red wood

Heart wood

*This sketch shows a one-eighth piece of wood. Take heart out at dotted line, then split in half board fashion. Now work into bolts for different parts of a basket. When you have split the red and white wood down to two (2) inches or less, board fashion, then split the white and red wood apart. Split as near as possible between white and red wood.*

### Sketch 3

Part 1

8 ins.          Part 2          8 ins.

Part one of this sketch shows where to make the holes for nailing a hoop together. Drive first nail four inches from the end of hoop.

Part two shows the ends tapered eight inches for the lap. Taper flat ways; do not cut the ends narrow as shown in part one.

### Sketch 4

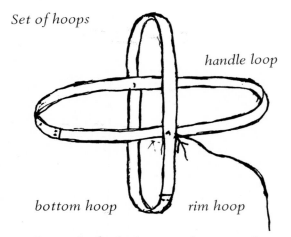

Set of hoops

handle loop

bottom hoop          rim hoop

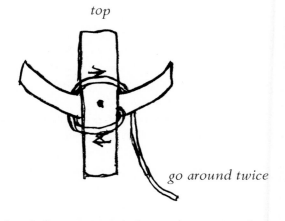

top

go around twice

Put end of split between hoops as shown by arrow; bend to left over outside hoop, up inside of rim hoop, across and outside of handle hoop, down inside of rim hoop out and around once more. Each end alike. Now ready for first set of ribs.

### Sketch 5

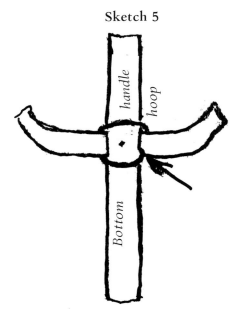

This shows at point of arrow is where to start the split between the hoops. Go around twice.

### Sketch 6

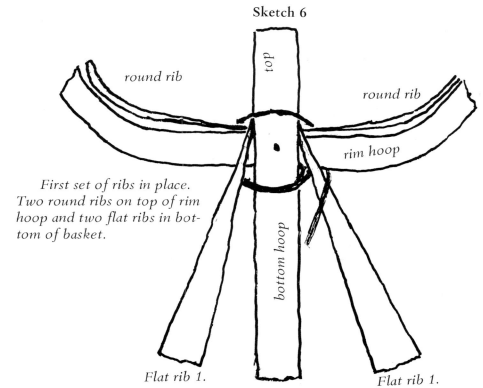

First set of ribs in place. Two round ribs on top of rim hoop and two flat ribs in bottom of basket.

This first set of ribs between the wrap-around split and rim hoop beside of the handle hoop. Do not go under the wrap-around split on bottom of rim hoop. Work each end of the basket exactly alike.

### Sketch 7

Start at circle and go as arrows show.

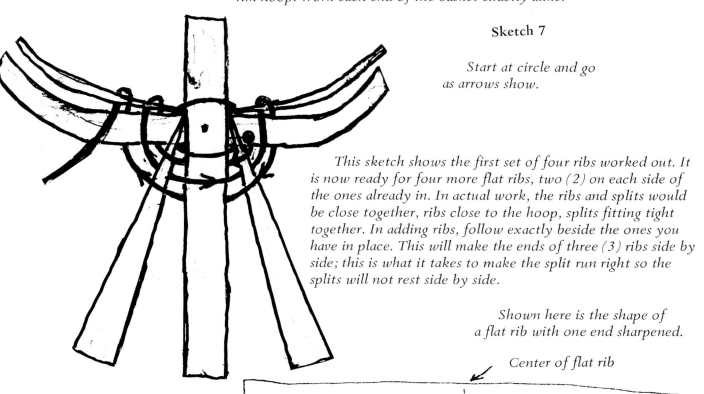

This sketch shows the first set of four ribs worked out. It is now ready for four more flat ribs, two (2) on each side of the ones already in. In actual work, the ribs and splits would be close together, ribs close to the hoop, splits fitting tight together. In adding ribs, follow exactly beside the ones you have in place. This will make the ends of three (3) ribs side by side; this is what it takes to make the split run right so the splits will not rest side by side.

Shown here is the shape of a flat rib with one end sharpened.

**Sketch 8**

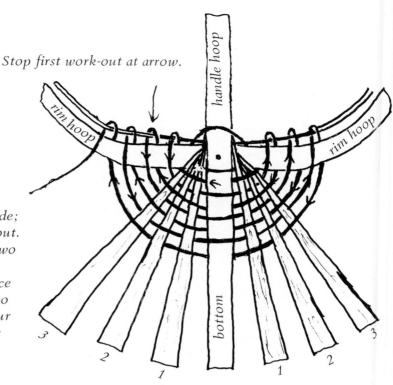

*Stop first work-out at arrow.*

*This shows ribs two and three on each side; these are the second set of flat ribs worked out. You are now ready for four more flat ribs, two on each side. Go directly beside ribs No. 3. Add four ribs each time you work out. Notice ribs No. 1 use only one on each side. The two round ribs on top of the rim hoop makes four in the first set. Seven flat ribs on each side is enough.*

**Sketch 9**

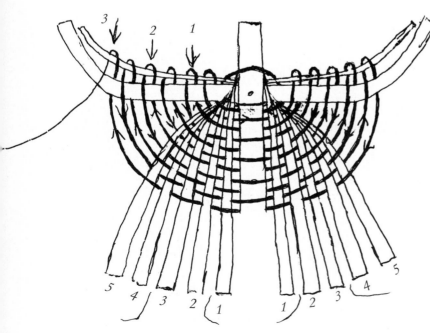

*This sketch shows a basket worked out to the third set of ribs, which is 4 and 5.*

*Rib No. 1 on each side of bottom hoop, plus the two round ribs on top of the rim hoop are set No. 1.*

*Flat ribs No. 2 and 3 on each side of the bottom are set No. 2.*

*Ribs No. 4 and 5 on each side are set No. 3.*

*Four more flat ribs, two (2) each side will be enough flat ribs.*

*Then fill up to the rim hoop with round ribs. This usually takes six to each side.*

*Work to arrow No. 1 in first set of ribs.*

*Work to arrow No. 2 in second set of ribs.*

*Work to arrow No. 3 in third set of ribs.*

## JESSIE JONES MAKES A BASKET

It was a gloomy afternoon in October 1980 when my photographer friend from Kingsport, Ken Murray, and I stopped by to see Jessie at his home in Dry Valley. We told him that we were interested in photographing the various steps of basketmaking; and he was happy to oblige. He grabbed a bunch of splits he had on hand and said, "Let's go down to the barn and we'll see what we can do." (This series of photographs of Jessie was made by Ken Murray.)

Jessie is shown here taking his basket material from his house to his barn-like workshop, which is on the opposite side of the road from his house.

This is Jessie's combination corn crib and stovewood shed and the place he uses to make his baskets.

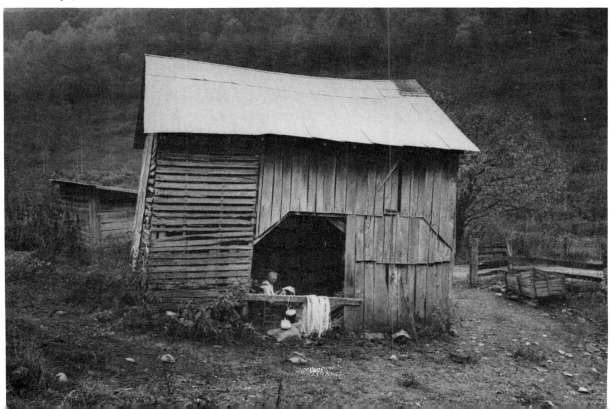

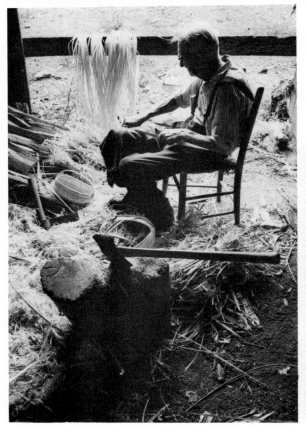

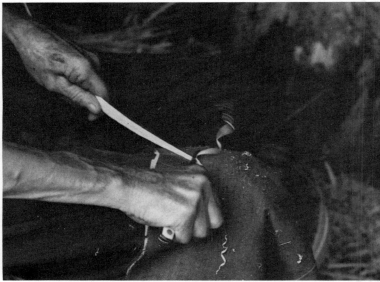

In these two photographs Jessie is shown making the first flat rib. The string-like material hanging in the background is white oak splits ready for weaving.

┼┼┼┼┼┼┼┼┼┼┼┼┼┼┼┼┼┼┼┼┼┼┼┼┼┼┼┼┼┼┼┼┼

The ribs are flat, an eighth of an inch thick, and pointed on both ends.

The first split is inserted at the point where the rim-band and the handle-band join.

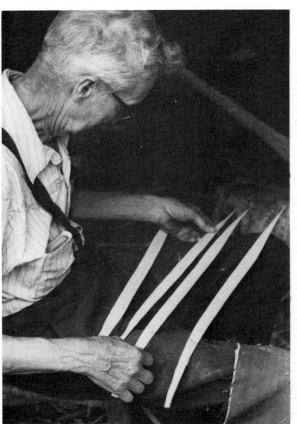

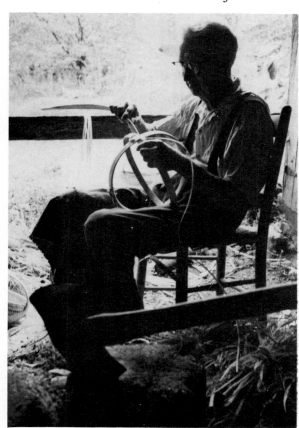

122

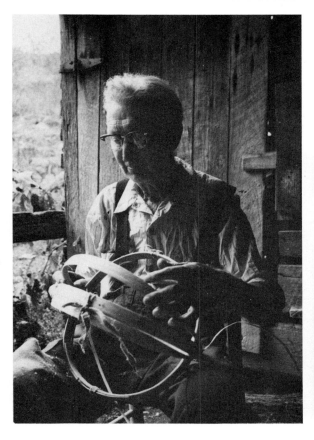

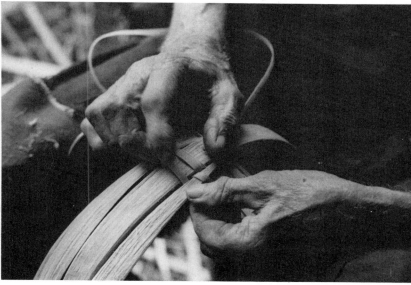

The first rib has been tied temporarily with a piece of cloth and the second one put into place.

After placing a flat rib on each side of the hoop, the weaving with the thin splits is started.

A total of six flat ribs have been inserted...

...and the weaving continues.

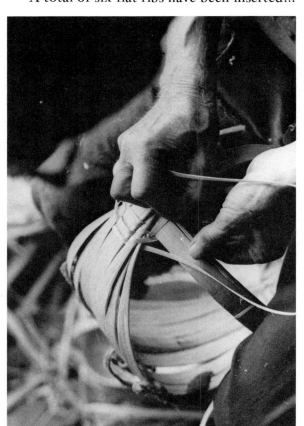

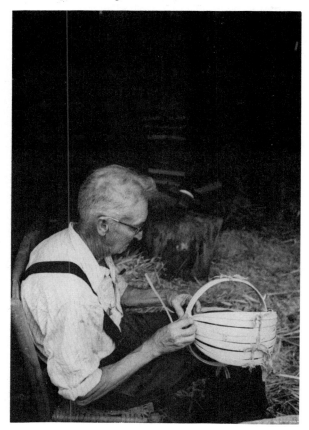

Jessie pauses briefly to explain to the writer his unusual basketmaking technique.

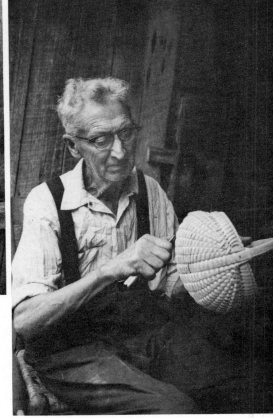

Jessie uses his pocket knife to cut the hair-like wooden strings from the basket before putting it down.

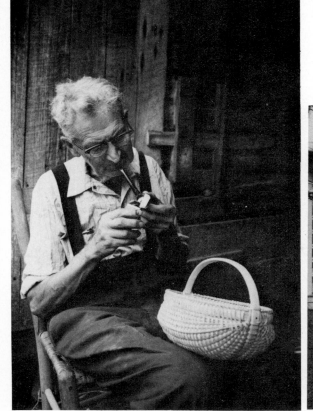

After several fast and uninterrupted hours of work, Jessie has finished a masterpiece and he lights his pipe for a well-deserved smoke.

Jessie enters his front gate to his modest but comfortable house which he built soon after he and Bertha were married in 1929. Bertha is shown sitting on the porch.

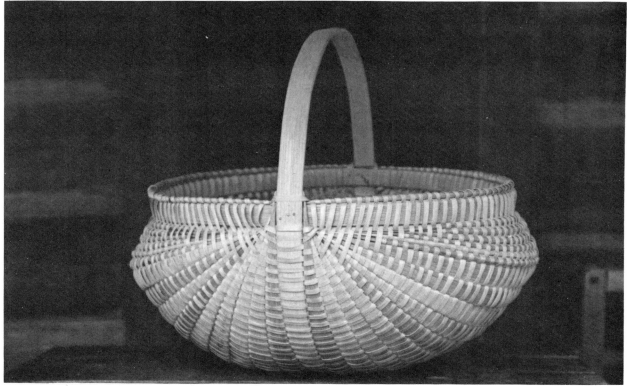

Bertha, too, is a basketmaker. She is holding some extraordinarily small baskets which she made similar to her cherished engagement basket.

This is a good example of Jessie's bushel baskets. It is a work of art in addition to being a servicable container which, with proper care, would last for generations. (Photo by Ed Meyer)

## THE ENGAGEMENT BASKET

Bertha Jones still has the little engagement basket which Jessie blushingly gave her over half a century ago. And it sits on a shelf in her living room, a daily reminder of the beginning of their happy life together in the mountains of Appalachia.

Bertha tells the story while Jessie's expression alternates between one of pensiveness to one of an embarrassed grin. One should not conclude that basket giving, or the presenting of any gift was a customary way of proposing marriage in this region. It was, in this instance, something that Jessie just "thought up". What this story does is to illustrate the individuality and imagination of the mountain folk. Bertha told me the story as we sat on the front porch of their modest home in the late afternoon of a cool autumn day.

"Jessie was living down close to Flat Rock. You go down there close to the river and then up to the fourth hollow. And I lived up this first hollow and we's a datin' and he'd walk to church. Then he'd walk me back home on Saturday night; then he'd walk back on Sun-

day morning. He done all the walking. (laughter) He carried the basket to church, Grit Hill, one Saturday night and I didn't know he had it 'til we got right up thar in the curve of the road and he come out of his pocket with that basket and handed it to me and said, 'Here take this old basket, I'm getting tired of carrying it.' That was in 1929."

The following poem, "The Basketmaker" was written in 1974 by Jim Champion, a friend of the Joneses. He does well in succinctly and poetically telling this interesting and touching story of Jessie and Bertha Jones and their engagement basket.

### THE BASKET MAKER
#### by Jim Champion 6-25-74

He searched the forest for the wood
To shape the rib and cane.
   Then straight and true he split each piece
To form the baskets frame.

He set each rib and wove each cane
With eye and hand so true.
   His skillful fingers placed each piece.
The basket slowly grew.

Finally complete it stood,
Sheer beauty, Oh so rare.
   The nature of the gentle man
And all his skill was there.

He loved a maid, a lovely lass,
And wooed her as youth should.
   Then presented her his master-piece
This basket made of wood.

Because he prized this work of art,
Yet gave it to this maid,
   She knew his love for her was true.
So then a match was made.

Now many years together show
Their love was not misplaced.
   That lovely basket on a shelf
Still holds their love encased.

The basket maker now has aged
Yet slowly plys his trade.
   Each basket that he weaves
Is still the finest made.

(Dedicated to Jessie and Bertha Jones)

### JESSIE JONES' RADIATOR BASKET
#### (Hancock County, Tennessee)

Although the ribs in this basket are the same as in other baskets Jessie Jones makes, the splits are made from the copper strips from the radiator of a T-model Ford. This typifies the ingenuity and the parsimony of Jessie and of the true mountain folk in general. (Photo by Gary Hamilton)

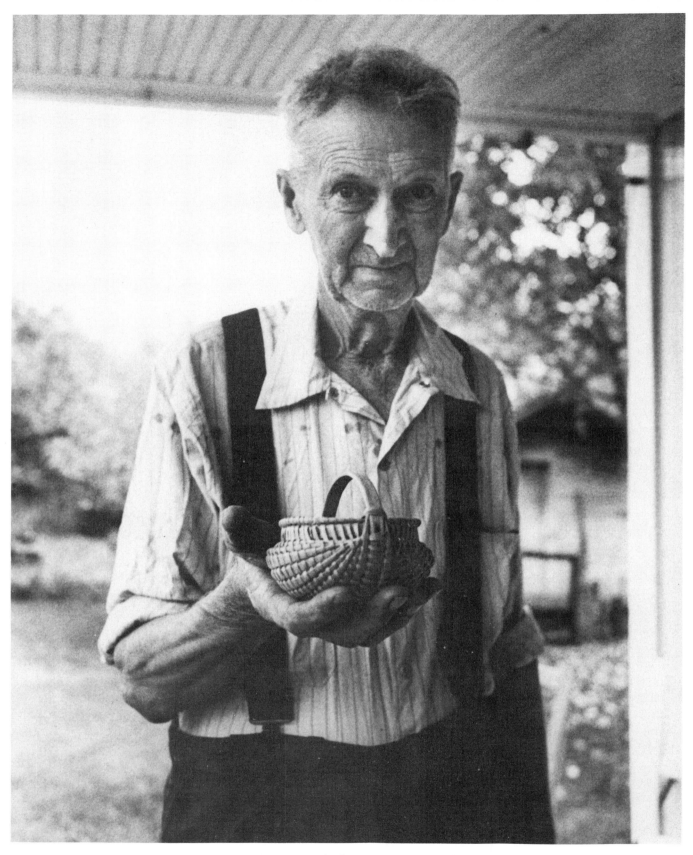

Jessie Jones with the "engagement" basket
he presented to his future wife fifty years ago.
(Photo by Ken Murray)

Mildred Youngblood of Cannon County, Tennessee, is shown here with a batch of her recently made baskets which the writer had just purchased for the Museum of Appalachia (Photo by the author).

## MILDRED YOUNGBLOOD, BASKETMAKER EXTRAORDINAIRE

I recall the little basket stands alongside the road in Cannon County on old Highway 70-S when I first started traveling to Nashville in the late 1940's. And for many years thereafter white oak baskets were sold in that area near the little county seat town of Woodbury, which I have dubbed the basket capitol of Tennessee.

But it wasn't until thirty years later that I learned very much about the basketmakers there. It started when my friend Bill Henry, the noted whittler and woodcarver from Oak Ridge, showed me a miniature basket made by a Mildred Youngblood. The quality of workmanship (or workwomanship) was unexcelled, and I decided then and there to visit her soon.

When I stopped by her modern home in rural Cannon County, I was warmly received and invited to her basketroom. And I was amazed to find the large room filled with several dozens of baskets of all shapes, sizes, and designs. At this time, and on subsequent visits, I acquired about 50 of her very best, representing various sizes and designs, for the permanent display collection at the Museum. (The others are for sale in the Museum Craft and Gift Shop.) Although Mildred is not an old woman by any means, she does have a strong and direct link to the old self-taught mountain basketmakers, as one will discover from the following account of my interview with her.

On August 15, 1980, on my way home from Nashville, I again stopped at Mildred's home to purchase a supply of baskets. It occurred to me that I should obtain more information from her relative to her background as a basketmaker, and that a small tape recorder would be better than making notes in longhand. As we started talking, I turned on the recorder and for half an hour we talked of the basketmakers of Cannon County. I was so impressed with Mildred's interesting and forthright responses that I decided to use the interview in its entirety and without editing; for she did well in telling her story and the story of her basketmaking family.

## INTERVIEW WITH BASKETMAKER, MILDRED YOUNGBLOOD
### Conducted by the author
### (Woodbury, Tennessee)

Q. I was just wondering, Mildred, how and why you started making baskets. I believe you said your mother was a basketmaker?

A. That's right, my mother was a basketmaker and my grandmother was also a basketmaker.

Q. What was your grandmother's name?

A. My grandmother, my mother's mother-her name was Pearl Davis Manis.

Q. Let's see-Davis would have been a Welsh name and Manis-maybe Irish?

A. Irish, yeah.

Q. Do you know where your grandmother learned to make baskets?

A. I never found out how she learned. I have asked around and I cannot find out how my grandmother learned how to make baskets. I was interested, you know, in how we became to be basketmakers. I asked my mother and she didn't know and I talked to my aunt, who is still living—how did Grandma learn to make baskets and who did she learn from? But she didn't know. Couldn't remember.

Q. How old were you when you first started making baskets?

A. I was too young to remember. I don't remember when I first started making baskets. (Mildred talks later about when she and her sister were put to work making baskets long before they started to school.)

Q. Were there other people in the community besides your mother and grandmother making baskets at that time?

A. Yes.

Q. And they traded them at the country store?

A. Yeah, everybody carried them to the store and bought groceries with the baskets. You didn't get money for them when I first learned how to make baskets. We took our baskets, mostly down here to the old T.O. Munsey store. It's called Bino's store now but it's the same one where we sold our baskets.

"This is how we carried our baskets to the store when I was a girl", Mildred recalled. "We'd take a couple of white oak splits and run through the handles. We'd trade baskets for groceries and that's how we made a living." (Photo by the author).

Q. How much would your grandmother get for baskets at that time?

A. Oh, fifteen—twenty cents.

Q. Who did the store sell the baskets to—the people in the community?

A. No, there would be a couple of people--I know one of my uncles was one--who would haul them to different states and sell them. And my brother sometimes would go along, and they would jest take a bunch of baskets from the grocery store and haul them to different states and sell them. Then they'd come back and pay the man at the store for the baskets.

Q. Do you know when your grandmother was born?

A. Somewhere in the 1880's. My mother just passed away last year and she was 76—so I guess grandmother was born in the 1880's.

Q. Did your family always use white oak?

A. Yeah, never used anything else--well, now back when I was just a little girl I can remember once in a while we'd cut a hickory that would make good hoops (for the handle and the rim). We could never make splits out of them, but we could make good hoops out of em. And occasionally they would cut a maple and could make maple splits--and they'd make baskets out of maple, but it's not as good as white

129

oak. These would be little toy baskets mainly for the children, and they'd sell for a nickel. But the splits weren't too strong and they'd break if you carried anything heavy in them.

Q. I guess that nothing is as good as white oak?

A. No, there isn't.

Q. We were talking about your grandmother, Pearl Davis Manis. Did she live on a farm?

A. Yeah.

Q. Your grandfather was a farmer?

A. My grandfather was a farmer.

Q. And did your grandmother make baskets on a regular basis?

A. She made baskets all the time. The only time when she wouldn't be making baskets was when she was gardening, you know, or canning the vegetables. She worked at it more in the wintertime.

Q. How many baskets would she make on a yearly basis, or on a monthly basis?

A. She would probably make-oh, I say about 15 a month.

Q. Was she a basketmaker all her life?

A. As far back as I evey knew, she made baskets.

Q. What style did she make?

A. Well, she mainly stuck to the round egg basket type. They used to call it just a round basket.

Q. People refer to them as egg baskets, but I assume they were used for various purposes?

####################################

This basket, like many made by Mildred, has a simple woven-in pattern created by using splits made from the darker heartwood of the white oak. (Photo by Ed Meyer)

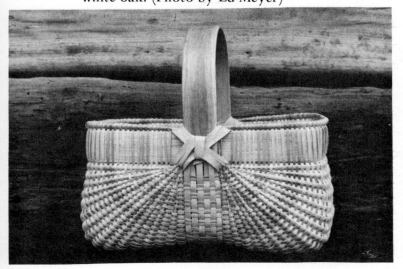

A. They were used for a lot of different purposes--clothespins, for apples, all kinds of garden stuff. You just about used a basket for everything because there wasn't such a thing as a plastic bucket back then.

Q. Who got the timber for your grandmother's baskets?

A. My grandfather.

Q. That was his contribution?

A. Yeah, that was his contribution to the basketmaking.

Q. Let me ask you this. When the Roses, who work for me at the Museum, do their splitting of the saplings in the woods, they don't use a froe as many oldtime basketmakers did. Did your grandmother ever use a froe for the splitting?

A. I can't ever remember ever seeing her use a froe—no. An ax serves the same purpose.

Q. You don't use a froe?

A. No, no, we just use an ax.

Q. Did other members of your family make baskets? We're talking about the time when you could first remember—in the 30's, I assume.

A. Yeah, the early 30's. All my relatives made baskets. It was a family affair.

Q. Your grandparents on your father's side—did they make baskets also?

A. Yes, my grandmother on my father's side made baskets also. Grandmother Thomas.

Q. Now Thomas is another Welsh name. Who was she before she married?

A. She was a Mears-M-e-a-r-s. I've always been told that the Mears was English.

Q. Now I've heard for some time that the little town of Woodbury or the area here near Woodbury, was sort of the center of the old-time basketmakers in Tennessee. Were they mainly your family?

A. Yeah, primarily my family. Well, there were a couple of other families that did make baskets. But for some reason they all got intermarried and intermixed, like the Murphys. Now Murphys made baskets and the Mathises made baskets. And the Murphys are married into the Thomas family and so are the Mathises married into the Thomas family and the Manis family. So if you are not related to all these families, then you've got a brother

or sister or a cousin who is married into these families some way or another. They live around here in what is called Thomas Town and Manis Town.

Q. So all the people who made baskets in this area which I call the basket capitol of Tennessee, were your people?

A. That's about right.

Q. How many basketmakers, would you estimate, are there in Cannon County?

A. Well, there are more people who can make baskets than there are who are still making them. If I had to guess, I'd say there are about a dozen basketmakers still active. Several other women who used to make baskets are working in factories and in town now.

Q. Mildred, let's go to your mother for awhile. I suppose she learned the trade from her mother?

A. Yeah, my mother learned baskets from my grandmother.

Q. Did she work at it as much—make as many baskets as your grandmother?

A. My mother made more baskets than my grandmother. She made them all her life. Now she had a pretty good thing going when my sister and I were at home. She would start the baskets and then we would finish them. So between all three of us we could make three in one day, way back when I was a little girl and my mother was a young woman. But all alone, just by herself, she could probably make one a day.

Q. Then she probably made a couple of hundred a year, or so?

A. Oh, yeah, at least, 'cause that's the only way we had of surviving. That was our livelihood—makin' baskets.

Q. Did you have a farm?

A. No, we lived part of the time on my grandfather's place, and part of the time we lived on other people's farms. Now one time when we lived about a mile from here, my Daddy did work on their farm some. I was born and raised in a two-room log cabin.

Q. Did your dad share-crop?

A. Part of the time, part of the time he made

moonshine, and the rest of the time he was drinking the moonshine that he'd made. (laughter)

Q. How many children did your father have?

A. Twelve.

Q. You're kidding!

A. No, I'm not kidding, there was twelve children born to my mother and father. Five died when they were young and there were seven who lived to be grown. I was next to the oldest girl.

Q. Well, I'm sure you didn't have running water in the log cabin?

A. Absolutely not.

Q. This was on your grandfather's place?

A. Yes, my Grandfather Thomas.

Q. And your Grandmother Thomas made baskets also?

A. Yes, Grandma Thomas did.

Q. Now how far was it from your Grandfather Thomas' home to where your Grandfather Manis lived? And had they always known one another?

A. If you went through the fields, it was about three miles. Yes, they had always known one another.

Q. Did any of the men in the area ever make baskets?

A. The only men I ever knew--some of the Mathises. That wasn't a man's job. You just didn't see men making baskets.

Q. In East Tennessee most of the basketmakers were men, it seems. I wonder why the difference?

A. Well, here in Middle Tennessee all the men made moonshine. They made the moonshine and they drank the moonshine while the women and the girls made the baskets and brought the groceries home.

Q. Did your Daddy ever get caught?

A. Yeah, sure did.

Q. What did they do to him?

A. Well, one time I remember he had to go to jail. He spent 11 months and 29 days.

Q. I suppose your mother and the children had to make a lot of baskets during that time?

A. We just made the same amount.

Q. How long did your family live in your grandfather's little log house?

131

A. Well, I got married when I was 14. I couldn't take it any more (laughter). I ran away.

Q. Where did you go?

A. We, my husband and I, we went to Georgia and got married. Then we came back and lived with my husband's stepmother and that's where we lived until my husband went into service—in 1942—November or December. Then his stepmother, she got married and left, and then my mother and father moved in with me. And I lived there until my husband got out of the service and then we moved to Chicago. And I lived 28 years in Chicago.

Q. How old were you when you went up there?

A. Oh, gee, I must have been all of 16 or 17 (laughter).

Q. Did you work there?

A. Yes, I was a waitress, worked in factories and did a lot of different things. I didn't make any baskets at all while I was in Chicago, other than when I would come home to visit my mother. And then I would always make a basket. It never left me. I would always make at least one basket while I was here.

Q. Then your mother continued to make baskets?

A. Yeah, my mother made baskets up until about a year and a half before she died. She was 76.

Q. Your mother's baskets weren't as well finished as yours, were they?

A. No, my mother made baskets for the money and money alone—that's the way it had always been.

Q. Well, she had to make as much money as possible in order to feed the family, I suppose?

A. That's right. She didn't have the time to fool around with them. A basket was a basket to my mother. It wasn't art. That was just a job with her. She made the baskets to get the groceries to feed the kids and that was it.

Q. Did she and your grandmother bottom chairs?

A. Occasionally, not too often, though.

Q. Where did your people come from immediately before coming here to Cannon County in Middle Tennessee?

A. I don't know. As far as I know they was always here. It just seemed like the family was always here in Cannon County and that's where they all stayed--here in Cannon County.

Q. What's Cannon County's claim to fame? Other than you?

A. I don't think they have any (much laughter). Just the basket weavers is all they've got as far as I know. Course now moonshining is out. It used to be moonshining and basketmakers. We do have some chairmakers.

Q. One other thing I wanted to ask you about was this practice of dying some of the splits as a means of sort of decorating the basket. Did any of your people do that, or was this something that was picked up in later years from "outsiders"?

A. I have seen it done. My mother used to dye the splits a different color and put in the baskets.

Q. What type dye did she use?

A. Well, she would get the dye from the store. At times, now, I can remember seeing my mother use elderberries and boil them. And she also used onion peel.

Q. Now the elderberries would make a red color and the onions would make yellow?

A. That's right. She would use those colored splits to make a chain pattern in the basket.

Q. Why do you think she went to all this extra trouble?

A. Well, they seemed to sell better. It was an eye catcher.

Q. Where did she get this idea?

A. My grandmother did the same thing.

Q. Have you ever seen baskets made of round oak splits instead of flat splits?

A. Yes, I have. I've seen two or three.

Q. It seems that it would require much more time to whittle out the splits in rounded form?

A. Well, yeah, unless you had a machine. If I was going to do something like that, first I'd invent myself a machine that had a

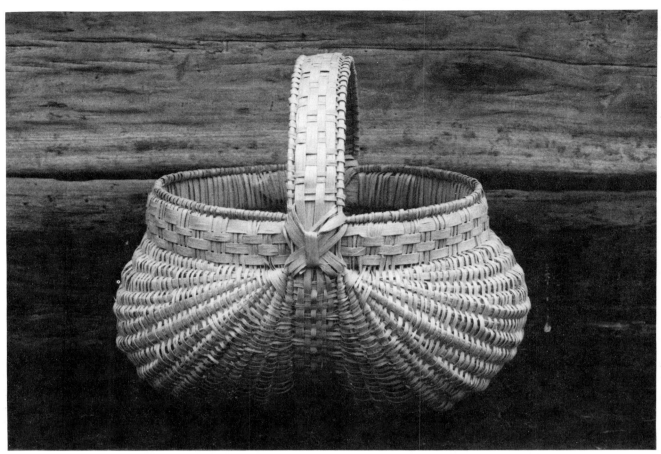

I know of no basketmaker whose style and design varies more than those possessed by Mildred Youngblood. These two photographs of baskets made by Mildred and housed at the Museum of Appalachia show a few of her varied creations. (Photo by Ed Meyer)

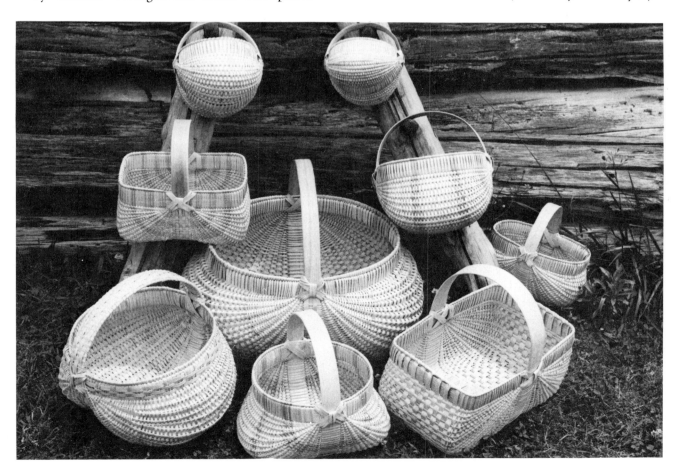

little hole in it and I'd just pull the split through. You'd have to have more than just one hole in that iron, because you'd have to keep pulling it through smaller holes and cutting it down to make it round because when you first started, it wouldn't be a round one; it'd be more square.

Q. Let me ask a question or two about your own basketmaking? What did you get for baskets when you first started making them?

A. Oh, for a small basket, probably ten cents. I can remember on up during the war it didn't seem to make any difference how big you made a basket, fifty cents was all you were going to get. That was for the best.

Q. There was no way that one person could go out and cut the timber and make the splits, ribs, rims and make a basket in one day, was there?

A. No, there was no way that you could make all of that and put the basket together in one day. If I want to work a hard day—if I want to get up early in the morning and get started, say at 7:30, and then work a couple of hours after supper. I can make one round basket in a day-- that's after I have everything whittled out, and everything made, I can make one in a day.

Q. You're talking about 10 or 12 hours.

A. I'm talking about 12 to 14 hours.

Q. Well, you're not getting rich at making baskets then?

A. No, I'm not (laughter). I like baskets, and I've always liked it, really. And I keep on trying to get better at it.

Q. I tell everybody that you're the best. They're always wanting to know who you are and how to find you so they can come buy some of your baskets and I give them some fictitious name and tell them you live somewhere in the lower end of Sequatchie County so they can't find you.

A. (Much laughter). No, I don't believe that (more laughter). I do take a lot of pride in my baskets--in my basketmaking. And I want to sometime, make my own collection, but so far everytime I make one I want to keep, like that one with the real fine splits, I always end up selling it. I have a little granddaughter and she wanted to give her teacher something at the end of school and she wanted it to be different from everybody else's. So she came by and wanted one of my little baskets. And she took one and give it to him and she told me later that he was jest thrilled to death with it.

Q. When you came back to Tennessee in 1973 after spending 28 years in Chicago, you started right away making baskets?

A. Yeah. I like to make baskets; and another reason for my starting back to make baskets was that I did not want to go out and get a job in a factory and work. I wanted to stay home. I got started back mostly just for the pastime and just for the fun of it and to see if I could still make them. And, like I said, I like to make baskets and to make different kinds. It's self satisfying.

## ALEX STEWART OF PANTHER CREEK
### (Hancock County, Tennessee)

Alex Stewart, I have often said, is the greatest all-around mountain man I have ever known. I choose to include him in the basket book, not because he is principally a basketmaker; but because he is a master of virtually all of the traditional mountain activities and crafts, including that of basketmaking. And most of the baskets of Southern Appalachia were made, not by full-time basketmakers, but by the all-around self sufficient individuals, like Alex.

Alex is an excellent farmer, a superb blacksmith, musical instrument maker (and player), herb doctor, carpenter, chairmaker, broommaker, wood carver, tanner, fisherman, one of the last spring pole turners, a cross bow maker and probably the country's best known cooper.

When I first met him in 1962, he had all but ceased to employ his skills in the fashioning of handmade items, mainly because their utilitarian value had weakened, he reasoned, because of a vastly changed lifestyle. Who would pay for the many hours of labor required to make a wooden staved bucket, when

he could buy a plastic one for a dollar or so?

But once persuaded to reactivate his crafts, he was beseiged with requests for his work--not for their intended utilitarian purposes, but for collectors, decorators, and those who just wanted a beautiful cedar churn made by the venerable old gentleman from near Sneedville in upper East Tennessee. He soon was catapulted into regional and even national fame. *National Geographic* featured him on the cover of their book, *Craftsmen of the World; Foxfire 3* book spread his fame further by including a long article and over sixty photographs of him; and numerous motion picture documentaries and commercial films have featured him.

Over the years I have spent hundreds of hours with Alex discussing dozens of subjects related to about every facet of mountain lore; but we, to my knowledge, had never really discussed basketmaking. On December 27, 1980, I spent a long day in the mountains of East Tennessee and southwestern Virginia with two young boys, Rob Irwin, my nephew, and Eric Erickson, my step-grandson. It was already dark when we neared Alex's home, but I wanted to see Alex and I especially wanted the boys to meet him.

We found him in his tiny room in back of the house by an open fire whittling on some toy or puzzle which he makes and gives away by the hundreds. He was in his ninetieth year, complained of being "no account", but possessing more alertness, keenness and perception than most people ever have. After he had given the boys some special presents he had made, I turned on the tape recorder with the following results. As in the case of Mildred Youngblood, the interview is presented with little or no editing.

Q. Alex, you have made almost every item that was ever used in the mountains--musical instruments, plows, all types of blacksmith items, traps, fishing nets, and of course, all types of coopered articles. Did you ever make any baskets?
A. Lord, I've made a many a basket.
Q. What kind of timber did you use?
A. I used white oak about all the time; that's

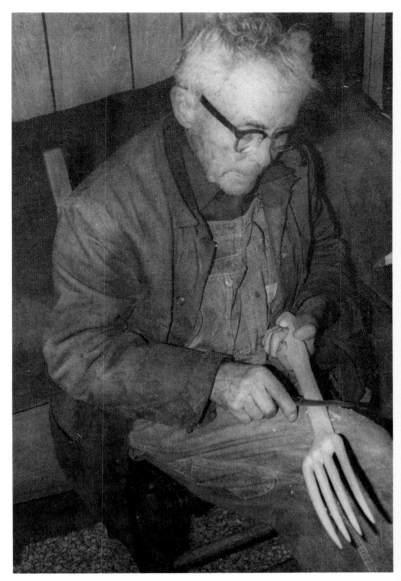

As we sat around the fire talking about baskets, Alex kept busy working on first one accoutrement, then another. Even at the age of 90 his products are almost flawless in workmanship and style. (Photo by the author)
╫╫╫╫╫╫╫╫╫╫╫╫╫╫╫╫╫╫╫╫╫╫╫╫╫╫╫╫╫╫╫

the best thing to make baskets out of. I've made willer baskets--made 'em out of willer, and made 'em out of honeysuckle. I's a studying tuther day that if I had some of that honeysuckle that's a'growing down there along that fence I'd make some baskets. That's about all I can do.
Q. Where did you learn to make baskets from willow?
A. I learn't that from my grandpap. You take and get them long switches and strip the bark off of 'em, and it's no trouble to make a basket. I learnt an old woman on Blackwater how to take the bark off wil-

ler switches. She wuz a'settin scrapin' off the bark with a pocket knife, and I said, "Sister, if you don't mind, I can show you how to get rid of that bark ten times as fast." She said she'd shore be proud to learn and I took a thin board and nailed it on the side of the porch and let it stick above the floor a couple of feet. Then I split it down a few inches. Then you jest put your switch in that split and pull. Lord, she's so tickled she couldn't get over it. And she made me a willer basket and give it to me for showin' her how. She said, "Law me, you've learnt me somethin'. I can make twice as many baskets as I used to."

Q. And your grandfather made willow baskets?

A.  Yeah, he'd make 'em to hold all the way from a half gallon on up to a gallon and a half--out of willows and honeysuckles. Then out of white oak splits he'd make em from a gallon on up to two-bushel baskets. I made one for old man Ross Lawson over here on the River Ridge that held five bushels. He came by and asked if I could make one that big, and I said, "Why yeah, I can make it as big as you want it."
"Well," he said, "you make me one that'll hold about five bushel and I'll take it." "Well, now," I said, "Mr. Lawson, if you want one that big, I'll make it." So I put in and made it fer him and got it done. I sent him word about it and he come up. He picked it up and looked at it and he said, "That's jest exactly what I wanted." "well now," I said, "What in the world did you want with a basket that big?" He said, "Well, I've got eight 'n ten calves up thar and I can take that basket and cram it full of shucks and take it out and give it to 'em and that's what I wanted it fur." I bet it's over thar yet--the old fellow's dead now.

Q. Alex, what other materials were used to make baskets?

A. That's about all-white oak, willer and honeysuckle--wuz about all ever I seed 'em made of. Now you can take the hull from broomcorn when it jest gets ready to shed its bloom and take them splits off of it, you can make baskets out of that. If you let it get ripe and it gets brickle it will break. You've got to use it when its green and then it will stay tough. I've made them in all kinds of shapes--square, round. You have to sew the bottom part til you get started.

Q. When is the best time to cut the white oak for making splits?

A. You always cut it on the old of the moon. It's better if you cut it when the sap's down, but you can cut them any time of the year as long as it's on the old of the moon. And you ort to get yer timber on the north side of the mountain. North is jest a third better and yer basket will last a third longer. You can blow through timber that's growed on the south side of the hill.

Q. Where did you get the idea of making baskets from broomcorn?

A. Well, my grandpap made, 'em. He made 'em to put eggs in--made em to hold about a gallon. He had a big sugar orchard (maple trees or sugar maple trees) and he'd make sugar and sell it and he'd use them broomcorn baskets to take his sugar out and sell to the store. Sold it for ten cents a pound.

Q. Alex, I've been seeing pictures of split baskets from this area which are said to be hickory. Can you make splits from hickory?

A. You can make the ribs out of hickory, but you can't make splits out of it.

Q. Can you use any type oak other than white oak?

A. You can use other kinds of timber if it's tough, but white oak is a lot better. It holds its own. And it's easy to work with. If you work it when it's green you can do as good as you can with a piece of string-- better in a way. That's one thing that makes it hateful about using honeysuckle --it's soft, and it's hard, after you get so far along, to run it through.

Q. Is it better for your splits to be seasoned?

A. No, it works better when it's green. Now

it's alright to have your ribs to be seasoned a little bit because when you bend them they will stay bent better. It takes four sets of ribs to make a basket--to make it like anything.

Q. How many baskets would an ordinary mountain homestead have?

A. Oh, they'd have four or five.

Q. Would there be different baskets for different purposes?

A. Yeah, they had different baskets for different purposes. My grandmaw, she had her one made, a sort of oblong basket, that she kept her quilt pieces and things in. I've seed her with it full a many a time.

Q. Who was the old basketmaker who used to live up here on the ridge, Ikie Johnson?

A. Ikie Johnson, yeah. I've got one he made, an old one now. He'd make a half a bushel basket fur a chicken. Now Mommie give him a hen to make her one to pack apples in and I've got the frame of it down there yet. I started to fix it back up, but ain't never done it.

Q. I understand that Ikie was about a hundred years old?

A. He wuz over 100 years old. He wuz about a hundred and four or five years old. He's a grown man when I wuz jest a little bitty boy.

Q. Alex, I've heard about berry baskets. Was there a special type of basket made for picking berries?

A. Yeah, they'd make special baskets for berry pickin. They's round jest like a bucket with slats or staves put in them-- and wide splits.

Q. What size were the berry baskets?

A. Oh, they'd make 'em different sizes. You'd make 'em to hold from about two gallon on up. My grandpap made a lot of 'em, and my daddy made a lot of 'em. And I've made a many a one of 'em. They're not too hard to make. You put the stave in-- straight up--and then you weave the splits in.

Q. Did you ever make baskets with lids?

A. I've seed a few with lids on them; but I never did make one. Oh, I've made a few little ones with lids on them, but not one of any size.

Q. How much did baskets sell for back when you were a youngster?

A. Oh, they'd sell all the way from a quarter to fifty cents, and a dollar--never got over a dollar for one.

Q. I suppose a lot of people would trade baskets for produce, meat and so forth?

A. Oh, yeah. They wasn't no money back then. They'd jest trade 'em for first thing 'n another. When my granddaddy died, I guess he had--oh, I couldn't tell you how many bushel of shelled corn that he had on hand that he had got for his work (baskets). He liked to help you out, and he'd take anything fer a basket. He's made hundreds and hundreds of pieces and never got nothing out of it.

Q. Did he take his baskets around the countryside and sell them like some of the other basketmakers?

A. No, they'd jest come there and get 'em. He'd take corn fer them and he couldn't use it all, and he kept it there so long hit got weavils in it; and he had a hard time gettin' shed of it; in fact he took a big lot of it and jest poured it out. He took and put some sulpher under some of it and that jest ruined it for making meal, that sulpher did, and he had to pour it out. Why, he'd jest take anything you let him have for baskets, chairs, spinning wheels, and whatever he made. He'd even let you work it out, or jest any way to help you out.

At this point Alex opened a little drawer and got a piece of slippery elm bark to chew. And he told the story of how the root of the elm had once cured his total blindness:

"I had the measles when I's jest a boy about seven or eight years old, and they settled in my eyes and left me blind. Why, I couldn't see a wink--not a bit more than that wall can see. Old Dr. Mitchell, he come to doctor me--he come every week. And he come up one day and I's a settin' there--couldn't see a wink. He called me Bringer, and he said, "Well, Bringer, I've done everything that I can to help you, but I'm a'goin to say that you're jest a blind boy". He said, "Your eyes is gone."

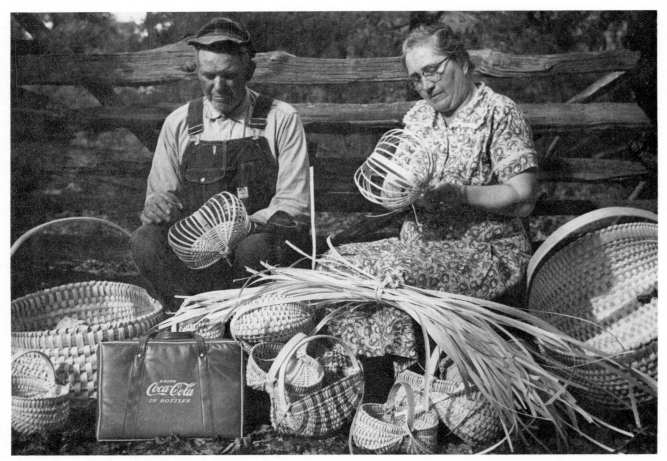

Pete and Lera Rakes were examples of old time basketmakers who continued their craft into the second half of this century. At the time this photograph was made they lived on Turkey Cock Creek in southwest Virginia near the community of Charity. Their white oak split baskets are common throughout Southern Appalachia and are merely called "round" baskets by many people of the area. (Photo by Earl Palmer made available by the Blue Ridge Institute at Ferrum College, Ferrum, Virginia.)

++++++++++++++++++++++++++++++++++

"And the very next day old man Dick Goins--he jest traveled all the time, didn't have no home a tall and jest eat where he could get it, and he come to our house about once a month anyhow to stay all night with us--and he come up there and I's a settin' there and he asked Mommie what was wrong with me.

"Why", she said, "he's blind. He took the measles and when they did go back they settled in his eyes and they put em out."

And Pap came up, and old man Goins said, "Joe, you know a slippery elm, don't you?"

And Pap said, "Why, yeah".

He (Goins) said, "You get your mattock and go 'n dig you a piece of the root about that long, and you beat it up, put sweet milk on it and bind it to his eyes, and I'll guarantee it to work."

Made Pap mad--thought the old scutter didn't know straight up. He didn't have no faith in it.

And Mamma told him, said: "They ain't nothin' like tryin'", said, "it don't cost nothin". She went and got some and put it to my eyes one night and I went to bed. I got up the next morning and I could tell that that was a helpin' my eyes. And it brought my eyesight back.

Q. Alex, going back to your early childhood on Newman's Ridge, how many basketmakers did you know?

A. My daddy and Grandpap Stewart was the only ones who followed making baskets around where we lived up there then. I didn't know of nobody else around there that did make 'em.

Now you wuz a talking' about making

them straight-up baskets. I can make them purdy. You can color the staves or color the splits and check 'em, and make one of the purdiest baskets you ever saw.

Q. Where did you get the idea of coloring part of the splits?

A. Well, Grandmother Stewart, she colored part of the splits. She'd take catnip and bile it down 'n color em green, or she'd take hickory bark and walnut and put 'em together and bile it 'n make it jest as brown as this bed. You'd jest put them splits down in there (the brew) and let them set a while and that dyed em. She'd put a little borax in the catnip.

Q. And your grandmother did that?

A. Yeah, she did all the coloring for Grandpap. She did all the coloring. That was a way back yonder, now. They colored the baskets for what we called the big folks. They'd want them to take the eggs to the store in. You could color all your splits or you could color all your staves, and you would have to check it then and hit was purdy.

Q. Were there other basketmakers anywhere in this area who decorated their baskets with colored or dyed splits or staves?

A. I didn't know of nobody else that done that. I don't know of the people that talked about that and wanted to know how it was done.

Q. What about the rib type baskets, would she ever color them?

A. Yeah, she'd color a few of them. It made 'em purdy to color the ribs.

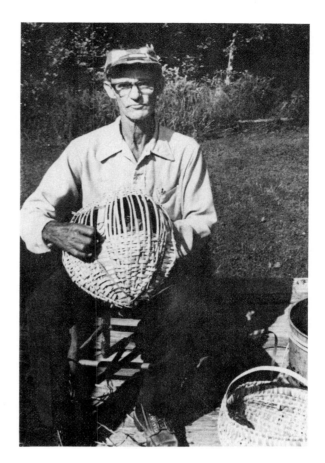

Bill Rose didn't start making baskets until he became disabled after over half a century as a farm laborer. Then he took up the craft which his father and grandfather had followed. He lives in Foust Hollow in Anderson County and is a brother to Russ, who along with his wife Nancy, makes baskets at the Museum and who were discussed at length earlier in this this chapter. (Photo by the author)

### THE DALTONS OF COKER CREEK
(Monroe County, Tennessee)

These expertly made baskets are the work of Ken and Kathleen Dalton of Coker Creek in the extreme southeastern section of Tennessee. Because of the quality of their baskets and because they actively participate in craft shows throughout the region, they have received more recognition than the other basketmakers. Their baskets are of white oak and are of the traditional rib and split construction.

Ken was born in the Coker Creek Com-

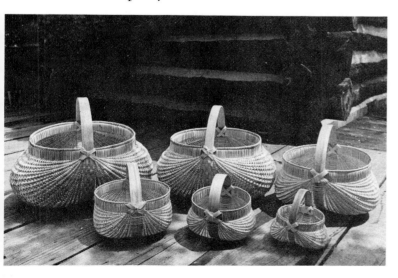

139

munity and Kathleen is from the county seat of Madisonville. Madisonville's chief claim to fame, I suppose, is that it was the home of Estes Kefauver, United States Senator, and candidate for the presidency. Coker Creek, with an official population of less than 100, is best known for the gold which was discovered there in 1831. Varying small amounts have been mined there, at times by hundreds of miners under the auspices of corporate enterprises. I have a very large gold washing machine on display at the Museum which was used in the Coker Creek gold mines. The area takes its name after Coco Bell whom the historians refer to as a beautiful Indian princess who spent her life attempting to bring peace between the Indians and the whites. She apparently made the infamous 1000 mile forced march to Oklahoma called the trail of tears because so many perished along the way. Years later Coco returned to "Coco", or later Coker Creek to join those of her kin who had escaped into the rugged mountains nearby.

Those renegade Cherokee, according to Kathleen, made baskets which they traded to the whites for meal, flour and other staples. The Daltons have two such baskets. It is interesting, as Kathleen points out, that the largely Scotch-Irish settlers were apparently not dominated, or maybe even heavily influenced, by the Indian style baskets.

Although Kathleen made her first basket at the age of 10 on her father's farm and although Ken was exposed to the trade, they didn't become professional basketmakers until the early 1970's. At that time they enrolled in a three day class of basketmaking sponsored by the Tennessee Arts Commission, an event which started them in dead earnest with the craft of basketmaking from which they have gained respect, not only in Southern Appalachia but throughout much of the country.

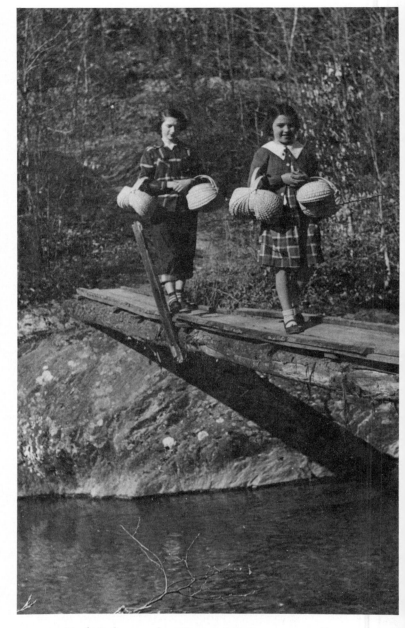

Earl Palmer, the "Roamin' Cameraman" from Cambria, Virginia, captured this view of newly-made white oak split baskets being carried from the mountains to the local general store to be traded for the staples their hillside farm could not produce. (Photo courtesy of the Blue Ridge Institute, Ferrum, Virginia)

# Chapter 5

# Miniatures, Toys, Keepsakes and Decorated Baskets

Much emphasis has been placed on the importance of the basket in the everyday lives of our forefathers (and foremothers) in the pursuit of their daily work. But in addition to the utilitarian value of the basket, it served other functions in Southern Appalachia as I presume it did in other parts of the country.

First, there were some utility or "work" baskets which were decorated purely for aesthetic purposes. Then there were miniature, toy, and keepsake baskets which served little or no economically useful purpose but which helped fill what may have been a void in the stark lives of people living in isolated and semi-pioneer conditions. These baskets were often highly cherished and well cared for-- hence often in better condition than those used on a daily basis. The following examples will give the reader an indication of how these keepsake baskets served a much broader and more fulfilling purpose than their mere intrinsic worth would indicate.

THE "ONE-EGG" BASKET
(Giles County, Tennessee)

This intricate little basket, which barely holds a single egg, was purchased from Johnnie Simmons who lived in the Pond Hill community some two miles east of Pulaski, Tennessee near the Alabama line. (Pulaski was the birthplace of the Ku Klux Klan in 1866 and the place where Sam Davis, the "boy hero of the Confederacy" was hanged for refusing to betray his superiors during the Civil War.)

The basket had belonged to the Francis Webb family, upon whose place the Simmons lived. It is made of white oak and is of the traditional rib and split construction. (Photo by Gary Hamilton)

## THE PRISONER BASKET
### (Grainger County, Tennessee)

In the mid 1960's, I purchased numerous mountain artifacts from Herman Newby and his wife who lived a few miles up the valley from the village of Liberty Hill in Grainger County, Tennessee. Among these items was this tiny basket--the most perfectly made miniature, I believe, that I have ever seen. The Newbys told me that it had been made by a prisoner "years ago". This may explain the slow and painstaking workmanship which would have been necessary to have produced such a fine example. The diameter of the top opening is about three inches. (Photo by Gary Hamilton)

############################################

This miniature is very similar to the "one-egg" basket shown on the previous page. But the handle, or bail, on this one is much broader and much higher, rather out of proportion to the body of the basket. It was acquired from East Tennessee, over 200 miles distant from where the Simmons miniature originated.

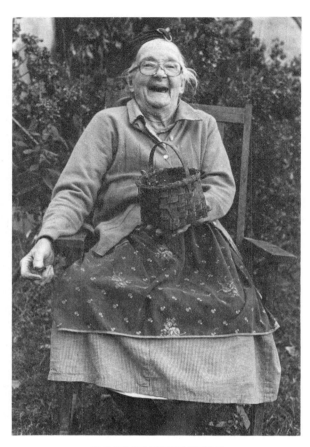

**DOLLIE TURNBILL**
(Anderson County, Tennessee)

Dollie Hoskins Turnbill lived at the foot of the great Cumberland Mountains some three miles from Oliver Springs, Tennessee and only a mile or so from the ancestral Hoskins homeplace in Hoskins Hollow.

In a visit with Dollie in November 1980, I chanced upon a tiny, tattered basket hanging on a nail near the open door of her woodshed. I asked her about it and this exuberant, fiesty, and wonderfully warm and friendly lady of 86 told me about her little basket. I am glad that she did because she died a few days later.

"Oh, that little ole basket! Well, it was a present to me way back when I's jest a girl.

"I took sick and liked to have died. I was in the bed for twelve months (apparently of polio). Then I got to where I could crawl for a few months, and then I got to where I could go a little on crutches. And then finally I got to where I could hobble around on a cane," she laughed.

"Well, it was during that bad sick spell that a neighbor girl, Rhoda Ward, made the little basket and give it to me as sort of a present. She made big baskets, of course, but she made this little un especially for me.

"I used it all the time to gather eggs in mostly. But I'm so crippled up that I can't get around and it's been a'hanging out there in that ole shed for the past few years--ruining, I guess."

She agreed to sell me the basket "before it gets knocked down and trampled up" so that it might be preserved in the Museum. And although its economic value is not great, it has very special meaning to me, having learned of its history. It is made entirely of white oak, and has been patched and mended over the years.

## THE SUNDAY SCHOOL BASKET
## AND THE SACRAMENT BASKET
### (Smith County, Tennessee)

Nellie Baird Armistead and her husband Zach had a large two-story house in Smith County, Tennessee, and several outbuildings, with various relics of the past; but Nellie reserved the front room of her house for her most cherished items. And among those treasured momentoes of fine glass, lamps, and family portraits, were two handmade baskets. When one observed the expert workmanship of the baskets and learned their history he would understand why they merited this special place in Mrs. Armistead's home and why they weren't for sale.

The small white oak basket which fits easily into the palm of one's hand had belonged to Nellie's mother, Betty Gill Baird, who lived there in Smith County in the New Middleton community, near the Middle Tennessee town of Carthage.

"That little basket was a prize my mother got when she was just a little girl for having perfect attendance in Sunday School. She was born in 1860 and could remember the Civil War. I'd say she wasn't more than five or six years old when they gave her that little basket prize--that would have been around 1865 or so, I guess. She gave it to me when I was a little girl, and of course it means more to me because it was my mother's."

The larger basket was the sacrament basket for the New Middleton Methodist Church and is made of willow, straw, and white oak. This basket also was a gift from Nellie's mother. She explains, "Well, Mother lived over on Dry Fork and she used this basket to carry the bread and wine to church for the sacrament. She had used it for that for as long back as I can remember and before that, I suppose. I'm satisfied it's over a hundred years old." (The numerous other baskets in and around the Armistead home were discussed at length in Chapter III.)

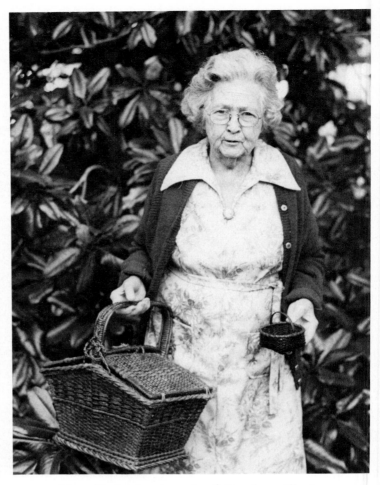

Mrs. Zach Armistead of Gordonsville in Smith County in Middle Tennessee with the family sacrament basket and with the miniature basket (shown below) her mother got as a Sunday School prize about 1865. (Photos by the author)

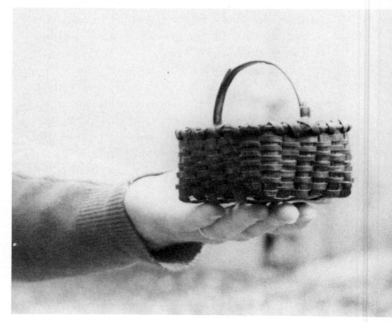

144

## COMB AND BRUSH BASKET
### (Anderson County, Tennessee)

This wall hanging knickknack basket came from the attic of the old Leslie Kennedy homeplace which was located some four miles south of the Museum. The oak splits are alternately green and reddish, but have faded on the front so that the colors are only faintly visible. But the back of the basket which has been protected from the light retains the rich hues.

The splits which form the curlicues were added after the basket was otherwise finished and serves no purpose other than that of decorativeness. This type basket was not common in early Appalachia and may be the result of the craft revival with strong outside influence, and which started in the early 1900's. Some students of the baskets of this region point out that the Indians made this type of curlicue. This information, plus the fact that the basket has several dyed splits, now faded, suggest that it could very well be Indian made. (Photo by **Gary Hamilton**)

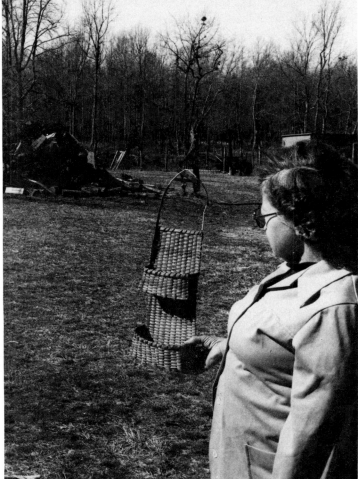

## WALL HANGING KNICKKNACK BASKET
### (Coffee County, Tennessee)

Mrs. Bob Meadows of Coffee County, Tennessee, is shown here with a white oak split wall hanging, catch-all basket that has been in the family for several years. It was made by Lizza Jane Henegar who at the time lived on Pine Creek near Smithville in Dekalb County in middle Tennessee. Although this type is often called a loom basket, this writer is not aware of evidence that it was used in this connection in our region--but maybe so. (Photo by the author)

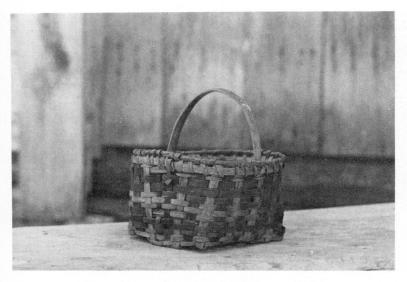

Because of the nature of the design, some believe this basket is Cherokee made. But it was acquired by Roddy Moore in Lee County, Virginia, and was said to have come originally from an old lady who lived on the Tennessee-Virginia line in a community called Blackwater. I am well acquainted with the area and know that some Indians lived there in the isolated mountains among the whites long after they had disappeared from most other parts of this region; so I would suppose that it was made by the whites who had "borrowed" from the Indians. This is the same area where Alex Stewart is from and Alex talks about the dyed-split decorated baskets his father and grandfather made.

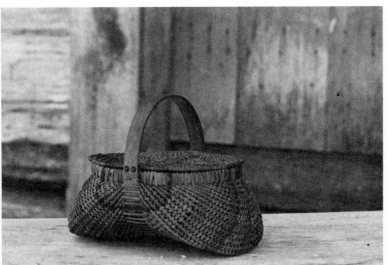

This classic style white oak gizzard basket is decorated with dyed splits to such an extent as to cause Roddy Moore to speculate that it may have been Indian made. But it would appear that the white influence is dominant--even if it were made by the Cherokee. It was collected by Moore in the East Tennessee area. The double lids as well as the method of hinging them are most similar to the Cherokee-made baskets in the Sloan family discussed in Chapter VI. (Photo by Roddy Moore)

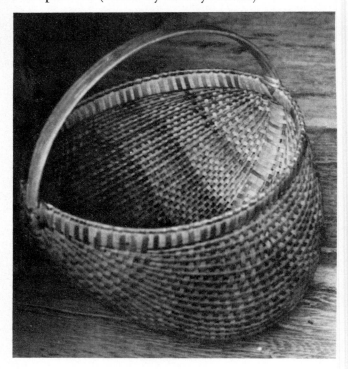

The narrow white oak split construction, the shape, and especially the ringed design of this basket makes it very similar to the one shown above; but the one shown here has no lid. The decorative rings are formed by a combination of dark brown and reddish splits. The hues are much richer inside the basket, indicating that much fading has taken place over the years. It was acquired in Fincastle, Virginia. (Photo by Gary Hamilton)

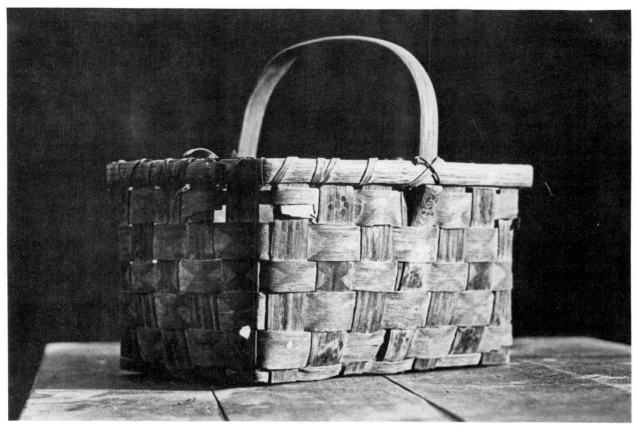

## DECORATED SHENANDOAH VALLEY BASKET

Decorated baskets of this type were seldom made in the frontier period of Appalachia.

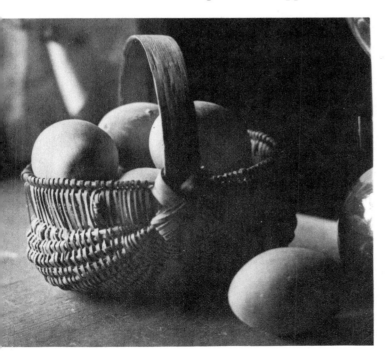

This one may be the result of the craft revival alluded to earlier. This renaissance of the native crafts was influenced by outside suggestions and guidance.

The basket was purchased in Fincastle, Virginia, but Roddy Moore of Ferrum College says that it was made by an old man in Woolwine, Virginia, a tiny town in the mountains near Ferrum. The rim and handle are of white oak, but the splits, fully an inch in width, are definitely not white oak. They appear to be ash. The decorations consist of a series of crude hourglass-like designs in dark blue, along with clusters of red and blue dots resembling cat tracks. (Photo by Gary Hamilton)

## SMALL RIB AND SPLIT BASKET

For as far back as I have been able to research, baskets of this size, only five inches in diameter, have been made for children as sort of a combination toy, memento and utilitarian item. This one is a replica of the large egg and general purpose type basket found throughout the region. (Photo by Gary Hamilton)

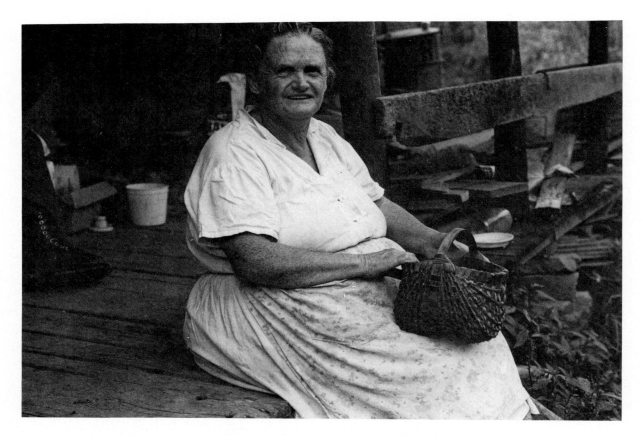

Alice Gibson is shown on the front porch of her log cabin home with the basket her sister carried her dinner in the last time she visited the family home on Christmas Day 1928. (Photo by the author)

## ALICE GIBSON'S KEEPSAKE EGG BASKET

### (Scott County, Tennessee)

Alice and I had worked our way through her little mountain log cabin, finding interesting items here and there amid the myriad stacks of boxes, clothing, tools, and literally thousands of miscellaneous items including several guns. Alice, who lives near the community of Norma in Scott County, Tennessee, was willing to sell many of the items, but when I opened the curtains to a small closet near the fireplace and brought out the pretty little white oak gizzard basket she apologetically informed me that it wasn't for sale.

"Lord Honey, that ole basket belonged to my sister and I jest wouldn't sell it. I'll never forget she packed her Christmas dinner in that little basket and walked all the way from Caryville--hit took her all day." (It takes about 45 minutes in an automobile to drive this distance over some of the most rugged terrain in East Tennessee.)

"Ruther than pack the basket back the next day, after she spent Christmas night with us, she give it to Mommie. And she took bad sick on her way back to Caryville and they had to take her out on a push car (on the railroad). That was in 1928 and she took pneumonia and never did get over it. She died the 9th of March in 1929. So you can see why I wouldn't sell the little basket."

In response to my further questions she said: "I don't know how old it is, but hit wasn't new by no means when my sister brought it here. I jest think that Uncle John Overton may have made it. He was an old time basketmaker. He lived over at Deane (near Norma). It held three dozen eggs and we would keep our eggs in it 'til we got enough for a settin' then we'd set a hen. And we used it to carry eggs to the store. We used it 'til the last few years and since then I've jest kept it as a sort of a keepsake."

## THE MINERVA McCOY BASKETS
### (Cumberland County, Tennessee)

My friend, Oley McCoy who lives on the Cumberland Plateau a few miles southwest of Crossville in Cumberland County, Tennessee, brought these two interesting baskets out of the closet for me to inspect.

"Now, the big basket", Oley said, "always hung from the rafters in Grandpa McCoy's old house and that's where they kept their garden seed: beans, pumpkins, turnips and so forth. They hung it down from the rafters on a string and of course that kept the rats and mice out of it. So when spring of the year would come, they would take down that ole basket and get their seed.

"Grandpa and Grandma McCoy lived over here at Genesis, but before that they came from Morgan County and I've been told that they came from Kentucky before that.

"Now this here little basket was made by my Granny McCoy. She was a half Cherokee and a Myatt before she married my grandfather. She made this little basket and I've had it and the big one, too, all these years. I've kept them as sort of keepsakes since they were made by my grandmother, but I'll jest sell them to you so they can be put in the Museum where everybody can see them. Nobody will ever see them layin' around here."

The small basket was doubtless made as a toy for a child, but the construction technique is the same as that employed in the large one. Both are made from white oak ribs and splits.

Oley McCoy with two baskets made by his grandmother Minerva Myatt McCoy, a half Cherokee who was an herb doctor, teacher, and mountain preacher. (Photo by the author)

## GERTIE McCOY'S KEEPSAKE BASKET
### (Cumberland County, Tennessee)

"Granny Haun wasn't what you'd call a basketmaker", Gertie told me. "She just made a few for her own use and to give to her neighbors--she was allus giving somebody something.

"Well, I was so young that I don't remember when Granny made me this basket, but I allus heard that she made it for me and I've had it for as far back as I can remember.

"I'd take my little basket and go with Granny and Mother to pick up apples when they were using their big baskets. You know how a child will imitate it's mother. Then I used it to gather hickory nuts and walnuts and such as that."

This is one of only two or three baskets I have seen made from poplar bark although it was much more commonly used for bottoming chairs. It is 5 inches in diameter and only 4 inces deep.

Margaret Elmore Haun and her husband, Haskell Haun, lived near Crossville, Tennessee in the Genesis community, but were originally from adjoining Morgan County. They are pictured on the following page.

149

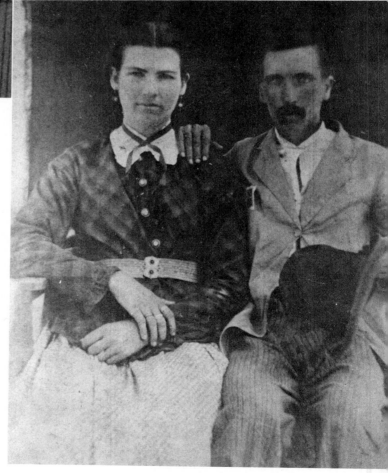

Gertie (Mrs. Oley) McCoy with the little basket her grandmother made for her when Gertie was a toddler. (Photo by the author)

Gertie McCoy's grandparents, Haskell Haun and Margaret, who made the little poplar basket for Gertie. They were married July 31, 1873. Haskell was shot in the back and killed as he worked in a field on his farm.

Oscar Ely, coal miner, farmer, herb doctor, and all-around mountain craftsman, is shown here on the porch of the log cabin he built in Poor Valley near Pennington Gap, Virginia. (Photo by the author)

## OSCAR ELY BASKETS
### (Lee County, Virginia)

These two baskets were hanging in the tiny log house belonging to my long-time friend Oscar Ely who lives in Poor Valley just west of Pennington Gap, Virginia, and near Appalachia's most infamous and notorious area, Harlan County, Kentucky. He and his wife bought them from a Harlan County family named Payne who lived "way over on Martin's Fork".

The decorative chain pattern created by inserting three dyed splits is occasionally found in various parts of Southern Appalachia. It is thought by many to have been introduced in this region in later years. Even Eaton in his well-known *Handicrafts of the Southern Highlands* says that the practice of dyeing came about with the revivalists in the early part of this century.

I would tend to agree with this theory had I not received conflicting information from several old-time basketmakers. Alex Stewart, the reader will recall, explained how his grandmother dyed basket splits with native materials in the last century in isolated Hancock County and Mildred Youngblood remembered that her grandmother had done likewise. (Photo by the author)

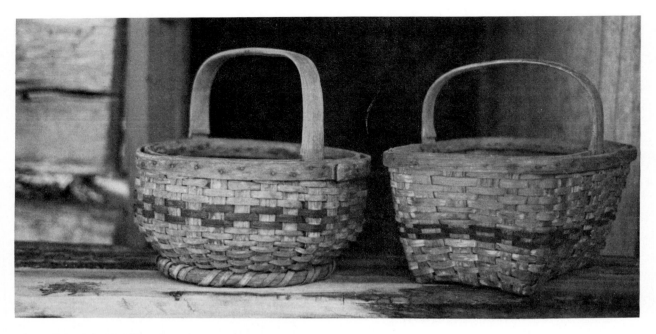

This is a close-up view showing the spoke-type construction technique used in the round Oscar Ely basket. (Photo by the author)

Here again, we find the chain pattern on this white oak split laundry basket from the Middle Tennessee town of Monterey in Putnam County. I bought it from Ina Copeland who was a member of one of the old pioneer families of that area. The chain pattern in the basket is created with splits dyed with store-bought blueing commonly used in small amounts in washing clothes as a whitener. It is 25 inches long, 16 inches wide, and 13 inches in depth. (Photo by the author)

# Chapter 6

# The Indian Influence on Southern Appalachian Mountain Baskets

Allen Eaton in his *Handicrafts of the Southern Highlands* states that "......there is general agreement that the American Indian has created the finest baskets in history". The extent to which the whites and Indians influenced one another in our area relative to the mode and manner of making baskets has not been studied extensively to this writer's knowledge. Some who have written about baskets in the Pennsylvania, New York and New England area say the Indian influence there was negligible. However, other writers insist that the influence was great and that the styles became so intermingled that it became impossible to tell an Indian made basket from one made by the whites.

The Swedes, according to some students of the subject, introduced the split or splint basket to the Indians in the Delaware Valley and this practice, it is claimed, spread among the Indians.

It has been my observation that the Indian influence in Southern Appalachia varies greatly with the terrain and with ethnic background. In the wide fertile valleys of upper East Tennessee, for example, an area with strong German influence, I have found little indication that the baskets displayed Indian characteristics. But a few miles to the East, in the isolated Smoky mountains, I have found a much greater amalgamation of the two forms, especially with respect to the style. Some baskets found in this area have so many Indian and white characteristics built into a single basket that it is difficult, as indicated above, to say with certainty whether it was made by the whites or by the Indians. This is to be expected when one considers that there was a much closer association between the two groups of people in the mountains. Additionally, there was a good deal of intermarriage between the two races.

The baskets included in this chapter are thought by this writer, and by local collectors, to be Indian-made or to have strong Indian influence.

Perhaps it should be pointed out that references to Indians in Southern Appalachia are somewhat synonymous with the Cherokee whom Robert White, former state historian, calls "one of the most splendid Indian tribes on the North American continent". Some Shawnee, Chickasaw, Choctaws and others had used this area as hunting grounds and had laid claim to parts of what we now refer to as Southern Appalachia. But it was the Cherokee who were here when the first white people arrived and some remain, especially in western North Carolina, to this day. They frequently intermarried with the whites, built log houses, and acquired the rifle and the white man's tools. But in the winter of 1838-39 the United States government attempted to remove all the Cherokee from the mountains of eastern Tennessee and western North Carolina, resulting in the previously mentioned "trail of tears" in which 4,000 died on the forced march to Oklahoma. Several of the Cherokee hid out in the mountains and were eventually "given" land in the form of the Cherokee Reservation in North Carolina, across the mountain from the present town of Gatlinburg, Tennessee.

## CHEROKEE EGG BASKET

This appears to be one of the earliest Cherokee baskets I have seen. It is made entirely of cane, which was apparently the most commonly used material by the Indian prior to the coming of the whites. All the weaver (horizontal) cane is dyed either black or reddish brown and are woven twill style, over three and under three, to create the design.

This basket belonged to Mrs. James Roberts who lived in the Ball Camp section of Knox County on Ball Camp Road. According to a relative from whom I purchased it, Mrs. Roberts had used it as her egg basket for most of her life. Mrs. Roberts died at the age of 94 in 1936. My long-time friend, W.G. Lenoir, who is now past 90 years of age, remembers hearing his mother say that when she was a small girl the Indians would come by selling their baskets. Perhaps this explains how the Roberts family came to have this early Cherokee basket--some fifty miles west of the Indian Reservation. (Photo by Gary Hamilton)

## GRANNY RICE'S INDIAN BASKET

Although this cane basket, apparently Indian made, belonged to my grandmother Rice of Knox County, Tennessee, I have no knowledge of its history except that knowledgeable people inform me that it was made by the Choctaw Indians of Mississippi. It is made of cane splits, some of which are dyed a reddish brown. How and under what circumstances it came into my grandmother's possession, I do not know. (Photo by Gary Hamilton)

## CHEROKEE CANE BASKET

This basket was acquired for the Museum from my compatriot, W.G. "General" Lenoir who bought it years ago in the East Tennessee area. It is made of native river cane and is doubtless Cherokee. The bottom is 10 inches square, the top rounded, and it has a depth of 8 inches. The bottom weave is over and under six members, while the sides are of the "over and under three" type. Three groups of horizontal weavers have been dyed a dark brown to create the chain-like pattern. The bottom is well worn, indicating a good deal of use. (Photo by Ed Meyer)

Everything about this basket, the white oak splits, the method of weaving, and the handle construction, is typically Southern Appalachian--except the shape. If the handle were removed and cane substituted for the white oak, then I suppose it could be Indian; so perhaps its form is of Indian influence. As had been indicated earlier, the Cherokee did use white oak splits in their baskets. This basket was acquired by Roddy Moore in the West Virginia mountains. It is 15 inches in height and has a diameter at its widest point of 11 inches. (Photo by Roddy Moore)

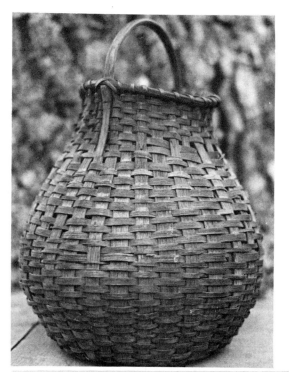

Here again we find the shape and configuration of a typical Southern Appalachian mountain-made basket, but with the design, cane, and type of weave indicating that it is Indian in this case. It was acquired in the extreme eastern part of East Tennessee by Tom and Nancy Walton. (Photo by Monty Walton)

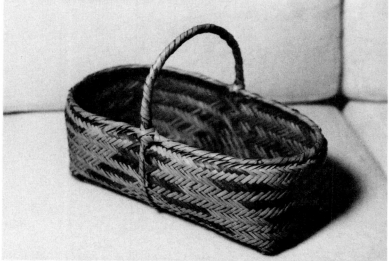

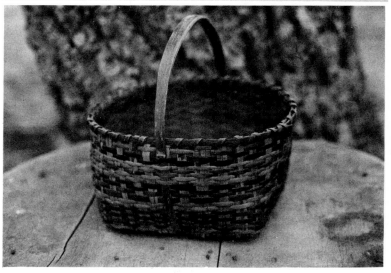

The shape, size, and the white oak handle of this basket strongly suggest that it was made by the whites. But the fact that it is made from river cane and has dyed splits to form a pattern indicates that it could be Indian made. It is a classic example of the two influences being fused into a single basket and apparently the maker was very familiar with both customs. It was acquired near the Tennessee-North Carolina line by Roddy Moore. (Photo by Roddy Moore)

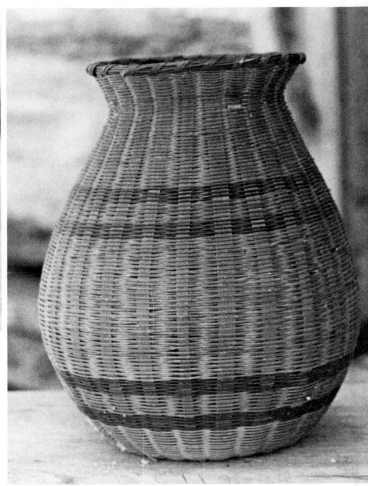

While the basket shown on the previous page is made from Indian material (river cane) and has the form and size of the white man's basket, the one shown here is the reverse. It is made of white oak splits but has the form and decorations which one associates with the Indian basket. It, too, was collected by Roddy Moore from near the town of Cherokee, North Carolina. (Photo by Roddy Moore)

This finely woven Indian basket which we shall call a Cherokee "urn" basket, was acquired by Roddy Moore near Cherokee, North Carolina. It is made of honeysuckle and white oak, stands 13½ inches in height, and is believed to date to the first part of this century. (Photo by Roddy Moore)

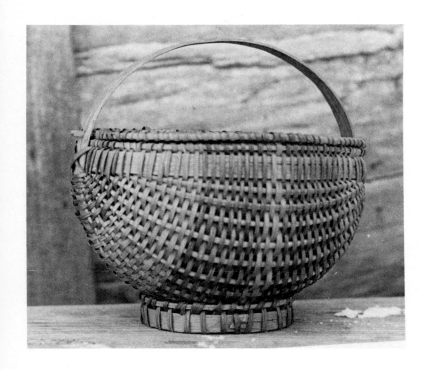

This unusual basket, the only one of its type I've seen was acquired in East Tennessee by Roddy Moore. Local basket collectors think it was made by the Cherokee, but for the whites. If it were made by the Cherokee it is quite evident that they borrowed much from the whites such as the oak splits and the rib construction. The expanded base would serve a most useful purpose in stabilizing the basket when it was in its resting position and in protecting its bottom when the basket was used in a wet or muddy locale. (Photo by the author)

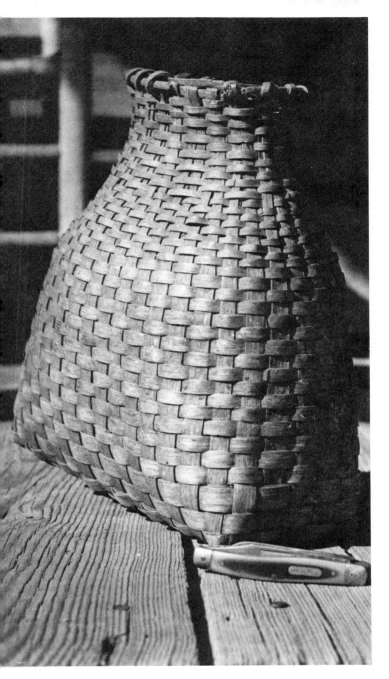

## CHEROKEE GATHERING BASKET
### (Buncombe County, North Carolina)

This most unusual basket, though made of white oak splits, was probably either made by the Cherokee or by the whites heavily influenced by the latter. It is made in such a flat shape as to allow one to easily and comfortably hold it between the body and the upper arm thereby freeing both hands. Some students of baskets in the region claim it to be an Indian gathering basket and indeed it seems it would serve that purpose well.

The splits go from one side of the top around the entire body of the basket and to the top on the opposite side. At the bottom the splits widen to a half inch but on each end they are less than a quarter inch in width. The horizontal or weaver splits likewise get smaller near the top. It is 10 inches long at the base, 4 inches in thickness, a foot high, and has an oblong 3 x 5 inch opening.

I acquired this basket when I bought the old log church from the Tweed family within a few miles of Asheville, North Carolina. It was with a large collection of Indian relics from the nearby Cherokee which possibly lends credence to the suggestion that it is Indian made.

Rob Irwin demonstrates how the Indian berry basket can be held underneath the arm, thereby freeing both hands to pick berries, grapes, hazelnuts or other hanging foodstuff. (Photo by Gary Hamilton)

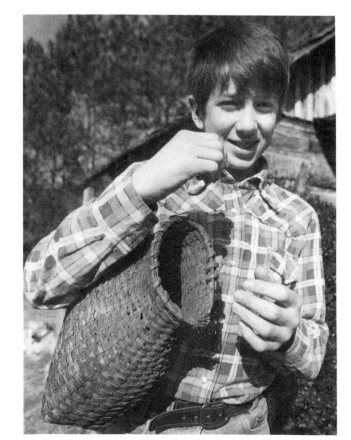

157

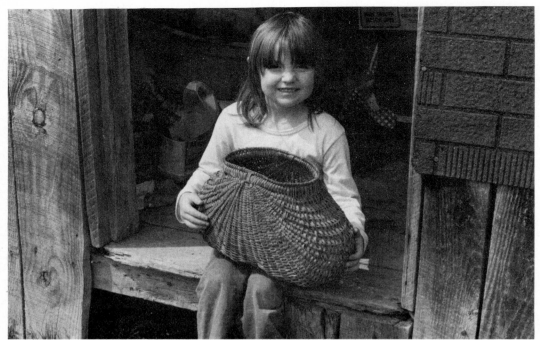

Luann Sutton who lives in Chavis Hollow at the foot of the Great Smoky Mountains is shown here with the Indian-type basket which belonged to Annie Lunsford, her great, great grandmother. (Photo by the author)

## THE ANNIE LUNSFORD BERRY BASKET
### (Cocke County, Tennessee)

The shape of this basket is quite similar to what has been referred to as a Cherokee gathering basket discussed on the previous page; but the white oak rib and split construction is definitely of the white man's influence. This basket is illustrative of the type referred to earlier which could have been made either by the Cherokee with white influence or by the whites with Indian influence. The fact that there was never a handle to this basket is further evidence of Indian influence.

It was purchased from Mrs. Velma Lunsford and her husband "General" Torrel Lunsford who live near the Smoky Mountains in a beautiful but rugged section of Cocke County, Tennessee, a few miles south of the community of Cosby. I reached their home after following the narrow dirt road for what seemed to be several miles.

After acquiring this basket I remarked to Velma that it resembled some Indian baskets I had seen. She stated that it had belonged to her husband's grandmother, Annie Lunsford, and that the old Lunsfords were part Cherokee. She said that they had lived in an old log cabin in a nearby place called Chavis Hollow.

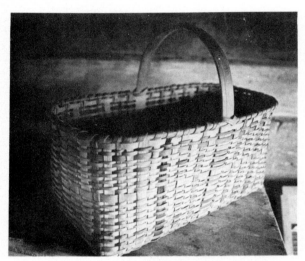

**CHEROKEE WHITE OAK BASKET**
(Loudon County, Tennessee)

Although the white oak splits and the hickory handle suggest the white man's influence on this basket, the woven color design and the style probably mean that it was Indian made. It was acquired from Mrs. Niles Stewart who lived in Loudon, Tennessee at the time she and her husband acquired it, probably in the 1930's. Several of the horizontal and a few of the vertical splits have been dyed--some a purple and some a reddish color. A price of $2.75 is penciled on the bottom, indicating that it was probably marketed on the roadside or by the makers who peddled baskets throughout the extreme East Tennessee area near the reservation. It is 9" x 16" and has a depth of eight inches. (Photo by Gary Hamilton)

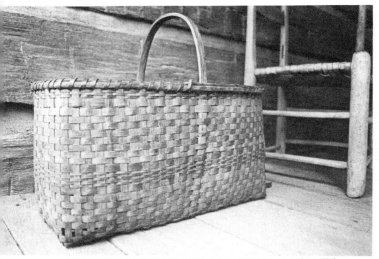

## SMOKY MOUNTAIN MARKET BASKET
### (Sevier County, Tennessee)

Both the splits, the handle and the rims of this basket are of white oak. But the dyed splits and the shape and styling of it belie its Indian influence. It was most likely made by the Cherokee to be sold to the whites. The horizontal or weaver splits are slightly wider than are the vertical ones. About five inches from the bottom there is a series of four weaver splits about half the size of others. This series of smaller splits is repeated at the top.

The basket is 20 inches by 9 inches and is almost 12 inches from bottom to top. Some of the splits have been dyed blue and the others a rusty red as in the case of the Stewart basket shown on the previous page. It was acquired from Sam and Margaret Thompson of Sevier County, Tennessee (near the Smoky Mountains) but its precise origin was unknown to them. (Photo by Gary Hamilton)

## INDIAN QUIVER
## OR FISH ARROW BASKET
### (Mitchell County, North Carolina)

When my friend David Byrd of Erwin, Tennessee, purchased this basket in the Cherokee country of North Carolina it was described to him as being a basket for carrying arrows for fishing. It is made of white oak splits with the vertical ones twice as wide as those running horizontally. In both cases every other split is dyed a medium brown. The quiver stands 17 inches high and is 3½ inches in diameter. It does not appear to be a very early piece--perhaps dating to the first quarter of this century. (Photo by Gary Hamilton)

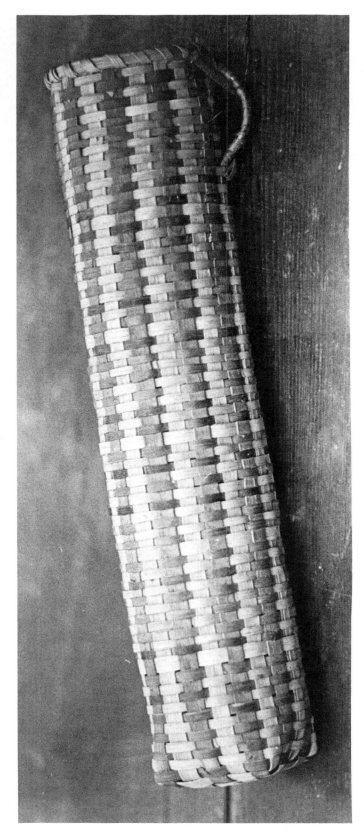

159

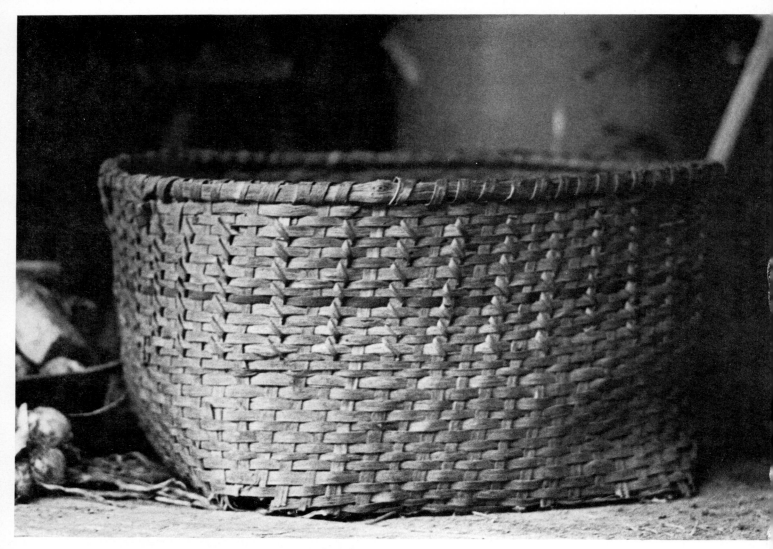

ROBARD WILLIAMS
CLOTHES AND SHOE BASKET
(Knox-Anderson County, Tennessee)

This basket has an Indian "look" about it. It has a single dark dyed split four inches from the top which encircles it. And every other vertical split starting in mid-center is enwrapped from that point to the top of the basket with splits in a special fashion. I assume this is for decorative purposes, although it adds some strength to the construction.

It was used by the Robard Williams family who lived in a pioneer type log house on the Knox-Anderson County line a few miles south of the Museum. Beulah Williams Sharp, from whom I acquired the basket, recalls that her mother used it for as far back as she could remember, as a shoe basket, serving as the repository of all the family shoes which needed repair and which were worn-out completely. Those beyond repair were kept for "spare parts" in patching and repairing others.

This basket, which at one time had a lightweight hand-hold type handle on each end, measures approximately 18 by 22 inches and is 12 inches deep. (Photo by Gary Hamilton)

160

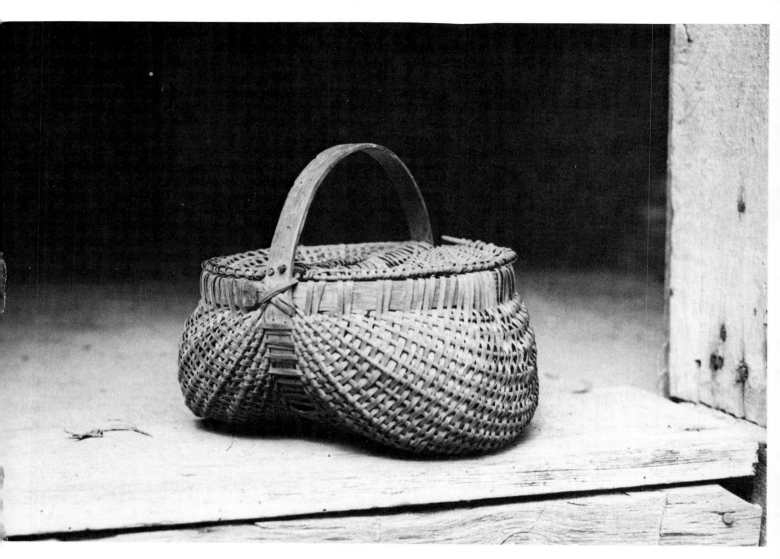

### ERMAN SLOAN'S INDIAN-MADE "DINNER" BASKET

Because this basket is a typically shaped Southern Appalachian gizzard basket and because it is made of white oak, one would not associate it with the Indians except for the faded design work created by dyed splits. And of course the whites of this region very seldom made lids as this one has. But these features, plus the following authenticated narration, indicates that it was made by the Cherokee. My longtime friend Erman Sloan, a retired farmer who still lives near Tellico River in the Notchie community of rural Monroe County, tells the story.

"My Uncle John Forrester lived here on the Tellico River but he worked over around Fontana, North Carolina. Me and my brother Erskin was jest boys--six or eight years old, I guess, and they wasn't much way to travel back then, and no roads through the mountains. So our Uncle John he walked to work over there in North Carolina--it was, they said, about 100 miles round trip. He'd uh go up through Farr's Gap and Slick Rock and he'd come home to see his family about once a month.

"Well, one time when he come home, he brought these two baskets. He had a bigger one for my brother because he was older, I reckon, and he give me the smaller one. He always said that he bought them from the Indians over there--the Cherokee.

"We used the baskets as dinner baskets— to carry our dinner (the noon meal) to school. That was here at Union Hall and after I started going over to Madisonville, I didn't use my basket any more. (Photo by the author)

161

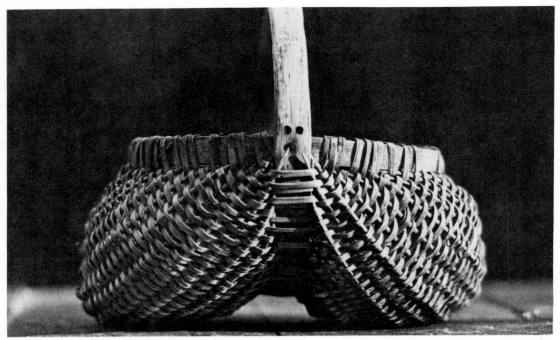

## FRANK SLOAN EGG BASKET
### (Monroe County, Tennessee)

This basket is included in the "Indian Made" category, not because of first and superficial observations, but because of the following reasons. First, it has the burned holes once used for attaching a lid. Both the burned holes and the lid are Cherokee characteristics. Secondly, the basket is very similar to the Erman Sloan basket just discussed and which is pretty well documented as being made by Indians. The two Sloan families are closely related and live within a few miles of one another.

Over the years I acquired hundreds of pioneer type relics from the old John Sloan place in Monroe County at the foothills of the Great Smoky Mountains. In going through the artifacts stored in one of his outbuildings, Frank Sloan and I found the little basket which had belonged to his ancestors. It is the classic Appalachian gizzard basket, but is considerably smaller than most with a top opening of less than 7 inches.

Frank Sloan is the son of the old mountain gunmaker, John Sloan, and the great, great grandson of pioneer Archibald Sloan who settled the homeplace there at Notchie, some ten miles east of Madisonville, about 1800. Frank doesn't know how far back in the Sloan family it goes, but indicated that it had been around for as long as he could remember-- about three quarters of a century. (Photo by Gary Hamilton)

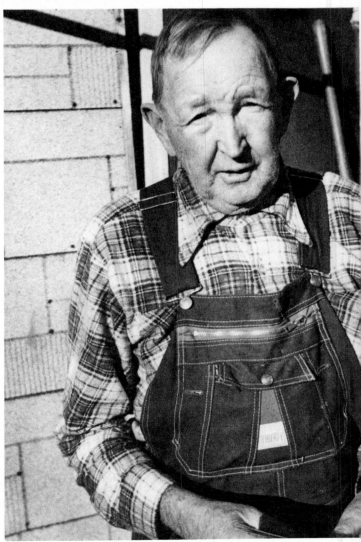

Frank Sloan from Tellico River, Monroe County, Tennessee (Photo by the author)

# Chapter 7
# Basket Related Items

In collecting the relics from the past generations of the Appalachian mountain folk one finds various relics bearing basket-like qualities in construction techniques, but which are not themselves baskets. Chair bottoms, woven sieves and horse muzzles are some examples. On the other hand, there are certain items called baskets but which do not possess the generally agreed upon qualities necessary to put them in the category of basketry. There may be mixed opinions as to which, if either, of these two groups should be included in a book on baskets. However, I am including a few examples of both these groups since they clearly relate to the total subject of baskets and basketry.

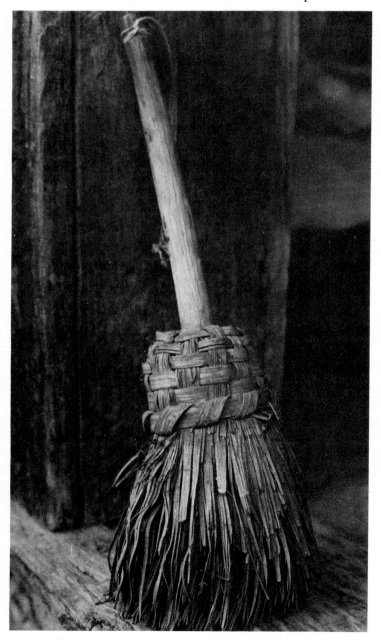

The split-like sweep and the woven binding on this small scrub broom is reminiscent of the basketry of this area. The shavings are whittled from the handle and are left attached so that the broom never looses its "straws". All the individual split sweeps and the handle are in effect one piece of wood. The shavings are bound by woven white oak splits. Although larger brooms of this type were used for scrubbing the puncheon floors, this small version was probably used as a fireplace broom. It was given to me by my longtime friend, fellow collector, and founder of the Lenoir Museum in Norris, W.G. Lenoir. (Photo by Gary Hamilton)

This chair-bottom type of basketry made of white oak splits is most typical of the Southern Appalachian region. This common over-two, under-two twill type of weave was done by Russ and Nancy Rose, discussed earlier in Chapter IV. (Photo by Gary Hamilton)

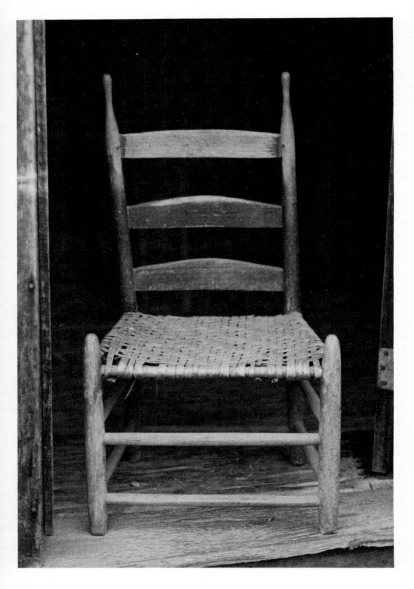

Since there is a vast variation of types and styles of chairs in Appalachia, it would not be correct to characterize this one as common. But this general style was occasionally found throughout the mountains, and the white oak bottom is most common. I would speculate that 75% of all chairs of the region a century ago had this type white oak bottom. (Photo by the author)

## ALEX STEWART'S HICKORY BARK CHAIR BOTTOM

This chair bottom is the same as the one shown at left except that it is made of hickory bark instead of white oak. The bark is stripped from young hickory saplings and can be obtained only after the sap rises in the spring. The bark is actually split and the rough exterior portion is removed and discarded. Only the inner bark is used. It is considered by many, including this writer, to be the most satisfactory and the most permanent of all commonly used materials for bottoming chairs. This one was made by Alex Stewart.

I purchased the fine old rocking chair from Ellis Stewart, a first cousin to Alex Stewart. Ellis lived in an old mountain log house on Newman's Ridge in Hancock County, Tennessee. He told me that the chair was made by his grandfather, Boyd Stewart, who was also the grandfather of Alex.

A few hours later I stopped by to see Alex on Panther Creek and as usual Alex came out to inspect the relics I had acquired that day. He peered through the window of the van, shaded his eyes from the glare of the light, and said, "Why, I'll be switched--you've got one of Grandpap's chairs thar."

In a joking manner I said, "Alex, that couldn't be one of his chairs because I bought it over 200 miles from here."

And in his typical quick and confident manner he said, "I don't care if you got it in China--I know my Grandpap's chair when I see one."

And indeed he did.

He went on to say, "Well, hit needs a bottom and I guess I bottomed over a thousand, but I've done quit. I don't know at the people that I turned away who've come here wantin' me to put a bottom in their chair. But I'm going to break my word and put you a bottom in Grandpap's old chair. And hit'll be the last one I'll ever do, and hit'll be there when you're dead and gone."

And I have no doubt but that Alex was right--as he always is.

Boyd Stewart's rocking chair, circa 1880, showing the hickory bark bottom which his grandson Alex re-bottomed almost a hundred years after it was made. (Photo by the author)

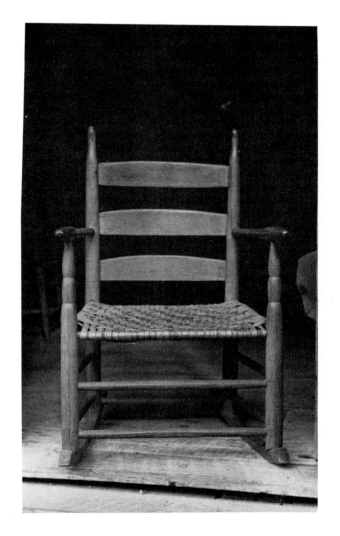

## THE RICER FRUIT DRYING BASKET
### (Greene County, Tennessee)

From pioneer times until well into the twentieth century the drying of fruit and some vegetables was the primary means of preserving such food. My recollection in the 1930's was that everybody dried apples and beans and some still do, including my family.

My grandfather Irwin used to tell me of the times when, in addition to apples and beans, peaches, pumpkins and even blackberries were dried. It would be misleading to infer, however, that the split drying basket

was common in this area. As a matter of fact I have known of only a very few. In some of the more prosperous homesteads one would often find well constructed wooden trays with slatted bottoms. Flat basket drying trays, similar to this one, were considered rather common in the northeastern part of the country, but in the typical mountain homestead the fruit was often placed on a cloth and put on the roof of the smokehouse, woodshed or corn crib. Each night it had to be brought inside to prevent the nightly dew from negating the effects of the day's drying. And every time an afternoon thundershower threatened, the women and children had to rush out and bring in all the drying fruit and vegetables.

This white oak split basket with an unpeeled split hickory sapling as a rim was purchased at public auction by David Byrd from the Ricer homeplace on Camp Creek, some eight miles east of Greeneville, Tennessee. It is about 24 inches at its longest point and 18 inches wide. According to family members it had been used for drying fruit. Roddy Moore, mentioned earlier, states that baskets very similar to this were used in the Blue Ridge section of Virginia for carrying charcoal.

## "SAGE" GRASS BROOM

The weaving together of the common sedge (or sage grass as it is called in this area) is reminiscent of the technique used in making the straw baskets. Note that the finger-sized bundles of straw are tied together separately, as in the case of the rye straw basket, before being bound as a unit. This grass matures in late autumn and often reaches a height of four feet or more. Apparently the use of this plant for making brooms was not common in this region; but it does make a practical broom for very light sweeping, and was occasionally used. (Photo by Gary Hamilton)

166

## THE GRAIN WINNOWING SIEVE
### (Campbell County, Tennessee)

In early Appalachia and for many centuries before, wheat, barley, oats, and rye were threshed by hand flails or by being tramped by oxen or cattle. The straw was then removed, but much chaff, burrs, and broken straws remained with the grain. This foreign matter could be effectively separated from the heavier grain by means of tossing the mixture into the air and even a gentle wind would blow the light husks and bits of straw away. The grain would fall back into the container, usually a winnowing basket or a winnowing tray.

It was at this point that the sieve came into play--for sifting out the large objects, allowing the smaller grain to fall through the mesh into a container. In the quarter century of collection and in the acquisition of over 200,000 relics from the region, I have found only two pair of basketry-type sieves. In both cases one of the pair had a mesh about one inch square. This was used first, of course, and the second one, with considerably finer mesh, was employed next. And when the grain was sifted through the finer sieve, it was about as clean and pure as was possible with the crude and impoverished tools available.

Both pair which were found and acquired for the Museum are made entirely of white oak. The band is rived, shaved thin with a drawing knife, and then formed into a circle. The sieve itself is woven with the same type splits one would use for making a regular basket or for bottoming chairs.

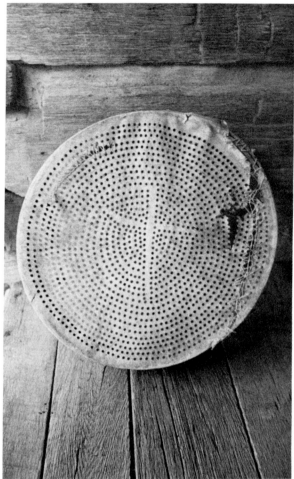

**LEATHER WINNOWING SIEVE**
(Yancey County, North Carolina)

While this hide sieve is not directly related to basketry, it was an alternative to the woven white oak. The mesh is too small for grain and it was probably used for cleaning certain types of grass or legume (clover, most likely) seed. The cross appears to be intentional, but it is highly unusual. I do not recall ever seeing this symbol on any other tool or utilitarian artifact in Appalachia. I bought it from David Byrd, who in turn bought it in the mountains on the Tennessee-North Carolina border near his home in Erwin, Tennessee. (Photo by Gary Hamilton)

The large mesh Dagley-Grant sieve showing the practical and artistic method of looping and securing the splits at their terminal points. It is believed to have been made by Jesse Grant, second cousin to President Grant, in the early 1800's. (Photo by Gary Hamilton)

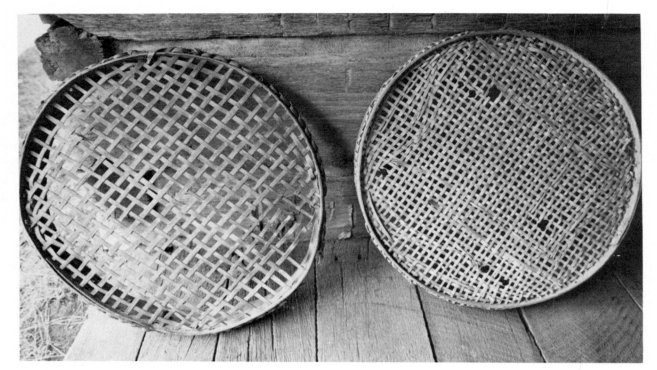

This pair of white oak grain sieves was acquired from the late Jim Dagley who lived some 20 miles northwest of the Museum in the Grantsboro community of Campbell County. They had been handed down from the Grant family, probably Jim's great grandfather, Jesse Grant, for whom the communtiy was named. Jesse was reportedly a second cousin to President Ulysses S. Grant. (Photo by Gary Hamilton)

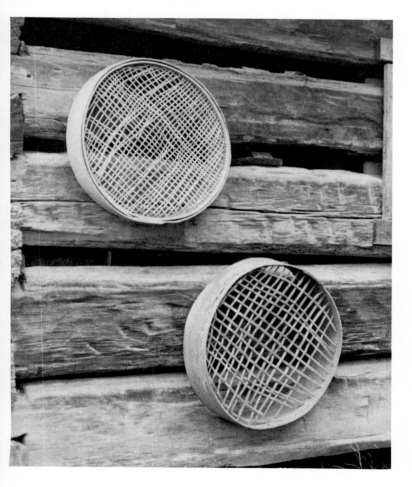

This pair of winnowing sieves, like the ones shown above, are woven from white oak splits. The variation in the size of the mesh in this pair, however, is considerably greater than in the Dagley-Grant pair. It leaves open for speculation the question of whether or not a third, or intermediary, sieve might once have been employed with these two. This set was bought from my trader friend, Lynn Stiner, who lives near Lafollette in Campbell County, Tennessee, the same county where the Dagley-Grant pair originated. (Photo by Ed Meyer)

## ALEX STEWART FISH BASKET
### (Hancock County, Tennessee)

Although this fish trap is not basketry in the true sense, it is called, nevertheless, a basket, possibly because of the pioneer method of making fish baskets fashioned from the white oak splits.

This one was made for me by my long-time mountain friend, the great Alex Stewart whom we discussed at length in Chapter IV. On one of his visits to the Museum, Alex noticed that I didn't have a fish basket; so he decided to make one for me. When he finished it at age 87, he wrote me the following letter:

*Helow John hop you are well. I have bin lookin for you sometime, but havn't saw you. I have a good nice fish basket. Would like for you to come and get it if you want. If so I'll be lookin for you soon as I had 7 or 8 that wants it. But I maid it for you.*

*Yours as ever*
*A.L. Stewart*

Alex, who lives on Panther Creek in Hancock County, Tennessee, remembers when "nearly everybody had themselves a fish basket down here in Clinch River." This one is made of oak slats.

The throat of the trap allows the fish to enter, but the sharp, pointed ends of the slats prohibits them from escaping. When placed in a stream the mouth end of the basket is placed downstream. This keeps the opening from being filled with driftwood and trash. And it is a more effective trap when set in this fashion, according to Alex, since fish feed upstream. The writer's nephew, Rob Irwin, is shown examining the door through which the trapped fish are taken out. (Photo by Gary Hamilton)

## TENNESSEE RIVER FISH BASKET
### (Loudon County, Tennessee)

This fish basket, or fish trap, is very similar to the one Alex made, except that the taper is not nearly so great, and the door is considerably larger. The slats have been permanently taken out in the end to allow small fish to escape. This trap was used until the late 1970's in the Tennessee River near Loudon, Tennessee. (Photo by Gary Hamilton)

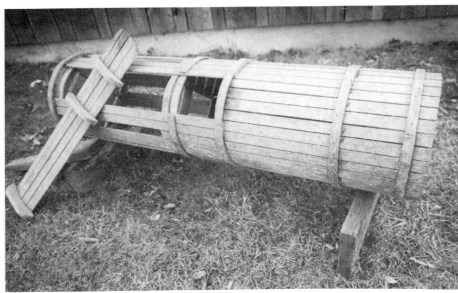

## BASKET FISH TRAP
### (Western North Carolina)

The unusual feature about this white oak, fish basket trap is that the throat, or trap portion, is itself removable from the basket. This is the only means by which the fish can be removed. It was acquired from Brian Cullity who bought it in the northwestern part of North Carolina. It is three feet in height and has a diameter of seventeen inches. (Photo by the author)

## FISH BASKET (TRAP)
### (Buncombe County, North Carolina)

This white oak split fish basket was acquired by Roddy Moore in the mountains of western North Carolina near Asheville. It is 45 inches in length and about 10 inches in diameter at the base. Since there is no door, I assume that the splits at the small end are merely untied to remove the fish. Its size and funnel-shaped entrapment design is similar to the eel traps used in streams nearer the ocean.

The mouth of the fish basket showing the sharpened staves to prevent the fish from escaping.

**WHITE OAK SPLIT BED MATTRESS**
(Washington County, Tennessee)

The four heavy rails of the old cord beds were held intact by tightly stretched rope, crisscrossed, and forming openings about eight or ten inches square. In order to prevent the feather bed from protruding through these openings, the flat white oak basketry type mattress was sometimes used. This one, which I acquired from Paul Ryan of near Jonesboro, Tennessee's oldest town, was the first one I had seen. Since then I have seen one other; and Roddy Moore reports that he has encountered a few in southwest Virginia. This one is made of white oak splits and is approximately six feet by three feet. (Photo by Gary Hamilton)

**THE TOBACCO BASKET**
(Knoxville, Tennessee)

The tobacco basket, which barely qualifies for the name, may well be the most commonly used basket in Southern Appalachia today. Tobacco has been the primary, and often the only, money crop for many families in this region. And every fall hundreds of millions of dollars of this burley is sold at auction from these flat, square baskets. They are usually made of sawed oak slats and are about three feet square. They are used for a few weeks in the tobacco warehouses each year (until the tobacco is sold) and to my knowledge serve no purpose for the remainder of the year. (Photo by the author)

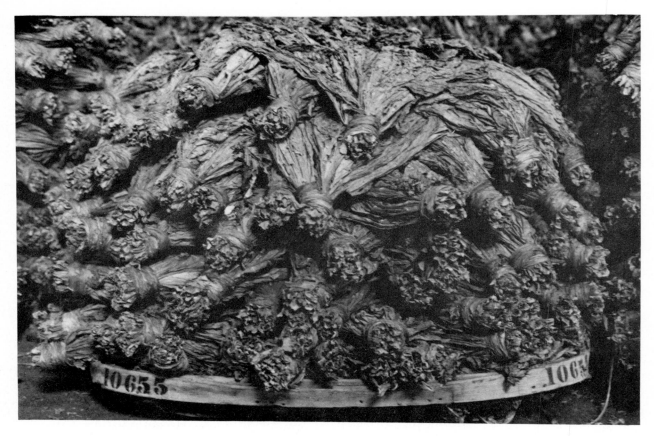

This basket is loaded with "hands" of burley tobacco at a Knoxville auction warehouse. The basket is sometimes piled 5 feet high and can bear 6 or 7 hundred pounds of tobacco. The outer portion of the baskets stand a few inches off the floor, allowing warehouse workers to push their handcars underneath them. With the handcars one man can easily move them at will. (Photo by David Irwin)

## OSCAR ELY DONKEY MUZZLE
### (Lee County, Virginia)

No matter how well one trained the mules and horses, it was virtually impossible to keep them from partaking of the young tender corn shoots while plowing. I well remember using all types of methods to stop old Kate, our best plow mule, from this unfortunate habit. But nothing worked, and I had plowed up half the patch fighting with her when my Grandpa Irwin appeared on the scene.

"Why pshaw", he said, "you need a muzzle for that mule." And he straightforward went to a nearby pawpaw patch, peeled bark, and soon had a temporary, but most effective, restraining device. And when old Kate learned she could no longer grab a bite here and there, she accepted the fact and the plowing continued expeditiously.

Since muzzles were generally made for temporary use, perhaps for one season, and because cheap store-bought wire muzzles have been available for a long time, the old bark and split ones are quite scarce. I asked my long-time friend Oscar Ely, who has lived alternately in the mountains of Lee County, Virginia, and Harlan County, Kentucky, if he could make a mule muzzle. He laughed heartily, "Lord, I've made a many a muzzle for a horse and a mule. I'd go out in the spring and the corn 'ud be about waist high and every time you'd turn around the old mule would be a jumping and grabbing for a mouth full of that green corn. So, I'd have to stop and make me a muzzle and that would put a stop to it."

The next time I visited Oscar in his home in Poor Valley near Pennington Gap, Virginia, he brought out the muzzle and proudly presented it to me. "I went up here on the ridge and peeled me a hickory and made it out of hickory bark, jest like we used to do. I guess that's the last one I'll ever make."

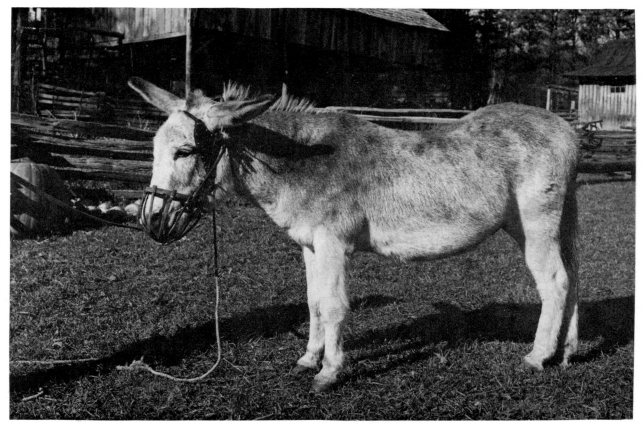

Charlie, the Museum jackass is shown here with the muzzle made by Oscar Ely. It prohibits him from opening his mouth wide enough to bite off the green corn stalks when one is using him to plow. (Photo by the author)

Shown here is a close-up view of the hickory bark mule muzzle made by Oscar Ely. (Photo by the author)

My daughter, Elaine Irwin Meyer, wearing the wooden (white oak split) hat which Nancy Rose made for herself during the depression when she worked as a field hand in the tobacco patch. (Photo by the author)

## NANCY ROSE'S WOODEN HATS
(Museum of Appalachia, Norris, Tenn.)

I had never seen nor heard of white oak hats until I found these hanging in the back room of Russ and Nancy Roses' house. I asked Nancy about them and she said, "Well, hit uz back in the depression and we uz having to work out in the backer (tobacco) fields all day and we didn't have no hats, and yer head got pretty hot. So I figured if you could make a basket out of oak splits, why couldn't you make a hat. So I jest set down and made em. And they come in pretty handy."

The caps were made for Russ and her son and the hat Nancy made for herself. All the items are on display in the basket section of the Museum of Appalachia. (Photo by the author)

# Chapter 8

# The Basket in Appalachia Today

In March 1935 Allen H. Eaton wrote to the Early American Industries Association and requested information of any basket collection in the country. He stated that he knew of none in the North Carolina, Tennessee, Virginia, West Virginia, South Carolina, northern Georgia, or northeast Alabama area. He wanted to observe other collections for comparison purposes. The editor responded that he knew of none.

Today there are no doubt many hundreds of significant basket collections in the area to which Eaton referred, and there are countless other small ones. And no traditional-oriented decoration scheme, it seems, is complete without the use of baskets.

Casual observations in leafing through various domestic-type magazines, those devoted to homes, gardens, and home decorations, indicate a phenomenal interest in baskets. I decided to do a little comparative research on the subject.

The first magazine I picked up from our den dealt with the decorative aspects of the modern home and had a total of only 128 pages. It contained photographs of 61 baskets. These were shown inside the home primarily and were used for such semi-utilitarian purposes as containers for fruit, nuts, cookies, and for holding various types of floral arrangements. Some were used as containers for kitchen utensils, for storing shoes, and for many other decorative and aesthetic purposes. Some hung from exposed beams and ceiling joists, too high for everyday use, but in such a manner as to set a mood for the room—to create a warm and informal atmosphere. Many adorned the shelves of cupboards and the tops of other furniture. Some were even hung with their bottoms flat against the wall so as to create short, shelf-like objects upon which dolls and accouterments were placed.

Well, so impressed was I with the results of my research that I randomly chose another magazine from our very limited selection. This magazine had pictures of 44 baskets in a total of 150 pages. Not quite so emphatic, basket-wise, as the first, but nevertheless very impressive.

In an endeavor to expand on this most elemental research regarding the emphasis on baskets as decorative items, I retrieved a 1912 copy of *"The Ladies Home Journal"*. It contained 80 pages, each twice the size of the modern magazine, and it was heavily endowed with photographs of all types, including those of home interiors. But in the entire magazine I found only two basket pictures and neither was featured in connection with home decoration. One was shown in an advertisement on ribbons, and the basket and its handle were so covered with bows and ribbons that the basket itself was barely visible. The second basket was a factory made one containing produce and was shown in an advertisement in connection with glass canning jars.

Next, I chose *American Country*, the nationally popular book, which had featured the Museum of Appalachia. I knew that its author, Mary Ellisor Emmerling, who is decorating editor of *House Beautiful* magazine, had included a number of baskets as part of the contemporary decorating schemes. But until I consciously started counting them, I had no idea of the extent to which the baskets were emphasized. In the 244 pages of text, this well done and warmly appealing book showed a total of 347 baskets in the superb photo-

175

graphs. Keep in mind that this is not a book on baskets, but rather a well balanced treatise on contemporary American country living.

I know of no other category of relics of the past which has risen so sharply and so dramatically in popularity as has the American basket. This is true, I feel, in Appalachia as much so as on a national scale.

This new interest, as one would expect, has had the corresponding effect of raising basket prices to unparalled highs. But the point might well be made that baskets have been underpriced vastly in the past, and that they are only now reaching levels of comparability with other craft items.

Many collectors of antiques and memorabilia view the production of new items, i.e. the making of reproductions, to be most reprehensible. And these "counterfeit" items are to be avoided totally. But, interestingly, this attitude does not exist with regard to basketmaking. While the old baskets are preferred, new and well made ones are about as expensive and as much sought after. It is doubtful if this is true to such an extent in any other antique-related area.

The higher prices have enabled some old-time basketmakers to "reactivate" their trade and it has encouraged others to learn the art of basketmaking. Several such examples have been cited and discussed in Chapter IV. These higher prices also have motivated country folk to retrieve old baskets from leaky building and dirt-floored sheds, many of which would have otherwise deteriorated and been lost.

This chapter will provide a brief glance at the role of the basket in Appalachia today. It still is used to a very limited extent as a work basket; but it more commonly is used, even in this region, as a keepsake or decorative item.

## CORN BASKET

This double-handled, three-quarter bushel basket was acquired from my 90-year old neighbor and collector friend, Will G. Lenoir, who bought it at an auction in Knoxville. Jeannette Lasansky in her book, *Willow, Oak and Rye,* shows a basket almost identical to this one as it appeared in the 1902 Sears Roebuck catalog. It was advertised as a corn basket and as having been made from "patent" staves. The total weight was two pounds and it sold for 13 cents. This type basket was, and is, used for a wide variety of purposes on the farm as well as to accurately measure corn, oats, wheat, etc.

The photo of the bottom portion of the basket reveals the spoke-like method of construction, reminiscent of the older handmade baskets discussed earlier. The applied rim on the bottom serves as reinforcement as well as to provide a sturdy base upon which the basket could rest. (Photos by the author)

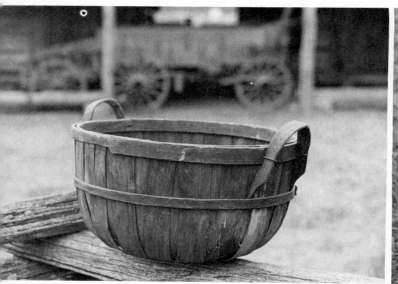
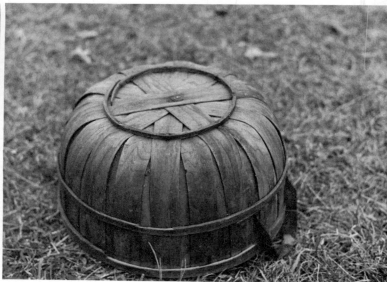

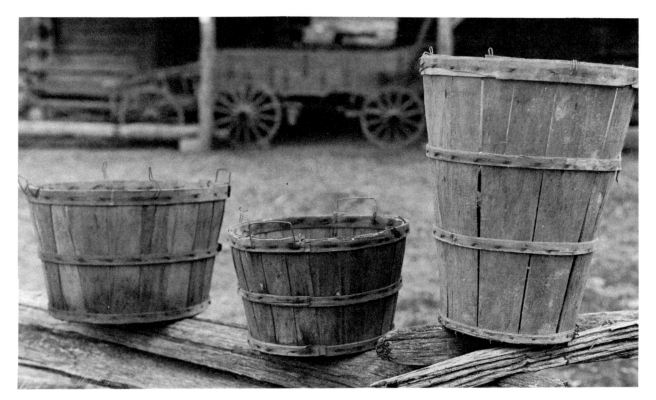

## THE BUSHEL, HALF BUSHEL, AND HAMPER BASKET

In the vernacular of Southern Appalachia, these baskets were the half bushel basket, the bushel basket and the hamper. If my father asked me to fetch a bushel basket I knew he meant this type--the wide, split, factory-made type.

To a great extent these baskets replaced the old handmade baskets. They were very cheap in price, and most often were acquired free of any charge at all, often coming with the apples or oranges one bought. The fact that they were a standard measure added to their popularity as farmers used them to measure their potatoes, corn, tomatoes and other produce. The taller basket, the hamper, held a bushel. The only advantage immediately obvious to the shape of the hamper is that it is easier moved and handled, since one does not have to bend over to move it. Also it required less "setting" space on the floor of a wagon or truck. (Photo by the author)

## THE FACTORY-MADE "MARKET" BASKET

Although various types of handmade baskets are referred to as market baskets in other sections of the country, this cheap, factory-made type was the market basket in Southern Appalachia. It seems to me that some of the more affluent folk, at least those wanting to appear less "country", tended to use this store-bought basket for shopping, carrying their food to the all day singing and for other public uses. It was as if they were ashamed to carry the old hand-made type. This basket is still in common use, and perhaps because it is a basket, it is starting to be collected and used in home decorations. (Photo by the author)

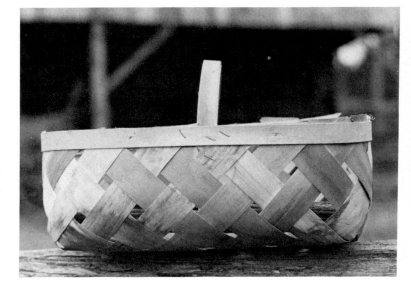

## THE OLD TYPE BASKET IS STILL UNRIVALED FOR GARDEN USE

One would be amiss to infer that the old type basket has been completely abandoned as a work basket in Appalachia. Some are still used for their intended purpose, as evidenced by this photo of the author's wife Elizabeth with one of the Rose baskets filled with green beans from the Irwin garden. (Photo by the author)

## DR. WILLIAM ACUFF AND HIS "FIREPLACE" BASKETS

For nearly two generations these white oak baskets were used to carry corn for cattle, horses, and hogs. But their days as feed baskets are over and they now serve as wood and kindling baskets beside the fireplace in the almost 200 years old restored homeplace of Bill and Sandra Acuff of the John Sevier community of Knox County, Tennessee. Bill, a Knoxville surgeon and former chief of staff of the University of Tennessee Hospital, is a long-time friend and avid collector of the frontier-pioneer relics of our region.

The two baskets shown in the upper portion of the photograph came from the Callie Jackson homeplace in Washington County in East Tennessee. The third one shown at the bottom came from the Joe Thornburgh place near Greenville, Tennessee. Seen peering from the large basket is a not-to-happy Alex Acuff, Bill's young son. (Photo by the author)

This old Union County egg basket now sets in permanent repose in the den of the Irwin home and serves no purpose other than as an aesthetic container for gourds, which are themselves wholly ornamental. (Photo by Gary Hamilton)

The following photographs reveal a few of the several dozens of baskets found in the home of Tom and Nancy Walton who live in Knox County, Tennessee. The baskets, as well as other items which they collect, came largely from the East Tennessee area. (Photo's by the author)

Nancy Walton examines one of her prized baskets which adorn every nook and cranny of the spacious Walton country home.

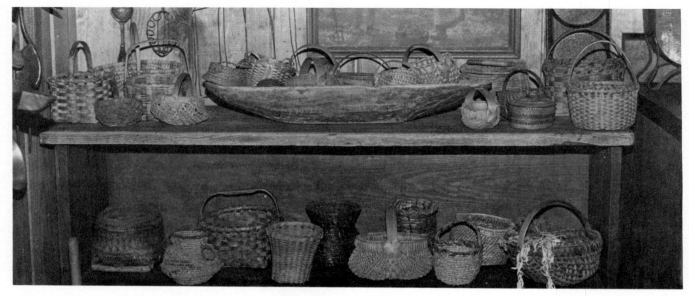

The drudgery of the kitchen work is made a little more pleasant in the Walton kitchen with the ever present company of the friendly miniature baskets.

In the Walton home baskets are used in the bathroom,

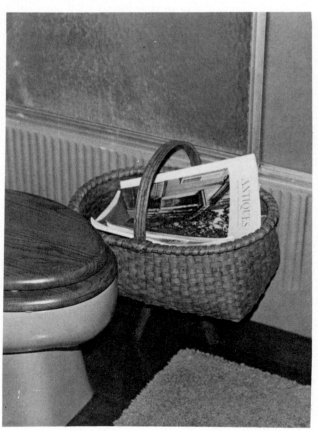

-----in the den as a magazine holder,

----on top of the three-corner cupboard,

----by the writing desk,

---as a letter holder in the study,

---to hold the dried floral arrangement in the bedroom, and for dozens of other purposes.

This wall-hanging basket, sometimes called a loom basket, serves the author's family well as a repository for the garden sage. It can be easily obtained when needed in seasoning meats or other foods. (Photo by the author)

A simple basket of gourds adorns the kitchen "eating" table at the Irwin home. (Photo by the author)

While the canned vegetables serve decorative purposes as well as providing the Irwin family with the winter food supply, the baskets shown in these two photographs serve almost totally decorative and ornamental purposes. (Photo's by the author)

These baskets have found peaceful repose in a bedroom in the author's home. (Photo by the author)

## A PIE SAFE, A T.V. SET, AND BASKETS

The doors of this pie safe usually remain in a closed position revealing only the artistic pattern of the tin panels of this fine Virginia piece. But when my collector friend wishes to watch television, she opens the doors, thus not only exposing the T.V. set, but revealing also a few of her many dozens of baskets. During commercials, or during boring parts of the program, she can admire the beauty of her baskets. The three on top of the pie safe are typical Appalachia baskets, while those shown inside are Cherokee and Choctaw. Among the Cherokee baskets is the one with the heart-shaped decorative pattern, shown in the center of the top shelf, and the large rectangular basket immediately above the T.V. The tall Indian basket shown at the left of the television is Choctaw. (Photo by the author)

184

Even Bertha Jones, from the basketmaking family who thought baskets were made only to be used, now employs this one as a decoration piece. (Photo by Ken Murray)

# Bibliography

Campbell, John C. *The Southern Highlander and His Homeland.* Louisville: The University of Kentucky Press, 1921, 1969.

Christopher, F.J. *Basketry.* New York: Dover Publications, Inc. 1952.

DeLeon, Sherry. *The Basketry Book.* New York: Holt Rinehart and Winston, 1978.

Eaton, Allen H. *Handicrafts of the Southern Highlands.* New York: Dover Publications, Inc., 1917, 1973.

Emmerling, Mary Ellisor. *American Country.* New York: Clarkson N. Potter, Inc. 1980.

Hopf, Carroll. *Basketware of the Northeast.* Thesis, State University of New York, 1965.

Lasansky, Jeannette. *Willow, Oak, and Rye.* Lewisburg, Pa.: Keystone Books, Pennsylvania State University, 1979.

Rothteleki, Gloria. *Collecting Traditional American Basketry.* New York: E. P. Dutton, 1979.

Stephenson, Sue H. *Basketry of the Appalachian Mountains.* New York: Van Nostrand Reinhold Co., 1977.

Wigginton, Eliot. ed. *The Foxfire Book (I).* New York: Doubleday, 1969, 1973.

# Index

189